ELLSWORTH KELLY

ELLSWORTH KELLY
The Years in France, 1948–1954

Yve-Alain Bois Jack Cowart Alfred Pacquement

National Gallery of Art, Washington

Prestel

The exhibition was organized by the Galerie nationale du Jeu de Paume, Paris, and the National Gallery of Art, Washington

EXHIBITION DATES

Galerie nationale du Jeu de Paume, Paris
March 17, 1992–May 24, 1992

Westfälisches Landesmuseum, Münster
June 14, 1992–August 23, 1992

National Gallery of Art, Washington
November 1, 1992–January 24, 1993

COVER: *Colors for a Large Wall,* 1951, The Museum of Modern Art, New York, Gift of the Artist. Photograph © 1992 The Museum of Modern Art, New York. (pl. 74)

FRONTISPIECE: Ellsworth Kelly, Paris, 1950 (photo: Sante Forlano)

Photographic credits:
Color photographs of works from Ellsworth Kelly's collection by Jerry L. Thompson, Amenia, New York. Color photographs of pl. 17, cat. 17, and pls. 43, 50, 57, 59, 62, 74, 82, and 95 have been supplied by the lenders and reproduced with their permission.

Texts by Yve-Alain Bois and Nathalie Brunet are © copyright the authors, 1992

Edited by Mary Yakush, National Gallery of Art
Designed by Phyllis Hecht, National Gallery of Art

Translated by Thomas Repensek, Chronology and Pacquement essay; Gregory Sims, Bois essay

Typeset by Artech Graphics Inc., Baltimore, MD
Color separations by Karl Dörfel Reproduktions GmbH, Munich
Printed by Karl Wenschow Franzis-Druck GmbH, Munich
Bound by Conzella Verlagsbuchbinderei, Aschheim
Printed in Germany

Library of Congress Cataloging-in-Publication Data
Bois, Yve-Alain.
 Ellsworth Kelly: the years in France, 1948–1954 / Yve-Alain Bois, Jack Cowart, Alfred Pacquement.
 p. cm.
 Published in connection with an exhibition held at the Galerie nationale du jeu de paume, Paris, Mar. 17–May 24, 1992, at the Westfälisches Landesmuseum, Münster, June 14–Aug. 23, 1992, and at the National Gallery of Art, Washington, Nov. 1, 1992–Jan. 24, 1993.
 Includes bibliographical references.
 1. Kelly, Ellsworth. 1923- —Exhibitions. I. Cowart, Jack. II. Pacquement, Alfred. III. Kelly, Ellsworth, 1923- . IV. National Gallery of Art (U.S.) V. Galerie nationale du jeu de paume (France) VI. Westfälisches Landesmuseum für Kunst und Kulturgeschichte Münster. VII. Title
N6537.K38A4 1992
709'.2—dc20 92-15853
 CIP

Prestel-Verlag
Mandlstraße 26, D-8000 Munich 40, Federal Republic of Germany
Tel: (89) 38 17 09 0; Telefax: (89) 38 17 09 35

Distributed in continental Europe by Prestel-Verlag Verlegerdienst München GmbH & Co KG, Gutenbergstraße 1, D-8031 Gilching, Federal Republic of Germany
Tel: (81 05) 21 10; Fax: (81 05) 55 20

Distributed in the USA and Canada on behalf of Prestel by te Neues Publishing Company, 15 East 76th Street, New York, NY 10021, USA
Tel: (212) 288 0265; Fax: (212) 570 2373

Distributed in Japan on behalf of Prestel by YOHAN-Western Publications Distribution Agency, 14-9 Okubo 3-chome, Shinjuku-ku, J-Tokyo 169
Tel: (3) 208 0181; Fax: (3) 209 0288

Distributed in the United Kingdom, Ireland and all other countries on behalf of Prestel by Thames & Hudson Limited, 30-40 Bloomsbury Street, London WC1B 3QP, England
Tel: (71) 636 5488; Fax: (71) 636 4799

ISBN 3-7913-1189-1 (hardcover)
ISBN 0-89468-185-0 (softcover)

Contents

Foreword

This exhibition of works by Ellsworth Kelly exemplifies the proposition that in the late 1940s contemporary artists found new voices and visions in response to a new, postwar world. Kelly's years in France, from 1948 to 1954, were marked by profound personal and stylistic discoveries, the result of his pursuit of a broader understanding of our shared European cultural heritage, mixed with an American spirit of adventure. He matured quickly to become the remarkable artist we know and so admire today.

We are delighted to be able to join with the Galerie nationale du Jeu de Paume in Paris to present this first comprehensive exhibition and catalogue of Kelly's paintings, low-relief sculpture, and works on paper from his years in France. Our two cities share not only the status of political capitals, but also the cultural ideals that made possible Ellsworth Kelly's critical awakening.

Our project could have developed only with the enthusiastic support of the artist, who put his collection and personal archives at our disposal and followed closely every step in the preparation of the exhibition and catalogue. We thank him for his patience and generosity. Thanks are due also to Jack Shear for his constant aid to the artist, Henry Persche for his support in the artist's studio, Tim Bartholomew for his assistance with the installation, and Joseph Helman for his early enthusiasm for the exhibition.

Special recognition is due Jack Cowart of the National Gallery of Art and Alfred Pacquement of the Galerie nationale du Jeu de Paume, who as co-curators collaborated on the research, selection, and organization of this exhibition. Their work allows us to make this important period of the artist's development better known to all. We are especially grateful to Yve-Alain Bois for allowing us to publish his insightful essay on the idea of anti-composition in Kelly's art. We would like also to thank Nathalie Brunet for her exhaustively researched chronology and those she cites in its introduction, especially Louis Clayeux and François Morellet, and Ralph Coburn. Catherine Craft's documentation also contributed significantly to the success of the catalogue.

We appreciate the support and interest of Erich Franz, curator, and Klaus Bussman, director, at our other European venue, the Westfälisches Landesmuseum in Münster. The German public had the opportunity to see this exhibition of the early works of Kelly at the same time that his recent works were being shown at the Kassel Documenta and in a related installation at the Münster Kunstverein.

Thanks are due to the institutions that have made notable loans: the Museum of Modern Art, New York; the Musée national d'art moderne, Centre Georges Pompidou, Paris; Rijksmuseum Kröller-Müller, Otterlo; and to Monsieur Louis Clayeux, Anne Weber, and other private collectors who wish to remain anonymous.

The history of art is a marvelous discipline that allows for constant reevaluation and rediscovery of the past. It is with a sense of deep appreciation that the National Gallery can now benefit from this process as we present "Ellsworth Kelly: The Years in France, 1948–1954." Through it we learn more about ourselves, our history, and Kelly's exciting role in the creative arts of our time.

J. Carter Brown
Director Emeritus

Acknowledgments

Our first and most sincere thanks go to Ellsworth Kelly who has matched and further inspired our enthusiasm for his work and this exhibition with his own support, openness, and special energy. He has helped us understand the spirit of these critical early postwar times both through his many reminiscences and his profoundly effective art.

The entire staff of the Jeu de Paume worked with great diligence to ensure the success of this French-American collaboration, which benefited especially from the early support of Dominique Bozo. We would like to extend special thanks also to Catherine Sentis, chief secretary-general, and Jean-Luc Delest, registrar. Françoise Bonnefoy, assisted by Stéphane Crémer, coordinated all of the editorial work for the French edition.

In Washington the exhibition received the enthusiastic support of many individuals at the National Gallery. We thank J. Carter Brown, director emeritus; Roger Mandle, deputy director; Charles S. Moffett, senior curator and curator of modern paintings; Ruth E. Fine, curator of modern prints and drawings; D. Dodge Thompson, chief of exhibition programs, and his staff; and Gaillard Ravenel, Mark Leithauser, and Gordon Anson of the department of design and installation. Mervin Richard surveyed the works on paper, which were prepared by Hugh Phibbs, and Stephan Wilcox worked on the frames for the paintings. Andrew Krieger and Pierre Richard meticulously coordinated the packing and handling, Michelle Fondas organized the transportation throughout the tour. Linda Johnson carried out the task of updating the documentation and reviewing galleys, and at the same time maintained channels of communication between all involved. Frances Smyth, editor-in-chief, and Mary Yakush and Phyllis Hecht edited and designed the English edition of the catalogue, and coordinated the production of the catalogue by our colleagues at Prestel-Verlag, Munich, who with expertise and good humor managed the printing of the French and English editions and the translation, editing, and printing of the German edition as well. Finally, almost every painting and many of the other Kelly works illustrated in this catalogue were newly photographed by Jerry Thompson of Amenia, New York. The catalogue is greatly enhanced by the high quality of his work, accomplished over a period of many months.

Jack Cowart Alfred Pacquement

Ellsworth Kelly in France:
Anti-Composition in Its Many Guises

Yve-Alain Bois

Flashback I

1969: Ellsworth Kelly gives *Colors for a Large Wall* (1951; pl. 74), which is not only one of his most important works but an emblem of twentieth-century art, to the Museum of Modern Art in New York. This generous gift had a dimension that can be termed critical, even polemical. For, in part, the artist was endeavoring to rectify a historical oversight.

As far as I can determine, the only precedent for such a gesture was Matisse's gift of his *Interior with Eggplants* (1911) to the Musée de Grenoble. In this case the government had just acquired its first Matisse, the *Odalisque au pantalon rouge*, one of the most academic canvases from the Nice period, which it had purchased for the Musée du Luxembourg. In reaction, Matisse bought back his "large decoration" from Michael and Sarah Stein in order to give it to a provincial museum selected for its support of contemporary art. "This is the real Matisse," the painter seemed to be saying. "This is what you should be buying instead of these gay little farces." He wasn't wrong: until the *Porte-fenêtre à Collioure* arrived at the Musée National de l'Art Moderne—which took until 1983, and even then it was a bequest!—no painting of equal stature was to be found in French public collections. In fact, the prodigious outpouring of 1910–1914 was wholly unrepresented, with the result that, until the monumental retrospective organized by Pierre Schneider in Paris in 1970, the general public had no idea that the "douce France" hedonism with which the painter's name was associated was in fact merely the visible and extremely limited tip of a gigantic iceberg.[1]

This is not to suggest that Kelly objected even implicitly, to the purchase of *Running White* (1959) by the Museum of Modern Art on the occasion of its famous *Sixteen Americans* exhibition held the same year (which also included works by Jasper Johns and Frank Stella)—though, in my view, this painting is not terribly representative of Kelly's best work at the time. And, *a fortiori*, it's hard to imagine him bemoaning the 1968 purchase of *Green Blue*, a large polychrome sculpture he had completed that same year. But he would have been quite entitled to argue that the acquisition of two works over a period of twenty years is a little on the meager side.[2]

Kelly did not, of course, have to *buy* back *Colors for a Large Wall*. But he did have to endure the admonitions of Sidney Janis, his dealer at the time, who was imploring him instead to sell, since the Tate Gallery was in the market. And finally, in 1969 Kelly's situation with respect to his work from the period 1948–1954 has little in common, at first sight, with that of Matisse in 1922. Whereas ever since the fauve phenomenon Shchukin and the Steins had fought over Matisse's canvases, the American painter had an embarrassment of works to choose from (had he given in to Janis' demands, it would only have been the third of his Parisian pictures to have been the object of a commercial transaction)[3]. There again, however, the comparison holds: when he donated *Interior with Eggplants*, Matisse still retained a good half-dozen of his own pivotal works, any one of which could have served the purpose just as well; so one can only agree with Dominique Fourcade that this work had the status of a manifesto.

Colors for a Large Wall must have had the same function for Kelly. At the time, it was the largest painting he had ever made (and if he could have afforded it, it would have been even larger, hence its title). There is also the fact that, while his opportunities to exhibit were rare, on two separate occasions he chose *Colors for a Large Wall* from among all the other possibilities in order to confront the public: first in a group exhibition at Maeght's where he presented three other works (October 1952); then on the occasion of his first New York exhibition at Betty Parsons' gallery, in 1956.[4] The only other time the painting left his studio was for the traveling *Art of the Real* exhibition in 1968. It should be emphasized that no disavowal was involved in this temporary shelving of the piece: on the museum front, no one asked to borrow it in the interim. If, during the sixties, Kelly didn't pass up any opportunity to present his Parisian works along with his more recent canvases (in his personal exhibitions), it is not surprising that he reserved the lion's share of space for the latter, and that he chose paintings of less imposing format to represent his older work. It is, however, remarkable that every one of these tutelary appearances passed completely unnoticed, so much so that, when in 1963 Kelly explicitly returned to his earlier principle of assembling monochrome panels (a principle different from but not unrelated to that of the monochrome panel polyptych used in *Colors for a Large Wall*), it was hailed as a radical novelty even by as well-informed a

critic as Michael Fried.[5] As John Coplans (rightly unhappy about the length of time it took for Kelly's art to be recognized) notes, it was even taken for granted at the time that the serial and modular works exhibited by Janis from 1965 on (in this case, true monochrome panel polyptychs) were tributaries of minimalism![6]

This was not so much a question of ignorance as of credibility, or rather of non-credibility: an exceptionally attentive spectator inspecting the label of any one of the Parisian works at the time of their fleeting presentation would have found it virtually impossible to register the date read. Or if he had, as did Donald Judd with *Gaza*—shown in 1963 as part of a group exhibition at the Green Gallery—it was merely in order to brush the work somewhat offhandedly aside, as if it were no more than an inconsequential chance event, a random statistic, "a fluke."[7] Even when Kelly's Parisian work was actually mentioned in essays as widely read at the time as Barbara Rose's "ABC Art" (1965), or Lawrence Alloway's "Systemic Painting" (1966), the situation remained unchanged.[8]

The *Art of the Real* has to be imagined in such a context. There is no doubt that *Colors for a Large Wall* acquired a certain pre-eminence in that show—and all the more so since it was accompanied by other key works of the Parisian period, such as *Window, Museum of Modern Art, Paris* (1949; pl. 36) and *Painting for a White Wall* (1952; pl. 81), not to mention *White Plaque: Bridge Arch and Reflection* (pl. 95), a "shaped canvas" done in New York in 1955, based on a 1951 collage. Moreover, it was while this exhibition was passing through London (after a stay at the Museum of Modern Art in New York, the Grand Palais in Paris, and the Kunsthaus in Zurich) that the Tate Gallery declared its interest in *Colors for a Large Wall*. However, in spite of Eugene Goossen's well-informed catalogue, and in spite of the accurate chronological presentation of these works alongside others from the same period (paintings by Newman and Rothko, for example), it doesn't seem that the temporal gap separating them from minimalism (which formed the bulk of the exhibition) impressed itself upon the spectator. Once again, it was just so much whistling in the wind.[9]

As a result, we can understand the thinking behind the gift to the Museum of Modern Art: since this museum had always been the guarantor of a linear, teleological conception of history, Kelly must have imagined his pictorial manifesto duly exhibited in its rightful historical place. Alas, once again the critical cliché proved intractable; in spite of all its good faith, it was only recently, in 1990, that the museum decided to present the great polyptych in a room devoted to the 1950s (and even then, it took the crutch provided by a Matisse cutout for this to happen, in other words, another form of anachronism). For more than twenty years, even when the painting was actually hanging on the wall of the museum, it remained virtually invisible, obscured by the wiles of the two cardinal sins of formalism, namely ahis-torical essentialism and pseudomorphism. Alongside a Carl Andre plaque, a Brice Marden polyptych, or a Sol LeWitt lattice, *Colors for a Large Wall* becomes just one more minimalist object. Even its size assumes no particular meaning in this entourage. The work was done in Paris without any knowledge of the new scale that had been invented on the other side of the Atlantic by Pollock, Newman, Rothko, *et al*, and, as a mural, it opposed the small-scaled works of French "lyrical abstraction." Yet, in a minimalist context, it even seems ever so slightly on the small side.[10] In other words, its "manifesto" aspect, that which constitutes its brilliant novelty, is completely effaced.

However, I have no intention of turning Kelly into a precursor: as I've tried to demonstrate elsewhere, what happened to Reinhardt in this regard should be warning enough of the dangers involved.[11] To quote Alexander Koyré's celebrated remark, "No one is ever truly considered to be someone else's precursor; indeed, it is simply impossible to have been a precursor. And to envisage someone as such is the best way to preclude the possibility of understanding his work."[12] It is more a question of determining what constitutes the particular brilliance of this painting and others like it; and to do so, the series of works in which they figure needs to be reconstructed.

By way of a counter demonstration, imagine for a moment a minimalist reading of *Colors for a Large Wall*. Undoubtedly, and quite rightly, such a reading would focus on the modular character of the grid, and on its additive agglomeration, the "one thing after another" effect, to use one of Judd's expressions (the sixty-four panels that make up this work are as independent of each other as are the metal squares Andre juxtaposes in his floor plates; they are particles placed end to end). But such a reading could not account for two of the painting's most important aspects, namely the aleatory origin of the distribution of colors and their range—the latter due to what could be called a "readymade" dimension (this combination of strident colors, for which one would be hard pressed to find an equivalent in modern painting before Warhol, has a commercial origin: a French school child would have no trouble recognizing the assortment of gummed, colored paper he or she used in nursery school, and which Kelly employed for the collage from which the painting came). Overlooking these two traits, the minimalist reading would miss what in my opinion constitutes the historical specificity of *Colors for a Large Wall* and of other works of the same period, namely the confluence of four different strategies (the "readymade," the aleatory, the *all over* grid and additive elementarization), all directed to the same goal: the elaboration of an a-compositional mode. Even though the goal in question is given pride of place in the minimalist program (if such a thing can be said to exist), even though at least two of these strategies form a part of its arsenal, and in spite of the glimpses of the Duchamp ready-made (most often repressed if not denied outright[13]), no minimalist artist ever deploys or plays this specific

quartet of strategies. It is not my purpose here to list the historical reasons for this, but suffice it to say that, as a cousin of the automatism at work in abstract expressionism, the aleatory is ruled out for the minimalist, as is the ready-made, especially the *colored* ready-made, being the grandfather of pop art. It is enough to point out that even if Kelly's and, fifteen years later, minimalism's anti-compositional aims are in some sense parallel, they don't have the same meaning, since they are inscribed in different historical contexts: Kelly had no score to settle with abstract expressionism (since he was totally unaware of its existence), nor with pop art (which had yet to be invented).

Flashback II

1954: Kelly is penniless, ill, and feeling more isolated than ever. Leafing through an issue of *ArtNews,* he came across a photograph of Reinhardt surrounded by his latest canvases (one of the geometrical *all overs* that the artist called his "brick-paintings"). He thought to himself, "If this kind of thing is being exhibited in America, maybe I could manage to sell my work there," and he decided to return to the home front.[14] It was not that he'd had no success in Paris (after all, as meager as these results might seem to an artist nowadays, used to the dazzling careers increasingly engendered by the voracity of the market, to have a one-man exhibition at the age of twenty-eight—at Arnaud's in 1951—and to have twice participated in group exhibitions at a gallery as prestigious as Maeght's, was in no sense negligible). But, for one thing, as we have seen, this success was purely critical (no one bought anything), and was also based on a misunderstanding. Without exception, all the reviews of his Parisian shows associated Kelly's art with Mondrian and his peers, and even went so far as to link it to the remains of the "Geometrical Abstraction" tradition ("he could be an excellent student of Dewasne," observes the critic from *Arts*[15]). Even Michel Seuphor, at the time the best connoisseur of the Dutch master's painting, was enthusiastic about the young American's work in that it seemed to him a continuation of neo-plasticism, a "constructed" art, as he later put it.[16] Although Kelly did not complain (why discourage favorable criticism), this doesn't mean he agreed with the critics. I would say that it was in part to escape the specter of geometrical abstraction that he embarked for New York, where he adopted a pictorial language based almost entirely on the curve, and broke in many respects with his Parisian trajectory. It should be noted in passing that if the Parisian critics were mistaken, the artists themselves were not always duped. Certainly, the jury of painters and sculptors at the 1950 Salon des Réalités Nouvelles (that den of geometrical abstraction) accepted *Relief with Blue* (pl. 47) and *Antibes* (pl. 50), both works from the same year (it is easy enough to misinterpret these two pieces), but *White Relief* (pl. 48), also from 1950, was coldly refused on the pretext that "it wasn't art"—its serial repetition

of a hexagonal motif having nothing in common with "constructed" art. A further example: in December of the same year, the stable of artists from the Denise René gallery voted almost unanimously against admitting Kelly to their ranks.

The hopes that Kelly placed in his repatriation were immediately dashed. He found himself as alone in New York as he was in Paris, if not more so. Knowing no one, he looked up Rauschenberg (whom John Cage had mentioned in a letter), whose early assemblages he encountered without knowing anything of their pre-history (he would have found it extremely interesting), which meant he had no way of appreciating them. "When I left Paris in 1954, I saw no art that was being 'made' like mine, and returning to the U.S. I found no one 'making' art that way either," writes Kelly in his first retrospective text, precisely contemporary with the gift to the Museum of Modern Art and, like the gift, intended to serve as an historical rectification.[17]

One event put the finishing touch to his disappointment. In early December 1954, Alexander Calder, whom Kelly had met in Paris (and who had provided him with much-needed encouragement), informed Alfred Barr that the former G.I. scholarship holder was back in the country. Barr did react, but none too zealously; at the end of the same month, being too busy to visit the studio, he wrote to Kelly, asking him to have some works sent to the museum. Somewhat outraged by this procedure, the artist responded by declaring that he had only large works to show (a further clue that *Colors for a Large Wall* and other works of the same stamp—for example, *Twenty-five Panels: Red Yellow Blue and White* (pl. 77), or *Painting for a White Wall* (pl. 81), both from 1952—seemed to him the most apt representations of his work). He went on to say that he would therefore wait for the right moment, when the director-curator was not quite so busy. Matters would have ended there had it not been for the tenacious Dorothy Miller, who had her eyes and ears open and, not being one to hang back, visited Kelly's studio, emerging much impressed. Over the course of the spring, after much cajoling on her part, Miller persuaded Kelly to leave six works of his own choosing at her office, so that Barr might catch a glimpse of them (they remained there throughout the summer).

Kelly's selection was in part governed by the necessity of differentiating himself from Mondrian. Accordingly he chose: two works from 1954, his first two strictly New York canvases, which were also the first two in which he used curves (*Black Curves* and *Yellow Curves*); the sole "Arpian" canvas from his Paris period, *November Painting* (pl. 61) (dating from 1950, and coming from one of the numerous collages "based on the laws of chance"); a Duchampian-looking object, the remarkable *Window, Museum of Modern Art, Paris* (pl. 36) from 1949 (at the time, however, its title was still *Black and White Relief*); a yellow, gray, and white vertical diptych, a work whose horizontal axis consists of a strip of black wood separating the two panels

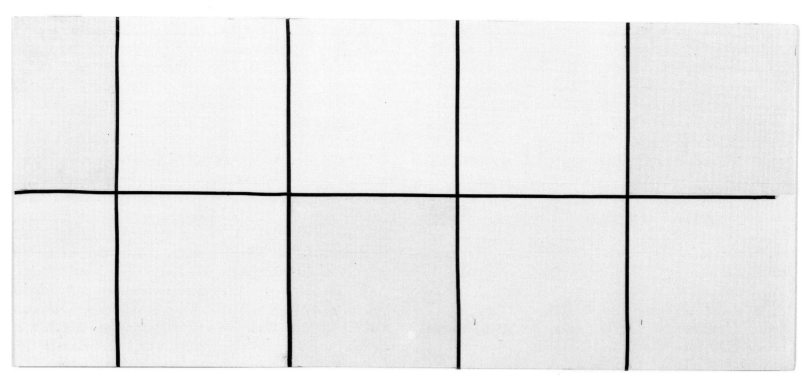

fig. 1. *Bathroom Tiles*, 1951, collage, 8¼ x 19¼ in

(*Dominican,* 1952; pl. 78); and finally a small polyptych of six monochrome panels from 1953 (*Red Yellow Blue White and Black* (pl. 84). Apart from the colors in this last work, nothing in this ostensibly diverse collection can be suspected of having the slightest connection with neo-plasticism (and there is every reason to believe that Barr didn't fall into the primary colors trap; he had too practiced an eye not to perceive immediately the features that rendered the polyptych radically incompatible with Mondrian's art).

If we can thus presume that the tactic Kelly used to dissociate his work from geometrical abstraction was a glowing success with the officials from the Museum of Modern Art, its secondary effect was manifestly disastrous: the pictures were politely returned to the artist. It seems highly likely that the stylistic disparity of the works was attributed, at best, to juvenile inconsistency (a curable ailment), at worst, to eclecticism (a fundamental flaw for an apostle of modernism): where would we be if all young artists started doing a Picasso number—taking a little something from everywhere and changing styles like changing shirts? Barr was no better positioned than anyone else at the time to see past the stylistic obstacle, especially given the fact that Kelly's perfectly understandable addition of two recent works to the Parisian cocktail (neither of them in any way forming a part of the same set) only muddied the waters more. In fact, the critical fortunes of Kelly's Parisian work long remained hostage to the same "double bind." It was seen either as pure abstraction *à la* Mondrian, or as the all-stops-out production of

a young Turk, a disordered mine to which the artist would return for inspiration several times during his career. Even the monographs by John Coplans (1971) and Eugene Goossen (1973), which provide a detailed examination of the early works, or that of Sims and Pulitzer (1982), which scrutinizes the objects and sculpture of the period, don't entirely break with this tradition. To be sure, they do manage to pay off the Mondrian "mortgage," but without trying to determine the principle that might link the various strands of Kelly's work during this period.[18] His art is praised for its lack of "dogmatism," for the fact that it goes off simultaneously in several "contradictory" directions. It is partly in order to demonstrate that all these directions are intimately connected by a single principle, and to determine its logic (which is not at all eclectic), that I propose to carry out a step-by-step analysis of Kelly's Parisian output.

It was not the multiform character of this body of works that first struck the New York critics (understandably since Kelly, made wary by the Museum of Modern Art's lack of enthusiasm, was careful not to reveal, pell-mell, his whole repertoire). Instead, the label that stuck to him was "follower of Mondrian" (see the reviews of his first exhibition at Betty Parsons', in 1956).[19] For several years, Kelly refrained from showing even the slightest of his Parisian works, only bringing them out again in the early sixties, once his adventure with curves (from 1955 on) had discouraged those who were bent on tracking down every whiff of neo-plasticism in his work. At the

very least, the artist drove his point home, and never missed an opportunity to restate his disinterest in geometrical abstraction. In a deliberately ironic gesture, he sent *Green White,* an undulated silhouette from 1961, to the "Geometrical Abstraction in America" exhibition, organized by the Whitney Museum of American Art in 1962, where the work must have seemed disturbingly out of context among the up-tight productions of Bolotowsky, Rice Pereira, and other veterans of the American Abstract Artists.[20]

Yet it would have been easy for Kelly to exhibit a whole segment of his Parisian output without having to suffer immediate pigeonholing as a neo-plasticist. If he refrained from doing so, it was because there were other labels around that in his eyes seemed even more detrimental. Two works from 1950 will serve as good examples of the inanity of pseudomorphism.

Neuilly (pl. 41), a white-on-white cardboard relief, bears a very close resemblance to a Vantongerloo from the early twenties (minus the color, with an added thickness). Now this "composition" has nothing to do with De Stijl. On the contrary, we are dealing with an anti-composition, this time particularly subtle, since it mimics the Belgian artist's painting with great precision. Far from being "abstract," it is in fact a very exact *tracing* of a paved surface in the garden of the American Hospital at Neuilly, reproduced precisely.[21] Had Vantongerloo known about this relief and its origin, he would probably have taken it as a caricatural attack, and would have shown Kelly the door, all the while assailing him with one of the infamous diatribes to which he was given toward the end of his life. (Instead of this, when the young artist payed him a visit, Vantongerloo gave him a lengthy disquisition on the advantages of mathematical calculation over intuition in the elaboration of a pictorial composition. Kelly later said of this 1950 visit to Vantongerloo that he came away feeling relieved: "He made me understand that *his* kind of paintings had to have reasons. I was glad that mine didn't."[22]) A second example: a few months later, still using this tracing technique, Kelly made a collage that was an identical reproduction of a fragment of the "modular grid" formed by the tiles in his bathroom (fig. 1). Who can fail to see how much this work (which today is impossible not to consider ironic) would have irritated Mondrian, and not just because of its referential nature? Didn't Mondrian fly into a rage when Tériade, in an article decrying non-figurative art, presented neo-plasticism as a "strictly decorative" form of painting, and took up a fashionable critic's argument that such pictures were just the right thing for bathroom tile patterns?[23] Who can fail to see that Kelly's very procedure represents a complete inversion of the neo-plastic esthetic, which states that the balanced composition of a painting is a utopian metaphor for the peaceful openness of social relations in the future? It would have been enough for Kelly to have revealed what was behind these two works for every association of his work with neo-plasticism to dissolve forever.

Why, then, did Kelly remain silent for so long concerning the origin of *Neuilly* (Coplans is the first to mention it, even though he doesn't provide a reproduction), exhibiting it at Arnaud's in 1951 under the title *Relief: Blanc sur blanc I*? Why did he never show or allow the tile collage to be reproduced? Kelly's prudence stems from the risk of two different misinterpretations:

A. Until Goossen's text for the *Art of the Real* catalogue, the artist had jealously kept his "sources" hidden, fearing the iconographic virus from which the majority of historians and critics suffer. If he didn't object when, toward the end of the sixties, this corner of the veil was eventually lifted, it was once again in order to signal that his art differed—this time, not from Mondrian, but from minimalism. The result exceeded his hopes; a whole spate of virtually detectivelike investigations was launched: finding the "woman underneath"—as Poussin and Pourbus put it when confronted with Frenhofer's unknown masterpiece—became the critics' favorite occupation when dealing with Kelly's Parisian *oeuvre.* As a result, the work's heterogeneous nature, which until then had been incomprehensible, was now ascribed to the diversity of its "motifs." Everything fits together, juvenile hyperactivity no longer has anything to do with it, the French Kelly is simply a "new look" impressionist, who sits down with his sketch pad, sometimes at a window, at other times in front of water reflections, or the shadows cast by a balustrade on a staircase, etcetera, and then reworks these "spontaneous" notes in the studio, just as Monet had done three-quarters of a century earlier.

Let there be no mistake. Today it seems clear that one of the most important aspects of at least half of these Parisian works is the way in which they relate to a "natural" referent (by which I mean a referent accessible to the senses). But if Coplans, Goossen, and Sims and Pulitzer have to be thanked for worming this referential information out of Kelly, they can nevertheless be reproached for having limited their enterprise to this sole task. For what matters is not so much the existence of a certain motif, nor even which particular motif it might be, but rather A) what *kind* of motif it is; B) how it is used; and, finally, C) how this referential strategy relates to the other modes Kelly used at the time.[24] Failing this, one remains ignorant of the specificity of his work. One simply replaces the frock coat of a neo-plasticist with the smock of a *pleinairiste,* and it is not at all clear that anything is to be gained by this. I can testify to the *disappointment* I felt when, reading Coplans' book just after it came out, I discovered the referential origins of certain of the Parisian works. (There was even a sense of annoyance in my reaction. I saw Coplans' revelations as being in the same vein as the monstrous comparisons between microphotographs and nonfigurative canvases one found in the Fifties—and still finds today—in many introductory handbooks on modern art. To me, Kelly had for several years been one of the heroes of "abstraction." Coplans' revelations made me feel somehow betrayed.)

Of course, this disappointment and annoyance could have been avoided had I paid more attention to certain of the artist's remarks reported in Coplans' book. For, in these remarks, Kelly directly broaches the triple question of the motif just mentioned, and he does so at the very moment he is describing the limit-work marking the turning point in his referential practice (he remains allusive on the kind of referent, is clearer on how it is used, and perfectly explicit on how the strategy relates to the others he has used):

"In October of 1949 at the Museum of Modern Art in Paris I noticed the large windows between the paintings interested me more than the art exhibited. I made a drawing of the window and later in my studio I made what I considered my first object, *Window, Museum of Modern Art, Paris.* From then on, painting as I had known it was finished for me. The new works were to be paintings/objects, unsigned, anonymous. Everywhere I looked, everything I saw became something to be made, and it had to be made exactly as it was, with nothing added. It was a new freedom: there was no longer the need to compose. The subject was there already made, and I could take from everything; it all belonged to me: a glass roof of a factory with its broken and patched panes, lines of a roadmap, the shape of a scarf on a woman's head, a fragment of Le Corbusier's Swiss Pavilion, a corner of a Braque painting, paper fragments in the street. It was all the same, *anything goes.*"[25]

Point A) Apart from the scarf, which has to do with a New York work, all the examples here have to do with perfectly flat surfaces (or fragments of surfaces) offering or constituting a geometrical configuration. Point B) Except for size (and as we shall see in at least one instance, even this restriction doesn't apply), there is no transformation between the referent and its pictorial representation (nothing is added: it is simply a tracing, as is). Point C) It follows from the first two observations that: Kelly does not have to invent, compose, balance, "represent," interpret; all he has to do is isolate and copy. The motif is "already made."

B. Does this mean that we're dealing with ready-mades? I don't think so. Only one step separates the "already made" object from the ready-made, but it is a step that Kelly would never have wanted to take—even if I've used the term "ready-made" several times as a kind of shorthand, and always very gingerly. (The *motif* is *already* made, but the paintings and objects themselves are simply *made*. Even if the notion of anonymity is of the highest importance to him during his years in France, Kelly always insists on the fabricated aspect of his work). It was partly because he felt just as uncomfortable in "Duchampian" clothes as he did in all the others that Kelly hesitated for so long before revealing the "figurative" origin of his works of the period (the original title of each painting exhibited at the Arnaud Gallery was either generic or determined by the place where it was made—*Objet avec ficelle noire; Relief en Bleu; Peinture carrée* or *La Combe; Triptyque: Royan . . .*).

The case of *Window, Museum of Modern Art, Paris* (pl. 36) is in every respect exemplary; what could resemble a ready-made more closely? Even as late as 1983, Werner Spies found it inconceivable that, at the time, Kelly was unaware of *Fresh Widow* (1920). Yet a brief examination of the history of the work itself and of Duchamp's critical fortunes would have shown Spies that, in 1949, it was virtually impossible for anyone outside Duchamp's small circle of friends to know anything about *Fresh Widow,* not to mention Kelly's own chronology, which makes it even more improbable.[26] Like *Fresh Widow,* isn't *Window* a scale model of a window made absurd by its opacity, and thus transformed into a commentary on pictorial esthetics since the Renaissance (contrary to what Alberti thought, a window doesn't need to open onto the world for it to be a picture in itself)? Certainly, there is no play on words in Kelly's title (either in the original—*Construction: Relief en blanc, gris et noir* or in the current title), but the object itself is a "play on things," so to speak, a metaphor (the window as a picture) that, in spite of its non-linguistic nature, nevertheless loses none of its rigorous effectiveness. Indeed, the metaphor could be considered even more effective, more overdetermined than that of Duchamp, as Kelly's work constantly oscillates between three contradictory semantic poles (scale model, "abstract" painting, meta-painting), thus marking a kind of aporia.

As a scale model, the two sections of *Window, Museum of Modern Art, Paris,* like those of a real window, are not in the same plane. The lower section is inset as if the "window" were seen from inside a building; in addition, the shadows cast on this lower panel by the frame and projecting cross-pieces are real. As an "abstract" painting, its symmetry and the congruence between the figure and the field in which it is inscribed link the work to a problematic at the heart of early pictorial abstraction, but virtually ignored since Delaunay's *Simultaneous Disk* of 1912 and Malevich's *Black Square.* And as a meta-painting, the lower section is nothing but a stretched canvas turned face to the wall, whose frame and cross-pieces are painted black and the canvas gray (it is therefore possible to make a picture with two chassis almost without changing anything). A further metacritical aspect can even be detected in this work, again not far removed from Duchamp, namely the satirical packaging of the artistic institution. As its current title suggests, *Window, Museum of Modern Art, Paris* is the replica of one of the paneled windows (whose proportions are not that common in Paris) of the former Musée National d'Art Moderne at the Palais de Tokyo.

Yet, however ironic his intentions, for a long time Kelly kept the irony private (moreover, he admits not having immediately been aware of what he had done[27]; as was the case with Picasso and his *Demoiselles d'Avignon,* it took Kelly several years to digest the import of the blow he had dealt the pictorial tradition).

fig. 2. *Drawings from Four Chinese Seals*, 1948, ink on paper, 13⅛ x 10¼ in

He even refrained from sending the work to the "Salon des Réalités Nouvelles" because it was held in the west wing of the Palais de Tokyo (home to the Musée d'Art Moderne de la Ville de Paris), and the proximity of the model definitely risked giving the game away. Neither Rrose Selavy nor R. Mutt, it will be agreed, would ever have displayed such circumspection. If Kelly is not Carl Andre, or Mondrian, or Monet, neither is he Duchamp. This last point, however, is not easily established, and needs to be examined more closely.

Flashback III

In June of 1949, John Cage arrives in Paris to meet Boulez. He encountered Kelly who was staying at the same hotel, and Kelly showed him everything he had done up to that point. One canvas in particular caught Cage's eye, a brand new work called *Toilette* (pl. 21) (which Kelly later called, bizarrely, "his first abstraction"). It is an anthropomorphic figure whose head consists of a stylized representation of a Turkish or "squat" toilet, imme-

diately recognizable by anyone familiar with Parisian cafés. Contrary to what happened several months later when working on *Window, Museum of Modern Art, Paris*, here there is a process of transformation, of symbolization. Kelly has made a human figure out of a base object—an Ubu-esque human figure, true, but a human figure nonetheless (the allusion to Jarry is prompted by another picture from the same period, *Ubu* (pl. 20), in which one finds the same stylistic procedure; here, though, Kelly doesn't transform an object into an anthropomorphic figure, but rather an "automatic" doodle becomes an animal figure, an owl).[28] True, *Chuan-Shu* (pl. 9), painted the previous year, had already exploited this form of metaphorical displacement (another anthropomorphic figure, this one based on Chinese seals that Kelly had drawn at the Cernuschi Museum; fig. 2), but it has to be admitted that the scatalogical nature of the converted figurative material in *Toilette* amounts to a significant departure. We don't know whether Kelly, who supposedly suffered from shyness at the time, let Cage in on the origin of this canvas, or if Cage simply recognized the object himself, but I'm inclined to believe either one of these two possibilities—otherwise the praise heaped on the work would be highly disproportionate.

Contrary to what has repeatedly been suggested, Kelly does not recall discussing Duchamp with Cage (who already knew Duchamp quite well), nor does he recall any conversations on chance, and it is more than likely that the generous musician didn't want to overwhelm a young man in search of originality, and still very unsure of himself, by immediately unearthing a predecessor—unless Cage simply understood straight away what distinguished the Turkish toilet from R. Mutt's urinal (without doubt, a much more radical piece), and his patient maieutic attitude warned him against disclosing the existence of the Duchampian ready-made, knowledge of which could easily have prevented Kelly from pursuing his own line.

In fact, given Cage's particular brand of open-mindedness (which is also an openness to the world at large), there is every reason to think that his encouragement would have consisted less in launching Kelly on the path of the ready-made than in making the idea of the already made (the "anything goes" side of his work) more acceptable to him.[29] For the painter had already broached this possibility a few months earlier, during his first winter in Paris, but had immediately brushed it aside. Scrupulously recording in his sketchbook the colors and proportions of a checkerboardlike identification mark on the stern of a Seine barge, Kelly had made a painting out of it, his first "modular grid," which he destroyed soon afterward. Now, the reasons he gives today for this rejection seem entirely anachronistic, as *a posteriori* rationalizations.[30] Indeed, what distinguishes the destroyed work from *Chuan-Shu*, which is contemporary with it, or from *Toilette,* which followed soon after, is the absence of any attempt at symbolization. As with the later *Window,*

Museum of Modern Art, Paris, we are dealing here with a simple transfer—along the same lines as a photograph or an imprint, for example. The raw material remains untransformed, but above all—and this is the essential difference—it is almost untransformable: just try to make a human shape out of a grid! A landscape, maybe (isn't this what Klee did?), but a figure? In that case, one might ask, why the privilege accorded to the human figure? Against which model is Kelly measuring himself?

Soon after his meeting with Cage, Kelly left for two weeks at Belle-Ile with a Boston friend, Ralph Coburn, also freshly arrived from America. There he explored various aspects of "automatism" (scrawls, *cadavre exquis:* Coburn was well up on surrealist procedures), which constitute another mode of the already-made. However, it was only after he was on his own again (after a brief return to Paris to put his belongings in storage) that Kelly gradually understood the importance of the already-made for his work. In the meantime, he may have seen Cage again, but, far more important, he went to feast his eyes on an exhibition of sixty-four of Picasso's recent works at the Maison de la Pensée Française: he was particularly struck by *La Cuisine*, the big, black and white canvas from 1948 in which an abstract linear network has been transformed, solely through a few visual cues, into an interior scene with several characters. It wasn't the first time Kelly had seen Picasso's work (when leaving Boston for Paris, he repeated over and over that Beckmann, Klee, and Picasso constituted his whole modern art baggage), but after *Toilette*, for the first time he saw it as an incontrovertible obstacle, standing directly in his path.

No artist could be any more intimidating than Picasso, with his Protean inventive abilities. What is there left to do in the wake of someone who has invented *everything*? In this respect, at least, Kelly remains an American in Paris. Like Pollock and an entire generation along with him, he knows that, if he wants to accomplish anything, his first task is to escape the weight of Picasso. And since the latter cannot be outdone, the trick is not to try to outdo him. How? By eliminating the human figure, to start with—which means not just refraining from producing effigies *ex nihilo,* but also not engendering them by displacement or condensation, since even at this little game, Picasso is unbeatable (he has a magician's touch: not only does he have an infinite array of images in reserve, but he also has the ability to make something out of nothing), and the alterations underlying *Chuan-Shu* or *Toilette* today seem quite laborious alongside the very minimal permutation that turns a bicycle seat and handlebars into a bull's head. But getting away from Picasso also entails renouncing *all* choice, *all* composition. Which comes down to saying that abstraction, whose tradition had up to that point never interested Kelly (he had remained unmoved by the works of Mondrian and Kandinsky he had seen in New York, and what he saw in Parisian galleries seemed like pale imitations), hadn't the slightest solution to offer him. It is not terribly easy to forego every form of invention—strictly speaking, it is all but impossible, since the only solution, the one Kelly seizes on, is to *invent* various ways of avoiding invention.

I shall argue that, at the time, anti-composition was not principally a moral question for Kelly, even if his desire for anonymity and his interest in the "collective" art of the Middle Ages, as well as his desire to escape easel painting, do have to be understood in that way. In spite of his anti-romantic and anti-individualist stance (notably in a letter addressed to John Cage a year after their meeting, outlining the work he had done since), Kelly is not a militant.[31] Although he had very recently survived the Second World War, he felt no great urge programmatically to condemn Cartesian rationalism and subjectivism (as the dadaists had done, and as the minimalists were later to do) for having led humanity to catastrophe. Having to grapple with the Picasso giant was a sufficiently Herculean labor, and it was during his second stay in Belle-Ile, from August to October (and, in a way, throughout his Paris years as a whole), that Kelly set about finding a way of circumventing this obstacle.

There is a discernible logic to the Belle-Ile works (hesitant to be sure, and marked by all kinds of backward glances), which seems to run as follows: from "impressionist" stylization (*Tavant* and *Monstrance* represent, in simplified form, objects he had seen in churches) to the "transformed already-made" (*Mandorla, Face of Stones, Yellow Face, Kilometer Marker, Tennis Court*), and from the latter to the already-made as such (*Window I,* and above all *Seaweed*). None of these works occupies the same point on the vector that later ended in *Window, Museum of Modern Art, Paris. Tavant* (pl. 16), which followed attempts at religious painting the winter before, still remains attached to the human figure, and *Monstrance* (pl. 25) is a two-dimensional schema of a three-dimensional object (it is thus more translation than transfer).[32] *Mandorla's* (pl. 27) forms recall those of ecclesiastical objects, which, while perfectly planar, are nonetheless arranged in being combined; likewise, the arrangement of the stones that gave rise to *Face of Stones* (pl. 24) didn't come out of the blue (we are not even dealing with a "copy" here, as in *Tavant*, but with a minimal figurative invention *à la* Picasso); as for *Yellow Face* (pl. 23), it is clearly a regression compared to *Face of Stones*, though the metapictorial aspect of its *mise-en-abyme* (making a character's head out of a painting whose global field figures this same head) is not without interest; *Kilometer Marker* (pl. 22), perhaps the most intriguing painting in the "transformed already-made" category, is a step forward in the direction of the congruence of field and image, and thus toward the already-made as such (thanks to the close-up and the symmetry of the object, and above all the tangentiality of the horizon), but it is clear that the object in question had to pass through an extremely fine stylizing sieve before it could take on this aspect. (It is also worth noting a certain return to the "impressionist" problematic: anyone who has cycled

weed (in fact, it was the symmetry that had struck him) and to transferring it exactly in paint onto a canvas. As in the series of examples the artist gave Coplans when discussing *Window, Museum of Modern Art, Paris*, here we have A) the motif of a planar surface, B) transferred, C) without invention. Kelly's Belle-Ile retreat proved to be fruitful, and when he saw Cage again soon after his return to Paris, the composer was probably suitably impressed.

The Index

After that, everything happened fairly rapidly. There were certainly still some Picasso-esque "regressions" late in 1949. *Window II* (pl. 29), for example, which, compared to *Window I*, harks back to the problematic of *Toilette*, or *Wood Cutout with String I, II,* and *III* (pls. 33, 34, 32), heavily anthropomorphic works. Kelly was still very unsure of himself: at Christmas time, he went to the Palais Grimaldi in Antibes to see the enamel paintings, works in black and white such as *La Cuisine*, and this was enough to cause Kelly to return to Picasso's orbit (*Deesis I* and *II*

fig. 3. *Studies of a Cement Wall*, 1949, pencil on paper, 16½ x 12 in

fig. 4. *Stonework, Saint-Germain-l'Auxerrois and Walls, Quai des Tuileries*, 1949, pencil on paper, 13⅛ x 10⅝ in

on French country roads—before the increase in automobile traffic put an end to such pleasant diversions—knows how much the lone apparition of a milestone on the landscape's bare horizon can mean. Moreover, the realism of the texture, faithfully imitating the scratched paint of the cement markers, is opposed to the non-mimetic impasto of other canvases from the same period.) Finally, *Tennis Court* (pl. 28) would have been a perfect tracing if Kelly hadn't relied solely on his memory (which led to the outline remaining vaguely anthropomorphic). Even *Window I* (pl. 30) doesn't entirely manage to eliminate the specter of the human figure, though the congruence of figure and field is even more accomplished than in *Kilometer Marker*, and "interpretation" of the referent plays a lesser part.

In my opinion, only *Seaweed* (pl. 26) is a true already-made. Certainly, the artist must have had a hand in arranging his motif, since it involved pinning a piece of seaweed on a wall. But this was his only formal intervention. He limited himself to squaring off the symmetrical pattern of the stretched-out sea-

(pls. 37, 38), *Romantic Landscape* (pl. 39), *Medieval Landscape* (pl. 40) and *City Landscape* (cat. 55), all works done on his return to Paris in 1950, also in black and white, not to mention *Antibes,* a white-on-white relief).[33] Even *Célestins Relief* (pl. 45), whose humanoid form is this time the result of an accident (an error on the part of the cabinetmaker Kelly hired), seems to stem from some watered-down version of cubism. But on the whole, the end of 1949 and all of 1950, an extraordinarily fertile year, were marked by an obsessive exploration of the already-made.

Picasso had said it to Duchamp: It's not enough to sign a bottle-rack or attach a bicycle wheel to a stool, they have to be metamorphosed, endowed with an "imaging" intention. It doesn't take an enormous effort, the simplest manipulations suffice, as with the bull's head, or even—an extreme case conceived as a direct riposte to Duchamp—a pure nominative act: for a gas burner to become a *Venus,* you just need to call it Venus. But however minimal the wave of the magic wand, insisted Picasso, it has to take place if one is to enter the domain of art.[34] Kelly was now in a position to reply to Picasso: "No need to play sorcerer's apprentice; the figurative intention is not a necessary condition of esthetic transubstantiation; art can be made without transforming anything, without having to re-baptise; anything goes."

The large majority of paintings and objects, as well as sketches that never got past the first stage, along with paintings that were later destroyed, come under the heading of what I've called the transfer, and which in semiological terms would be called an *index*.[35] True, in some works, "invention" still played a large part: in *Gate-Board* (pl. 42) and in *Saint-Louis I* and *II* (pls. 43, 44), for example, painted in early 1950, Kelly elides certain details of the original architectural or ornamental motif (the forged iron grille that serves as the basis of *Gate-Board* is simplified and above all incompletely figured—this incompletion being ostensibly signaled in the work itself; as for the two *Saint-Louis,* here we can see how Kelly, after having tried to rectify the lack of pictorial unity in the *objet trouvé,* or rather in the *surface trouvée* (it is a wall) by transforming the door in it, finally decided to eliminate the bothersome eyesore altogether). Overall, though, in spite of these "regressions" mentioned above, the tendency is toward a transfer that is less and less tampered with: *Neuilly,* for example, whose configuration in relief repeats that of the actual paving stones, dates from the spring of 1950, or *Window VI* (pl. 52), a two-panel work whose motif precisely replicates an opening in the parapet on the roof of Le Corbusier's Swiss Pavilion in Paris, seen from the outside. For Kelly, the whole world becomes a reservoir of already-composed "compositions."

The impulse originates with the spectacle of urban existence, which interests Kelly perhaps more than any other because it is at once non-intentional and non-natural. We see the painter's fascination with the stains and volutes left on a cement pillar by a mir-

fig. 5. *Street Patterns below Tour d'Argent,* 1949, pencil on paper, 13¼ x 3⅝ in

fig. 6. *Awnings, Avenue Matignon*, 1950, pencil and gouache on paper, 5¼ x 8¼ in

ror that has been torn off it, which he scrupulously sets down and copiously annotates as if to ridicule the rhetoric of the *informel* movement (fig. 3). We see him fill up his sketch pads and note down, pell-mell, a ventilation cover from the Métro, balustrades, the cut of the stones on old Romanesque walls (fig. 4), billboards plastered with posters of all sizes and colors, the pattern made by new asphalt used to fill up holes in the road (fig. 5), shop fronts. Like Mondrian during his cubist phase, Kelly notes down the "compositions" formed on blank walls by chimney pipes or the colorful ghosts of semidetached apartment houses that have been demolished (wallpaper, the colors of bourgeois interiors standing out against dirty masonry). But unlike Mondrian, he in no way saw these *surfaces trouvées* as confirming the inscription of the world itself in a universal logic of the horizontal and the vertical, where all that's required is a gentle nudge in order to accelerate the process (in *Ormesson* [pl. 58], the only picture that resulted from this examination of the walls of Paris, Kelly limited himself to selecting a color code—sky:black; wall:white; chimney:green—and to group-

ing as a triptych three tracings from various places in the city). If the geometry of the urban landscape attracted him, it was because its non-systematic character stood out against this serial background, because repetition itself brings out the slightest disorder. It is because the awnings on a hotel are not all equally raised that Kelly notes down this chance invention in a little gouache (*Awnings, Avenue Matignon*; fig. 6). As in the case of *Ormesson*, however, this is an exception (which, moreover, did not result in a painting) in the sense that the original motif is made up of *several* distinct surfaces: what do you do with the intervals that separate them? To cheat, as in *Ormesson*, by placing the surfaces end to end, would inevitably have been to deprive the ensemble of what gives it all its charm; to represent the intervals by blank spaces (as in the gouache) would have been to return to an impressionist approach and to have renounced the fusion of figure and field so essential to the elaboration of the already-made. On the whole, Kelly adhered to the unity of surface, and transferred urban "compositions" that didn't present this problem. A later canvas, but one whose design dates from this

fig. 7. *Vaults/Flowers*, 1949, ink on paper, 16½ x 12½ in

period, is a perfect example of this mode of "pure" transfer, presupposing, as in *Window, Museum of Modern Art, Paris*, the absolute equivalence of image and field. *Rouleau Bleu* (pl. 57), from 1951, is the record of the "composition" produced on the glass roof of a warehouse (seen from a bus that the artist caught daily) by new panes different in color from the ones they had replaced.[36]

That said, the specter of Picasso had still not been definitively set aside. In his evident appetite for non-intentional marks, Kelly resorted to a procedure that the Russian formalists called *ostranenie* (deautomatization of perception), which Picasso had greatly exploited: highlighting an ignored aspect of the sensible world (ignored because too well-known), isolating it from its context, depriving it of its function or its causal explanation, inverting it.[37] True, Kelly no longer resorted, as he had several months earlier, to the type of metaphorical deautomatization so dear to Picasso (an example from 1949: the Gothic arches of Notre-Dame, drawn upside-down, become a flower; fig. 7). It is also true that the anthropomorphic universe of

Toilette had been left behind, but the very principle of deautomatization, which remains the way Kelly views his everyday life today and which governs his photographic activities,[38] always risks lapsing back into the figure, since it presupposes the active misinterpretation of a visual fact. Consider, for example, this reminiscence from his youth:

"I remember that when I was about ten or twelve years old I was ill and fainted. And when I came to, my head was upside down. I looked at the room upside down, and for a brief moment I couldn't understand anything until my mind realized that I was upside down and I righted myself. But for the moment that I didn't know where I was, it was fascinating. It was like a wonderful world."[39]

Let us imagine for a moment (an impossible geographical dislocation) that the room in question was a bathroom with a Turkish toilet. What Kelly would have seen here as a child wouldn't have been far removed from what he painted fifteen years later. Maybe he wouldn't have imagined the toilet as an Ubu-esque humanoid, but he necessarily would have seen it as something it is not. Later on, Kelly's perceptual epiphanies did not run this risk, since what he "saw" in the world, geometrical figures, was always given as such (a square of shadow remains a square, shadow or no shadow), but in 1949–1950 he had not yet reached that point.

I believe it was partly in order to eliminate the danger presented by his recourse to the Picassoesque *ostranenie* that Kelly set about exploring the nature of the transfer more seriously, wanting it to be more direct, less dependent on perception (and on the re-presentation of perception) than on the imprint. Two works, both from early 1950, mark this turning point: *White Relief* (pl. 48) and *Window V* (pl. 35). The first of them, later dedicated to Cage, uses a Japanese decorative transfer (enlarged for the occasion) as a stencil; it is a simple impression of the motif and, apart from the change in scale and the decision to use a white-on-white relief rather than an opposition of painted colors, "nothing is lost, nothing is created" (including the slight difference in the upper row of elongated hexagons, repeated everywhere else in a wholly mechanical fashion). There is no risk of translation, of encoding, no reliance on the work of perception. Just the imprint, as in the mouldings by Duchamp, Johns, or Yves Klein. True, all three of these artists shattered esthetic taboos with much more of a fanfare, since, starting with the human body, they explicitly intervened in the artistic tradition of modernism (didn't the suspicions concerning *L'Age d'airain*—the sculptor was suspected of simply having made a cast from nature—convince Rodin, in a way, that he had to leave some traces of manual labor [symbolic translation] on his works, in order to avoid even the illusion of a transfer?).[40] But Kelly's quieter, more private gesture is nonetheless of the same nature. Moreover, the painter intervened even less in *Window V*. Noticing the irregular pentagon of light that a streetlamp cast on the wall of a staircase, a silhouette traversed by large black horizontals formed by

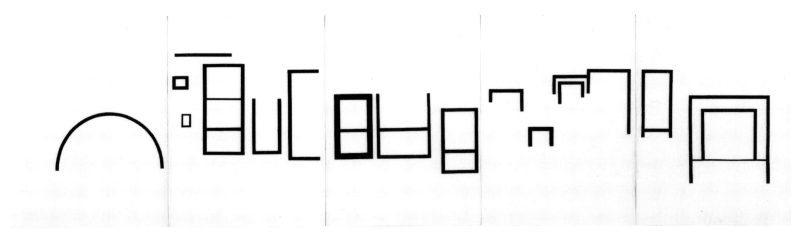

fig. 8. *Archaeological Plans of Ancient City II*, 1950, collage, 25½ x 58 in

the shadows of telephone lines, he "lifted" this form straight off the wall and used it to make his first *shaped canvas,* insisting as well on the autonomy of the panel as an object in its own right when he exhibited it at Arnaud's a year later, where it was hung by a thread in the middle of the gallery.

Contrary to Goossen, who really harps on this point, I don't think Kelly's interest in shadow came from his experience with camouflage in the American Army. Instead, I see it as his pursuing his research into the already-made; it can even be seen as a form of double "already-done." To transfer a shadow, which is an index in the strictly semiological sense that Peirce assigns to the term, is to transfer a transfer. In this second-degree transfer, the relation to the thing seen is at once raw, direct, but at the same time most often undetectable (nothing is more specific than a shadow, but nothing is less specifiable once it is isolated from its context, nothing is more "abstract").[41] The extraordi-

nary series *La Combe I, II* and *III* (pls. 66, 64, 63), from the winter of 1950–1951, based on drawings made in the summer, takes to an extreme this correction of *ostranenie* by means of the direct but invisible transfer. It has been described a thousand times, and Kelly himself has complacently provided photographic and drawn "proof" of his procedure: each one of these works constitutes a faithful transcription of the complex shadows formed on a stairway by a metal railing at a certain time of the day. There is a slight transformation (the three works are not of identical proportions, for example, as if the stairway had become wider and wider and its steps narrower and narrower), but the essential feature lies in the non-mediated aspect of the transfer: each step is treated independently, which eliminates all foreshortening; the step becomes a surface unit that functions a bit like a sheet of light-sensitive paper. Even the fact that the steps, which are separate surfaces in the folded space of the stairway,

fig. 9. *Fields on a Map*, 1950, collage, 25⅝ x 72 in

fig. 10. *Automatic Drawing: Glue Spots*, 1950, ink on paper, 3⅛ x 19⅝ in

are placed end-to-end in the painting is not an underhanded manipulation. Rather, it is the strict result of the mode of projection that Kelly employed, namely the ground plan—which provides no information about the vertical planes (what struck Kelly was obviously the double fact that the general shadow of the railing was fragmented by the steps and that this derealization was accentuated by the elision of the vertical surfaces). If any fraud is to be found, it consists in his mimicking the "accordion" of the stairway (effaced by the ground plan form) and emphasizing the independence of the surface units in *La Combe II* (perhaps the most delicate of his French works), articulating it like a folding screen: cheating in order to tell the truth.

Emboldened by this example of direct transfer, Kelly briefly turned to another type of index, geographic maps. A large, five-panel polyptych, which he destroyed soon after, was made by tracing the archaeological plan of an ancient city (fig. 8), and he had envisioned another one based on a detailed road map (a sketch of it remains, as does the large preliminary collage—blue lines on a white background; fig. 9). But the artist rejected this material since it presupposed a considerable labor of selection and thus too much intervention on his part (unless you include everything, and thus reproduce the map as is—go from the already-made to the ready-made, so to speak—you have to decide which line to highlight, which to leave out). It is not so easy to do complicated work, as in the three *La Combe*, without having to compose.

Nevertheless, this brief use of the map once again serves very well to distinguish Kelly from Duchamp, the master of the index, or rather from the Duchampian lineage, from Johns (to whom he has been compared) or from the early Rauschenberg, both of whom made use of the index as an anti-compositional procedure. The difference, already noted with regard to *Window, Museum of Modern Art, Paris*, becomes strikingly obvious with the simplified maps but also with the three *La Combe* works. At the time, Kelly absolutely did not want the original referent to be deducible from the work (he even says he was furious when Delphine Seyrig's brother, whose parents had put Kelly up at their villa La Combe, immediately recognized the stairway with interlacing shadows when he saw the work at Arnaud's). Like Kelly's, the works of Johns and the early Rauschenberg are in the domain of the transfer, whether they exploit the coincidence of field and image (Johns' flags and numbers from 1955 on; his maps from 1960 on; Rauschenberg's numbers of 1950 [*The Lily White*]; his famous bed of 1955); the pure imprint (Rauschenberg's 1949–1950 photographic blueprints, his 1951 and 1953 footprints and tireprint, Johns' handprint from 1960, his direct casts); the tracing (the example closest to Kelly is perhaps Johns' polyptych, *Untitled 1972*, whose central panel motif is copied from a stone wall in Harlem[42]), or more subtle allusions to the indicial procedure (for example, in Johns' series *Device Circle*, starting in 1959, where the ruler that serves as a compass to trace out a circle is actually stuck on the canvas in a gyrating position). But in all these cases, the referential link is underscored, the tautological character of the index reaffirmed. Johns' flags are immediately recognizable emblems, and with Rauschenberg's work it is impossible not to perceive the black ink coating on a roll of paper as a tireprint.[43] Among other things, it is because the referent is a given that these works are read as indices, and thus as non-compositional.

Things are quite different with Kelly. If he does a tracing of some motif or other, it has to be indiscernible as such; if he makes use of the index, he does so without pointing to what the sign indicates. Paradoxically, then, in her formidable "Notes on the Index," Rosalind Krauss is quite right to take Kelly's art as a summit of opacity and of modernist autonomy, as the very example of what the artists who took up the Duchampian tradition of the index in the 1970s opposed (even if the work she quotes, one of Kelly's diptychs from the 1960s where one of the panels is placed right on the floor, is also in its way an indicial transfer—as we shall later see with other monochrome polyptychs from 1951–1953, which can moreover be related to Rauschenberg's white polyptychs from the same period).[44]

There's no smoke without fire, as the saying goes; Kelly does not deny this, but he is solely interested in the smoke, and couldn't care less about the fire, as he prospects this illogical object, an index without a referent.

Chance

Despite appearances, all compositional danger had not been eliminated, but Kelly only became aware of this when working with his second great Parisian strategy (also called into play around 1949–1950), namely chance. I have already mentioned the brief exploration of "surrealist" automatism in the company of Coburn at Belle-Ile in the summer of 1949. In some respects, the transfer itself depends on a kind of objective chance (we see it with *Awnings, Avenue Matignon*: the artist "stumbles on" a constituted spectacle, and seizes the opportunity). Even the imprint in the strict sense can have an aleatory basis: an extraordinary series of drawings, which it is hard to see how Kelly could have transformed into paintings given his anti-expressionist position (they look like Henri Michaux's scrawls), is done simply by blackening the traces of glue (fig. 10) on the sheets of Kraft paper that protected his work table. Or again, in a slightly different genre, Kelly makes a painting out of a collage of pieces of colored paper found in a gutter (*Pink Rectangle*, 1950; pl. 54). Or finally, in a much more interesting way (but the serial principle behind this work was not used again until the series of collages entitled *Spectrum Colors Arranged by Chance* done a year later), the artist "transfers" the combination of black and white stripes formed by the slightly misaligned overlapping pages on the edge of an illustrated magazine (fig. 11).

The exploration of chance proper, however, followed several visits that Kelly paid to Arp during the spring, in the course of which Arp showed him certain collages done "according to the laws of chance" during the dadaist years (as well as the modular grids he had made with Sophie Taeuber-Arp). Between then and the autumn, Kelly made a large number of collages based on the same destructive-recuperative principle: drawings or collages that he didn't like were torn up or cut into little pieces that he then dropped onto a fresh sheet of paper and glued into place. Only one painting (pl. 61), very close to Arp's torn paper works, came out of this series, *November Painting* (the title is at once a chronological indication and a metaphor: the scraps of paper fell like autumn leaves), a fact that cannot be explained solely by his shaky financial situation. Indeed, everything suggests that Kelly had serious doubts at the time concerning the very possibility of chance as a non-compositional strategy. He may have been wondering whether, in the final analysis, it was impossible not to compose, whether it was finally worth all the effort it was costing him. It would seem the artist quickly realized that the works in question (like Arp's collages for that matter) were not terribly different from straight abstract compositions, at least not enough for their non-intentionality to be perceptible (hence the small number of finished works); even the fragments of *November Painting,* ostensibly randomly scattered, somehow seem deliberately arranged. (And in my opinion Kelly felt the same anguish in the course of 1950 about his pure transfers or indices without a referent. How do you ensure, without reveal-

fig. 12. *Automatic Drawing*, 1950, ink on paper, 9⅛ x 12⅛ in

ing your sources, that the final result of a transfer doesn't *look* like a composed abstract painting? Isn't *Neuilly* almost identical to a Vantongerloo?)

For a very brief period, this led Kelly to a certain exploration of composition proper. In a whole series based on cutting up and sticking back together, which Kelly today calls his "Meschers decadent period" (from the name of a village where he spent the summer)—but also a picture like *Colors on Wood* (pl. 51), based on a collage made with pieces of colored paper he had found on his work table—he tried to find an answer to the question: where does the concept of composition begin and where does it end, at what point do you abolish intentionality, mastery, invention? In the first place, it was a question of verifying that as soon as you start tampering, composition hits you right in the face, no matter how aleatory your starting point, no matter how rapid or "automatic" the process might have been. Two of the rare paintings he made at the time, *Fond Jaune* (pl. 55) and *Fond Noir* (pl. 56), both of which involved cutting up and regluing, are at once a striking failure (they give the impression of having been composed in the most traditional fashion) and an analytic success (they show that almost anything is

enough to abolish chance). The original material came from a drawing for *Toilette,* whose cut-up fragments were arranged and glued very rapidly, "as if without thinking," *alla prima,* on two sheets of paper (one yellow, the other black), these collages then being transferred to painting. It is certainly not insignificant that dadaist "chance" (that is, chance given a helping hand) should have been conceived here as another assault on Picassoesque figuration, but in my opinion the gesture is more in the nature of a test than a victorious attack. Kelly seemed to be asking himself: "I've abolished the figure, but not the appearance of composition. Is it due to the simple fact of having seen what I was doing that, in spite of myself, I fell back into the old ruts of traditional abstraction?"

Whence the necessity of a second verification, a second test, throughout the summer of 1950, during which Kelly resumed the exploration of automatism begun in Belle-Ile. This time he very clearly dissociated the aleatory from the transfer, on the one hand, and on the other from simple rapid scribbling, which it is naive to think precludes all control. It is even the question of visual control, to the extent that it is immediately linked to intentionality, that seemed utterly to preoccupy Kelly, and which he

sought to isolate as if by experimental method. Either he draws trees or twisted reinforcing rods sticking out of the remains of shelled concrete bunkers *without looking at the paper,* or, *with his eyes closed,* he draws some object from memory, a coat hanger, for example.[45] Once blinded, can the painter escape the grip of composition? The result, as interesting as it is, is basically negative. Either the drawings in question are too perfect (fig. 12), testifying to an exemplary motor coordination, or they are illegible failures that Kelly is not willing to accept as such, first because they look more like straightforward clumsiness than the product of chance, and also because, *a priori,* there is nothing to prevent one from detecting "unconscious" images in them, and thus falling back—the old surrealist saw—into figuration. He had to face the fact that the aleatory as such does not so easily give itself up to the eye, a fact of which he was finally convinced by the series of "tachist" pedagogical exercises he proposed to his pupils at the American high school in Neuilly during the winter of 1950–1951. For the disorder of chance to manifest itself, it has to be opposed to the strictest possible order; organization is needed for the unorganized to appear as such.

And what could be stricter than geometry, and more organized than serial repetition? A whole series of collages in the spring of 1951 set forth the opposition between chance and necessity. To make them, Kelly cut a drawing or a collage (generally striped) into squares of identical format and reglued them end-to-end on a support of the same dimension so that they formed an all-over modular grid. Here, it is impossible not to notice the unpredictable character of the joins. When he transcribed this series of experiments into paintings, the artist for a moment even imagined retaining the gamelike aspect in the final work. This is the origin of his first large polyptych, *Cité* (pl. 68), from the summer of 1951, made up of twenty wooden panels that he had anticipated could be permuted at will. It is logical, in a way, that this idea should have been abandoned and that the initial order "selected" should finally have been retained: since "anything goes," why not play the very first hand dealt, given that (in this instance) the geometrical distribution ends up being ever so slightly disrupted by the juxtaposition of bands of the same color (black or white) from one panel to the next? No doubt it was the pointlessness of the permutation that made Kelly abandon the polyptych form in the three other pictures based on the same principle (*Gironde* [pl. 70], in yellow on white, *Talmont* [pl. 69], in green on white, and *Meschers* [pl. 67], in green on blue), exhibited in the autumn, like *Cité,* at the Maeght Gallery. But what Kelly saved in labor, he lost in effectiveness in what could be called his fight against the pictorial tradition. Compared to the polyptych, the latter three works exhibit an elegance that borders on decorative prettiness and effaces the radicalness of the notion of an aleatory lack of control.[46] Moreover, this is exactly how they were perceived: a silk manufacturer from Zurich, on seeing *Meschers,* commis-

sioned Kelly to design some motifs for printed fabrics (the artist jumped at the chance, and took the opportunity to quit the job he had taken as a security guard after the American school had told him they no longer required his services—without, however, for a moment confusing his pictorial work with this mercenary task).

Perhaps *Seine* (pl. 71) (done in the autumn), a painting that momentarily reverts to the impressionist problematic, even stems from Kelly's desire to distance himself from a decorative reading of his work. It wouldn't be the first time that resorting to the natural referent had served as protection against the specter of the decorative (isn't Pollock's famous return to figuration, which took place at exactly the same time, partly governed by just such a concern?). I wager, nevertheless, that Kelly was surprised that his simultaneously digital and aleatory procedure produced such a mimetic result. In *Spectrum,* the series of collages that immediately follows, and which is based on a similar principle, the artist scrupulously refrained from making even the slightest referential allusion. The principle in question is half derived—but only half—from systematic art, as it had been initiated by van Doesburg in his *Composition arithmétique* (1930), and defined in his "Manifesto of Concrete Art" the same year. The notion of a systematic art calls for a mode of pictorial organization where everything has to be determined in advance by a calculus, where everything is set *a priori* by a given "system," and where the artist's sole decision concerns the rules themselves (in van Doesburg's key-canvas, for example, there is the choice of an arithmetical progression of homothetic squares). If, after all, van Doesburg, Max Bill and especially Richard-Paul Lohse were the most prolific and most conscientious representatives of systematic art, Vantongerloo (although in a much less rigorous fashion, notwithstanding the paranoiac obsessiveness of his calculus) had insisted around the same time that art required a "mathematical" motivation (the primordial difference between his compositions and van Doesburg's canvas or those of Lohse comes from the fact that their system is not discernible, and is only revealed by the title—and even then in a very succinct way).[47] It is therefore quite surprising that Kelly, who a year earlier had reacted so negatively to the pseudo-algebraic ratiocinations of the old Belgian artist, should have chosen this rationalist path.

There is no doubt that Kelly was momentarily tempted by the notion of a "systematic" art, and by all the illusions concerning the "universal" character of its formal language that go with it (in a way, the book he had proposed for a Guggenheim fellowship, dating from the same period—and which, it should be noted, he abandoned *illico*—was not far from the approach of a Bill or a Lohse in that it sought to demonstrate the possibility of a basic geometric alphabet, capable of providing material for all sorts of combinations).[48] But there again, we need to look more closely: the structure of *Seine* and of the various *Spectrum* collages is not just systematic, it is also aleatory. The system presiding over each of these works is in every case rigorous, but

also conceived as a pure receptacle of chance. The notion of a systematic art flowed from the necessity of suppressing the arbitrariness of composition, but the arbitrariness presiding over the choice of system remained. Kelly's extraordinary insight was to counterbalance that of the system with the still greater arbitrariness of chance, so as best to eliminate all subjective determination (François Morellet, a few years later, was the only other artist to use this method[49]). In *Seine,* Kelly decides to blacken in a strictly progressive manner a rectangular modular grid formed of forty-one by eighty-two units starting with each of its two lateral sides (zero, then one, then two, then three black rectangles, and so on until he reaches forty-one, the two central vertical rows being totally black), but the vertical placement of the black spaces is randomly determined, by drawing numbers out of a hat. The system is different in the *Spectrum* collage series (where it is a matter of accentuating the all-over aspect in order to avoid any figurative impulses), but the principle is identical. The only new parameter is that of color.[50]

This is an important difference, however, since it explains why Kelly waited two years before doing a painting based on this series of collages, and only did one. Despite the playful, jubilant use of the already-made color-spectrum furnished by the gummed paper, he was nonetheless worried about the complexity of the chromatic relations engendered by abandoning a binary system. Departure from a simple color opposition (black/white as in *Seine,* or at least bi-color, as in the series of pictures entitled *Répartition aléatoire de 40,000 carrés suivant les chiffres pairs et impairs d'un annuaire de téléphone,* done by Morellet in 1961), risks the forming of relations between colors, of pairs and triads being constituted, and thus risks "figures" emerging. In a way, as far as color is concerned, this is a demonstration that is the complete inverse of the one concerning form or drawing in the series that goes from *Cité* to *Talmont:* the more colors used, the more the risk of involuntary composition emerges, the more difficult it is to make the unintentional manifest (or, as Judd and Stella later put it in a famous interview, the more trouble you have freeing yourself from the *relational* esthetic, the harder it is to eliminate all semblance of intentional relations between the various parts of a painting).[51] That this is what Kelly felt about the *Spectrum* collages (beyond the simple lassitude brought on by the extenuating slowness of the process), is confirmed, I think, on the one hand by the continual evolution of his modular vein, immediately after these collages, toward an increase in the size of the color units and a decrease in their number, which accordingly diminishes the possibilities of internal chromatic relations (*Colors for a Large Wall* [pl. 74]: sixty-four panels; *Sanary* [pl. 73], the work that formally speaking is the closest to Lohse or to Bill: forty-two squares; *Two Yellows* [pl. 76]: twenty-five panels; *Méditerranée* [pl. 75]: his first purely abstract relief: nine panels); and, on the other, by his newfound interest in polyptych structures (which had lain fallow

since *Cité*), an interest that no longer has anything to do with the contingency of aleatory permutations.

Expressing color

Certainly, just as with *Sanary,* the color distribution in *Colors for a Large Wall* is still based on chance—all the more so in that the paper cutouts used for the two small collages from which these paintings originated constituted all that was left in the bag, so to speak, once the *Spectrum* collage series was finished. But this work marks a major turning point in Kelly's career, since it ushers in a period (eight months in Sanary from November 1951 to June 1952, and, back in Paris, on through to the spring of 1953) devoted to the monochrome panel polyptych.[52] In order to introduce the break produced by *Colors for a Large Wall,* let's just say that, after this work, until his return to America, drawings as such almost cease to exist in Kelly's oeuvre. True, he made some preparatory collages (fig. 13), but they were conceived as mock-ups for polyptychs, assemblages of independent, juxtaposed surfaces. From this point on, the collages are governed by a double law abolishing all *internal* division: the support is completely covered and therefore no longer functions as a ground against which the fragments added to it would stand out (moreover, in the smallest collages, there is no support at all, the surfaces of gummed paper being simply bound together through partial overlapping); and Kelly uses just one color per fragment (with three exceptions [*Two Yellows, Fête à Torcy* (pl. 79), *Dominican* (pl. 78)], all the paintings are polyptychs that meet this same requirement).

With this abrupt abandonment of the *internal* division of the surface, Kelly places his work straight back in the tradition of the monochrome, begun by Malevich's *Black Square,* and provisionally ended by Rodchenko, in 1921, before being picked up again by Strzeminski a little later on. In order to eradicate all division, and thus all "relations," all composition, all projection of an image onto a surface, it is enough to eliminate the slightest risk of figure/ground opposition (which is only possible if the image is identical with the field, and this latter is "unified"). That said, with the exception of *Tableau Vert* (pl. 89), made in 1952 after a visit to Monet's studio at Giverny (and exhibited for the first time in . . . 1988!), Kelly didn't make any real monochromes during his years in Paris: it would seem that, from this moment on, he had the vague intuition that the figure/ground opposition is not so easily gotten rid of, and that the surface of the monochrome stands out against the wall in exactly the same way as any geometrical figure in an abstract composition.[53]

True or not, even if Kelly half-glimpsed that the figure/ground opposition remains the insuperable horizon of human perception, he was only able to play around with it much later (most notably in the curved or irregularly contoured monochrome panels that appeared in the 1970s like isolated, floating

figures on the white walls of galleries and museums). For the moment, he considered his monochrome panels as blocks of color, as particles to be put together. Each particle is undivided, each plane of color is a "real" *object,* an opaque solid, which does not refer to any transcendence or produce any illusion. The "made" aspect of the polyptych is essential. *Colors for a Large Wall* is not the representation of a colored grid determined in advance in the secrecy of the studio (even if, in this case, Kelly did actually start from a collage). It is a wall of assembled colors, not "in a certain order," as Maurice Denis would say, but according to a purely additive process. Not only is the "process" of juxtaposition directly legible, but the division of labor is suppressed as well, in that conception and execution are fused (and here again, Kelly is close to Rodchenko, particularly the modular sculpture from 1921). Before the little square monochrome canvases are assembled, there is nothing, neither ground (no surface on which the painter could draw shapes, project a world), nor figure: the artist puts down one stone after the other, like the medieval mason who built the walls of the Romanesque churches that fascinated Kelly so much at the time (he has often said they were the origin of his polyptychs). In addition, given the deductive nature of the modular grid, the process itself is closed off, referring to nothing but itself (here the architectural metaphor no longer applies: *Colors for a Large Wall* is not a fragment of an edifice itself governed by a compositional schema). The painting thus comprises sixty-four little square canvases (the same number as on a chessboard, as if to underscore the gamelike aspect of the way the colors are arranged[54]), and amassing them in a square constitutes the least arbitrary, the most compact way of grouping them, the one that involves the least decision-making.

Colors for a Large Wall is the last important work to make room for chance and, for that matter, for the principle of the modular grid (at least directly), a further indication that it constitutes a rupture in Kelly's oeuvre. All the monochrome panel polyptychs from 1952–1953 are situated in its wake, and, as always with Kelly, in a critical manner.

Let us start by examining *Red Yellow Blue White,* made up of twenty-five square panels grouped in five vertical columns, each consisting of five panels. In many respects, this extraordinary work is one of a kind in Kelly's oeuvre. Two specific characteristics distinguish it from all the others of the period: the material used, and the incorporation of the actual surface of the wall. On closer examination, these novelties can be read as the continuation of what Kelly undertook in *Colors for a Large Wall.* Indeed, the color of the material is "ready-made" (pieces of dyed cotton, store-bought, which Kelly then simply stretched onto twenty-five small wooden panels), as if to underscore the contraction of the division of labor, which remained implicit in the large square picture.[55] As for the wall's role, it stems at once from the desire to dispel all transcendence (what you see is not an

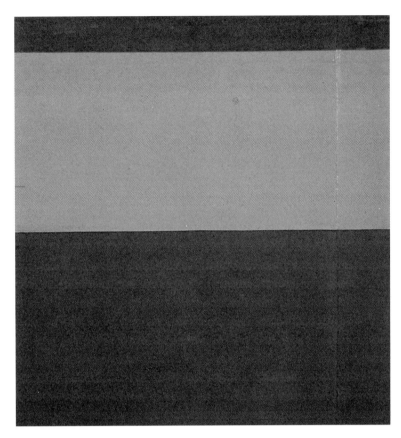

fig. 13. *Study for Three Color Panels,* 1953, collage, 6½ x 6⅛ in

image, a chimera, but an assemblage of monochrome panels in the perfectly real space of the room) and the determination to explode the modular grid as a form, as systematic *Gestalt* (had they been contiguous, as in *Colors for a Large Wall,* the five groups of five panels in *Red Yellow Blue White* [pl. 77] would have formed a square). The use of the wall does not have the function it later had (it doesn't serve as ground for a figure), but it is just as erroneous to compare this work to *Awnings, Avenue Matignon* (as has been done here and there). The interstice no longer represents the void between the figures: it is at once an affirmation of the *hic et nunc* and, through its dissemination and decenteredness, an openness of the work to the space of the world.[56]

In fact, the decenteredness in question is actually the result of a "centeredness": having pulverized the modular grid, and abandoning chance, Kelly thus broaches another mode of the index, that is, bilateral symmetry (every symmetrical field is an index of itself, and thereby escapes the arbitrariness of composition, as Newman had discovered in 1948).[57] Symmetry works in two ways in *Red Yellow Blue White.* First, on each side of the "central" column, the lateral columns are articulated through a pairing of identical groups of colors (a,b,c,b,a); second, the five columns themselves, *as shapes,* form a symmetrical configuration around a central axis (the middle column) and thereby determine a single field, this making it impossible not to "gather up" the interstitial surface as an integral part of the work itself.

In fact, *Red Yellow Blue White* tests the limits of the power of symmetry to designate a field. If the intervals between the "columns" had been larger, it would have been impossible to take the piece in all at once, and the surreptitious unification effected by the symmetry, already put seriously to the test by the optical dance of the color squares, would have been missed.[58]

That obviously left the question of color arrangement within the three types of columns (a, b, and c). It seems that Kelly felt some remorse at the arbitrariness here; at least this is how I interpret the slight step backward constituted by *Two Yellows* (pl. 76) and the collages related to it (all of them infringing, as does the painting itself, on the law regarding the unity of the monochrome). To the extent that it reopens the question of the partial configurations that had preoccupied Kelly in the *Spectrum* collages (and which can be likened to the groupings figuring in Mondrian's two *Compositions en damier,* dating from 1919,[59] even though Kelly was not aware of them at the time), this painting puts its finger right on the compositional snag that still disturbs the layout of *Red Yellow Blue White.*

It was a snag that Kelly eliminated in the three later polyptychs, *Kite I* (pl. 83), *Kite II* (pl. 82), and *Painting for a White Wall* (pl. 81), where all preoccupation with the grid and with exploding it is gradually effaced (in the same stroke, Kelly abandons any further investigation of the inclusion of the wall, the strategy used in *Red Yellow Blue White*). On the one hand, from the first to the third picture, vertical stacking is progressively abandoned (from now on, the units are juxtaposed horizontally without forming any sub-groups, each one having an equal part); on the other hand, symmetry is less and less emphasized here, as if the artist had discovered that it was completely unnecessary to stress this point (whatever the number of panels in a polyptych, even or uneven, and whatever the order of the colors, the general configuration of the polyptych will always be symmetrical provided the units are juxtaposed in the same linear fashion).[60] The tendency toward seriality is very noticeable from the first to the third of these pictures, yet it was only fully examined a little later on, after Kelly had discovered in *Painting for a White Wall* that the polyptych as he then conceived it becomes a color chart, like those provided by color merchants. This is what constitutes the mainspring of the formidable audacity of coloration in this work (I'm thinking not so much of the pink/dark blue association, no doubt more common because of its sexual connotations, but of the orange/pink juxtaposition: to my knowledge, this is unique at the time and was only tried by Reinhardt a little later on, and by Warhol in the 1960s).

To introduce this discovery, in which yet another aspect of Kelly's interest in the logic of the index is affirmed, I quote this anecdote, recounted by the artist in 1969:

"In 1952 I had a studio with a balcony overlooking a busy street. When I finished the first painting I had done in five horizontally grouped panels, I hung it on the balcony and went out to hear comments. A few people who noticed the painting were puzzled and said so. A child, pointing with his finger said: 'black—rose—orange—white—blue—blue—white—orange—rose—black'."[61]

We are still more than ever in the neighborhood of Duchamp. Consider *Tu m'* (1918), for example, this "panorama of the index," as Rosalind Krauss calls it.[62] In order better to indicate the picture's color chart function—among the false shadows cast by his own *ready-mades*—Duchamp includes a realistic representation of a hand pointing. What is at stake is a kind of "pictorial nominalism," as Duchamp himself puts it when describing his entire enterprise.[63] Kelly deploys a similar, but more radical nominalism (after all, the color chart in *Tu m'* is still a representation, still an image, or, in semiological terms, an icon, albeit the icon of an index). The monochrome panel as a color sample is an index of color as such, designating its own color without any transformations. There may be an Edenic dream at work here, a utopian desire for a wholly motivated language in which the linguistic map would perfectly cover the terrain of things (and isn't there a discernible allusion to language, to Western alphabetic writing, in the linear horizontality of Kelly's polyptychs, as if colors constituted the words of a language without syntax?). In any case, the temporary abandonment of "chromatic" colors (those furnished by the specter of the gummed paper) comes from this kind of vertigo, as does the adoption of what could be called "nominal," that is, primary colors.

It was also on the basis of the metaphor of the monochrome panel as an element of a color chart that Kelly resumed his examination of non-compositional (non-hierarchical) distribution of its units. In a large collage from the autumn of 1952, he states almost all of the statistical possibilities provided by the combination of seven, six, five, four, three, and two colored units drawn from the same stock (white, black, red, yellow, and blue rectangles). It is almost a conceptual piece, "logical, but not rational," as Sol LeWitt would say: a closed system, with no room for reflection, no choices to be made in order to "decline" it in its totality (*rosa, rosa, rosam, rosae, rosae, rosa . . .*).[64] Here again, however, as tempting as it may be, it would be wrong to see Kelly as a precursor, and it is hardly surprising that, in spite of all the possibilities afforded by the rules of the game, the painter should have contented himself with producing a single, seven-panel polyptych, *Red Yellow Blue White and Black with White Border* (pl. 86), done several months later (perfected shortly thereafter in another version, minus the "white border," *Red Yellow Blue White and Black* [pl. 87], and complemented by a smaller, six-panel polyptych—the one he left with Dorothy Miller).

As extraordinary as it may seem today, statistical analysis must have felt at once fastidious and terrifying to Kelly, too perfect a yoke, but also an impasse: how to go beyond it without falling back into one or another of the compositional traps he

had so patiently eluded? In my view, for a while, this is precisely what happened when he tried to combine the logic of the panel with that of the referential tracing. But Kelly had gone too far in the direction of an autonomization of the pictorial object and, to put it bluntly, had lost his grip, no longer knowing how to carry out a simple transfer, or at least was no longer satisfied with it. These are, if you like, impressionist "regressions." Certain of these works effectively cancel out the regressive aspect of the appeal to the referent through a strict recourse to symmetry and to the principle of the monochrome unity of the panel: *Train Landscape* (pl. 80) was the only painting he did at the time, but it was accompanied by a large number of collages. Others, more problematic, abandon symmetry but retain the idea of the monochrome unity of the panel (*Gaza,* painted in 1956, was based on a collage from this period, to which can be added the small collage now called *Paper Truck, Zurich,* dating from 1953). Finally, other collages—the least rigorous ones—refer to *Fête à Torcy* (pl. 79) and to *Dominican* (pl. 78), two diptychs from 1952 that do not respect monochrome unity, but whereas these latter two works counterbalanced their impressionist origin with a combined and antinomic use of symmetry and seriality, the collages in question are, strictly speaking, "zoom-ins." Variously colored horizontal bands traverse long vertical rectangles, without any motivation for the placement of these bands (these collages are vaguely reminiscent, *mutatis mutandis,* of some of Newman's paintings with a horizontal "zip," and they suffer from the same obligatory association with the landscape). As with the tracings from 1950, Kelly avoided then any hint at the referential origin of these collages (their titles have since been changed, becoming, for example, *Detail of Italian Sneakers* or *Boats in Sanary Harbor*). But precisely because they are no longer tracings but close-ups, where the "image" is larger than the field, we are brought back to the problematic of *ostranenie* that, for two years, the painter had been able to avoid.

The silhouette

Today Kelly willingly admits that his last year in France was not terribly happy. To begin with, his output diminished for various reasons (eviction from his studio, illness), and he no doubt felt he was going in circles. He found a final way of limiting compositional arbitrariness: he worked in pairs, in black and white, one picture being the negative of the other (as Morellet, whom he was seeing a great deal of at the time, would say, it limits the number of decisions you need to make).[65] This resulted in two splendid triptychs, *White, Two Blacks* (pl. 93) and *Black, Two Whites* (1953; pl. 92), but his heart was no longer in it. The last pair of works he did in Paris, *White Square* (pl. 91) and *Black Square* (pl. 90), returning to the discovery he had made with *Window, Museum of Modern Art* four years earlier, provided an excellent conclusion to his long stay. Or rather, there is some-

thing of the absurd in this pair, which allowed Kelly to abandon his Parisian problematic without regrets, and to move on to something altogether different. Once again, it is an already-made, an exact tracing (the artist measured with great precision one of the square panels of frosted glass that protect the terrace of Parisian cafés in the winter, and had two copies made by a carpenter). But what need is there to measure a square: isn't the square immediately recognizable as a *Gestalt,* just like the circle or the equilateral triangle? Doesn't it automatically constitute itself as an emblem, without scale, without any other determination than its own form, in the autonomy of its proportions? And if this is true of a square, what does it mean for all other forms? This is perhaps what led Kelly straight to the development of what Lawrence Alloway very appropriately called his "heraldic" system, which made him perhaps the only post-war American artist who could blithely dismiss questions of scale, except in the restricted sense in which his pictures are generally conceived as being "as large as or bigger than the viewer."[66] In the case of every other painter or sculptor (except perhaps for the Stella of

fig. 14. *Boats, Quai d'Anjou,* 1949, pencil on paper, 16¼ x 12⅛ in

fig. 15. *Reflections of Trees in the Seine*, 1949, ink on paper, 2⅞ x 4⅞ in

the 1960s, with his *shaped canvases*), this indifference to scale would seem to flow from a virtually immoral abdication as far as the material requirements of the work were concerned, a corruption seemingly worthy of airport art (think of the abominable enlarged mockups by Moore, Calder, or Noguchi, stigmatized by Richard Serra for the fact that they presuppose the *a priori* constitution of an image, prior to its material existence[67]). Now, after abandoning the tracing in 1951, Kelly shamelessly worked in a totally projective fashion—he started from small collages, proportional studies for works executed later in various sizes and media (it should be said in passing that these procedures confirm what Kelly has stated over and over again, namely that he was never influenced by Matisse—for whom the quality of a color is determined by its quantity—nor ever even understood the latter's use of color, something no one has ever been willing to believe).[68]

This is not the place to explain why Kelly could take such liberties with what could be termed the "nonprojective" ethic of post-war American painting and of the best European work, an ethic that governed, moreover, his own fight against composition. I would rather suggest that the heraldic aspect of Kelly's art on his return to America has its roots in a whole side of his French output that I have so far ignored, unlike my predecessors, notably Coplans and Goossen. (But if I have ignored it, it is partly because the artist did so himself at the time, not pursuing this vein, as if it were only after a very long detour, the one analyzed in these pages, that he was able to evaluate this possibility fully).[69]

Let us examine, for example, two drawings from 1949, *Boats, Quai d'Anjou* and *Reflections of Trees in the Seine* (figs. 14, 15). They both deal with the index, since they concern reflections on water (and in the second of them, we are dealing with an index deprived of its referent, as in the later *La Combe* series), but it is clear that what most interested Kelly is the *form* of these reflections. In the first case, the boats and their mooring lines, when duplicated by their reflections, form spindlelike

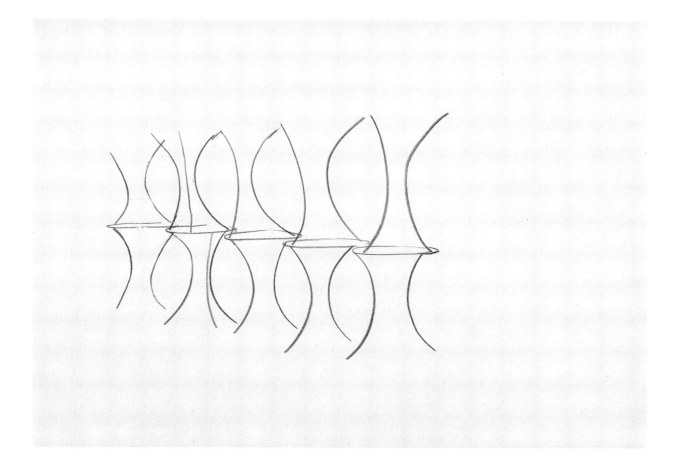

fig. 16. *Stacked Tables*,
1949, pencil on paper,
13⅛ x 18¼ in

shapes, unusual geometrical entities; in the second one, the tree reflections form frayed dolmens or stretched bowlike shapes. True, we are here firmly in the logic of *ostranenie* (as is also the case with the famous little sketch of a West coast Indian ceremonial plaque done around the same time). Kelly is deautomatizing perception, but here the process concerns less the cause–effect relation between a stimulus (referent) and its registration than the autonomy and formal specificity of the figure that emerges.

This interest in the silhouette was apparent starting with the first human figures he painted in Paris, whether inspired by Byzantine art, Romanesque art, or by Picasso, and culminated in 1949, as John Coplans has ably pointed out, with *Plant I* (pl. 17) (to which can be added the small, Matisse-like gouache entitled *Seaweed,* or the paper cutout *Head with Beard,* both from the same year).[70] Kelly did not immediately abandon this vein (*Wood Cutout with String I, II, III* (pls. 33, 34, 32) from late 1949, *Célestins,* and especially *Relief with Blue,* both from 1950, issue directly from it). But two works go straight to the heart of the problem raised by this fascination with the isolated form. One is a small drawing of a stack of tables in a bistro, done in 1949 (fig. 16), the other is *Cutout in Wood* (pl. 46), from 1950. In both cases, we find an inversion of the oppositional relations full/void, figure/ground. It is something like a gestaltist demonstration: whatever acrobatics are imposed on this opposition, a positive/negative, hierarchical binarism is unavoidable. For it to exist, a form has to stand out from a background: given this, how does one avoid the compositional *a priori*, assertion and invention?

The answer came much later, after the return to New York (and it wasn't by chance that Kelly should have been back in America when he did *White Plaque: Bridge Arch and Reflection,* four years after the collage that served as its model (fig. 17): the work is still Parisian, but already showing signs of New York). This response was only possible after the transfer, with its collapse of figure and ground (*Window, Museum of Modern Art, Paris*) had given way to the total abstraction of the nominalist monochrome panel: the form as emblem, as *blason,* the form as word, so to speak. Since it is not possible to be simultaneously interested in form as form and abandon binarism and compositional hierarchy, you may as well assert it as stridently as possible. For ten years, Kelly completely abandoned, at least in his painting, the various strategies designed to undo the figure/ground opposition (and thus composition), those strategies he had explored during his time in Paris (and summed up in *Colors for a Large Wall*). He has repeatedly insisted on the fact that every reading that talks about the undecidability of this opposition in the paintings from this period is based on critical blindness.[71] As for his sculpture at the time, it only serves to confirm the heraldic function of morphology, starting with *Gate* in 1959 and continuing with *White Ring* in 1963: as isolated stela, these frontal (and thus "pictorial") works simply stand out and, with a totalizing gesture, constitute

fig. 17. Study for *White Plaque: Bridge Arch and Reflection,* 1951, collage, 20¼ x 14¼ in

the space of the world as their very ground, neutralizing and semanticizing it at the same time.

The artist, however, was not completely done with his Parisian experience. In 1965, Kelly spent six months in Europe, during which time he did no painting, but went back over his French years with a critical eye. On his return, he resurrected the problematic of the monochrome panel polyptychs. But this time, he was no longer dreaming of an art totally stripped of illusion. On the contrary, this fundamental given of perception (that the figure stands out as such, and behind it the ground is optically hollowed out) gives rise to all kinds of manipulations bringing out this optical wavering in space. And when the emblematic forms came back in force during the 1970s, it was just as much in order to sound the nominalist alarm as it was to undermine it, affirming, against the Edenic myth, that neither forms nor colors can exist without risk, as if autonomously, in the self-confidence of their pure presence.

I am indebted to Benjamin Buchloh, Rosalind Krauss, and Mary Yakush for reading this text, ably translated from the French by Gregory Sims, and for making numerous editorial suggestions.

1. On Matisse's gift, see Dominique Fourcade, "Rêver à trois aubergines," in *Critique* 324, May 1974, 467ff.

2. Apart from the two works mentioned above, the Museum of Modern Art had received *Spectrum III* (1967, the year it was painted) from Sidney Janis. In the 1980s, the Museum received four important gifts: in 1980, *Brooklyn Bridge* (1962); in 1983, *Two Panels Yellow Orange* (1968); in 1984, *Curve II* (1973), and, in 1982, *Diagonal with Curve IX* (1979).

3. During his stay in Paris, Kelly only sold two paintings, *Antibes,* from 1950 (to Henri Seyrig) and *Red Yellow and Blue,* from 1951, (to a Venezuelan collector). Since then, only one other work has been sold, *Kite II,* of 1952 (quite recently, to the Musée National d'Art Moderne, Paris. The museum is to be congratulated—it is never too late to make amends). Apart from *Colors for a Large Wall* and the handful of works that Kelly gave to his friends over the years, *everything* is still in his studio: nothing could be easier, in a sense, than to mount this exhibition (and nothing could be more surprising than the fact that it has not been done).

4. Apart from *Colors for a Large Wall*, at the Maeght Gallery (the second "Tendance" exhibition), Kelly exhibited *Méditerranée, Sanary,* and *Fête à Torcy* (all three from 1952); at the Betty Parsons Gallery, he showed *Cité* (1951), *Two Yellows* (1952), *Red Yellow Blue White and Black,* in six panels, *Tiger* and *Train Landscap*e (all three from 1953) and finally *White Plaque: Bridge Arch and Reflection*, from 1951–1955 (the latter two paintings bore less suggestive titles), not to mention numerous American works.

5. *Art International,* "New York Letter" 7, no. 10, 16 Jan. 1964, 54. The works in question, dating from 1963, are not exactly polyptychs in the sense that most often there is a superimposition (or superimposition effect) of one surface unit on a larger one, and the figure/ground opposition is maintained (a silhouette still stands out against a background). There is an inscription of one surface unit (non-rectangular) inside another: the purpose is very different from that of the polyptychs from 1951–1953, and after 1965. If one had to compare the works presented at this exhibition with Kelly's Parisian output, the more likely candidate would be *Relief with Blue* from 1950.

An article by Michael Fried deserves to be rescued from oblivion here ("Anthony Caro and Kenneth Noland: Some Notes on Not Composing," in *Lugano Review* 1, no. 3, summer 1965, 198–206). Offering a shortened version of the demonstration concerning "deductive structure" that he had applied in particular to Frank Stella's stripe paintings in *Three American Painters* (Cambridge, 1965), this brief essay marks the only moment where Fried's position was not so far removed from that of the minimalists he was to lambaste two years later. But even here, in a note objecting to another critic's (Max Kozloff) assimilation of one of Noland's chevron paintings to a dadaist object, are indications of Fried's subsequent divergence. A year later, in "Shape as Form," the "literalness" of the "deductive structure," its non-compositional nature, was devalued in relation to the new illusionism at work in Stella's then recent canvases, and the notion of non-composition disappeared from Fried's critical vocabulary (*Artforum* 5, no. 3, November 1966). This is not the place to examine in detail the history of this disappearance; I simply want to indicate that Kelly's position during his years in France, as eccentric as it may have been in relation to developments in New York, nevertheless unwittingly concerned one of the essential critical knots since Pollock. Finally, let me note that when he saw Stella's black pictures and Johns' targets, numbers, and flags at the *Sixteen Americans* exhibition in 1959 (where he showed his then-recent curved silhouettes), Kelly recognized in these pieces a certain affinity with his Parisian canvases, and was surprised that painters he didn't know had arrived at solutions close to his own by taking entirely different routes. That said, as we shall see, it would be a mistake to pursue the analogy any further, and Kelly himself carefully refrained from doing so ("I like what they're doing most, but I don't know if I feel close to it in my own work," as he put it when speaking to Henry Geldzahler [in *Paintings, Sculpture and Drawings by Ellsworth Kelly,* exh. cat. Washington, 1963]). Indeed, it was precisely because the routes taken to non-composition were different, in spite of appearances, that Kelly's Parisian works differ radically from those of Stella and Johns in the 1950s.

6. John Coplans, *Ellsworth Kelly,* New York, 1971, 14.

7. *Gaza,* a monochrome panel polyptych, was in fact painted in New York in 1956, based on a collage done in Paris. Donald Judd's *mea culpa* appeared, not without some reluctance, in a note added to his essay on Barnett Newman, written in 1964 but not published until 1970. After having slighted in passing the "Arpish" (his term) canvases of the late 1950s for participating in the "old abstraction," Judd notes that if he hasn't changed his mind on this point, the judgment does not apply to "Kelly's later rectangular paintings." He adds: "At the time I had seen one early sectional painting in a Green Gallery Show but didn't know there were more like it and took it for a fluke." Reprinted in Donald Judd, *The Complete Writings 1959–1975,* Halifax and New York, 1975, 202.

8. Barbara Rose mentions *White Square* and *Black Square* (1953), which she compares to Malevich's *Black Squar*e (essay reprinted in Barbara Rose, *Autocritique: Essays on Art and Anti-Art 1963–1987,* New York, 1988, 61). Lawrence Alloway mentions the monochrome panel polyptychs from 1952 in a generic fashion (essay reprinted in Lawrence Alloway, *Topics in American since 1945* [New York, 1975], 79).

9. Gregory Battcock admits to being agreeably surprised by the date of *Window, Museum of Modern Art* ("The Art of the Real," *Arts Magazine* 42, no. 8, June 1968, 47) and James R. Mellow makes passing allusion to *Colors for a Large Wall* ("New York Letter," *Art Internationa*l 12, no. 8, October 1968, 61), but, like Dore Ashton, he is more interested in the fact, first revealed by Goossen, that certain of the Parisian works are based on an architectural referent, than he is in their historical strangeness (see Ashton, "New York Commentary," *Studio International* 175, no. 903, September 1968, 92). The rest of the criticism does not even mention Kelly.

10. A word on abstract expressionism. It may seem strange that Kelly should have completely sidestepped it, but one need only consider for a moment what he had access to at the time (for example, the special number of *Art d'aujourd'hui* in June 1951, devoted to American painting, where Julien Alvard reproduced *La Combe I* in an article entitled "Quelques jeunes américains de Paris") in order to realize that, with illustrations that gave no sense of scale, where the mediocre rubbed shoulders with the best, not to mention the inept commentaries of Parisian critics, it would have been impossible for anyone to have the slightest idea of what was really happening in New York. It was independently of the "New York School" that Kelly arrived at a new scale in 1951–1952, just as, a year earlier, he had arrived at the all-over with *Cité*: if not totally isolated (since he was surrounded with a group of friends), he was away from the city and missed both the exhibition "Regards sur la peinture américaine" in February–March of 1952 at the Galerie de France, and the Pollock exhibition in March at the Studio Facchetti, in other words the two rare occasions on which he could have seen abstract expressionist pictures.

11. See my essay, "The Limit of Almost," in *Ad Reinhardt* (New York, 1991).

12. Quoted by Georges Canguilhem, *Etudes d'histoire et de philosophie des sciences* (Paris, 1970), 22.

13. Donald Judd, for example, wrote: "Until lately we had a guy who found a snow shovel and who talked for decades, producing talking artists

. . . For my part, I've lived in the shade of a coat-hanger and a bedspread" (a direct allusion to Johns and Rauschenberg). "On Russian art and its relation to my work" (1981), reprinted in Donald Judd, *Complete Writings 1975–1986* (Eindhoven, 1987), 17. Oppose to this the more ambivalent attitude of Robert Morris, whose minimalist period was directly preceded, in 1962–63, by a focus on the Duchampian object.

14. Even if he only read it in a bookstore (too broke to buy the magazine), Kelly would have been perhaps much more impressed by Tom Hess' article, the first serious text on Reinhardt, than by the disappointingly uninformative photograph illustrating it. From the outset, Hess insists, for example, on the fact that, though Reinhardt's canvases at the time resemble those of Mondrian, the resemblance is wholly superficial. Tom Hess, "Reinhardt: the Position and Perils of Purity," *ArtNews,* December 1953, 26–27 and 59.

15. G.B. (Georges Boudaille?), review of Kelly's exhibition at Arnaud's, 4 May 1951. This critique also mentions the Bauhaus. In *Les Nouvelles Littéraires,* a column signed "Le flâneur des deux rives" notes that "admirers of Mondrian and Vantongerloo will find Kelly's paintings and reliefs quite seductive" (3 May 1951, 5). As for the chronicler from *Combat,* he doesn't mention any names, but his characterization of Kelly as a "pure plastician" is in the same mould (8 May 1951).

16. "Mondrian's patient instruction is bearing fruit," writes Michel Seuphor concerning Kelly in the issue of *Derrière le miroir* that served as the catalogue for the "Tendance" exhibition in 1952. In a letter to Kelly dated 21 October 1953, Seuphor writes: "I think that amongst Mondrian's serious successors, you're going to be the best" (Kelly archives). We find the same kind of thing, although now somewhat watered-down (since, in the interim, the number of pretenders to the throne had increased, according to Seuphor) in "Sens et permanence de la peinture construite," *Quadrum* 8 (1960), 37–58.

17. "Notes from 1969," in *Ellsworth Kelly* (London, 1980). This text was written following interviews with the artist by John Coplans who was at the time preparing the first monograph devoted to Kelly. Prompted by the occasion, the artist reviewed for the first time a large number of his works which had been stored in a warehouse since his return to the United States. Revisiting them led to some surprises, to an entirely justified increase in self-esteem (the gift to the Museum of Modern Art was perhaps one of the consequences), but, in view of the diversity of the material, it also led to the elaboration of certain myths of unity and prefiguring: the idea that the scattered fragments of *November Painting* (1950) "prefigure" the curved and ostensibly partial silhouettes of the years 1955–1964, which Kelly proposed to Coplans (and which was subsequently repeated on numerous occasions), seems as suspect to me as likening a bit of sky by Cézanne to an Yves Klein monochrome (even if Kelly himself would pursue just this kind of assimilation in his "close-ups" from 1952–1953).

18. Coplans 1971; E. C. Goossen, *Ellsworth Kelly* (New York, 1973); Patterson Sims and Emily Rauh Pulitzer, *Ellsworth Kelly: Sculpture* (exh. cat. New York, 1983). The two monographs devoted to Kelly's drawings and collages, as useful as they are for the numerous documents to be found in them, unrepentently sing the impressionist song (Diane Waldman, *Ellsworth Kelly: Drawings, Collages, Prints* [Greenwich, 1971], and Diane Upright, *Ellsworth Kelly: Works on Paper* [New York, 1987]).

19. The critic for *ArtNews,* Parker Tyler, uses the term "metaphysical" twice in the space of a few lines, and refers not just to Mondrian, but to De Stijl and to the Bauhaus (summer 1956, 51); the *New York Herald Tribune* talks about a "Venetian blind pattern" and about Mondrian (2 June 1956); only Barbara Butler, in *Arts Magazine,* is more perspicacious, and refers to Malevich as well as Arp, which in a way (but only in a way) is not quite as far from the mark (June 1956, 52). A year later, the *New York Times* again

refers to Mondrian when commenting on Kelly's second exhibition at Betty Parsons' (29 September 1957), in spite of the fact that, this time, Kelly carefully avoided including any of the Parisian pieces.

20. In a note to his preface for the catalogue for the Kelly exhibition at the Tooth Gallery in London (May–June 1962), Lawrence Alloway notes this incongruity (without for a moment imagining that it could come from the artist himself): "It was, I think, misleading to put Kelly in the exhibition of *Geometric Abstraction in America,* as happened at the Whitney Museum, without distinguishing his painterly coloristic concerns from regular geometric art. Possibly the habit of expecting colour in painting to be linked with a somewhat free painterly style is to blame. Kelly's colours, though usually related in pairs, and always rigorously firm and consistent in surface, have a visual warmth and largeness very different from the earlier line of geometric and constructivist art (as represented in the United States, for example, by Fritz Glarner and Burgoyne Diller)." This note is an addition to the slightly shorter version of this otherwise excellent text, published a month earlier in *Art International* (6, no. 3, April 1962, 52–53) with the title "Heraldry and Sculpture."

21. Sims/Pulitzer 1983, 46.

22. Goossen 1973, 29.

23. Tériade, "Documentation sur la peinture—III Conséquences du Cubisme," *Cahiers d'art* 5, no. 1, January 1930, 22. Mondrian in fact addresses his response to the much more widely read *Intransigeant,* in which Tériade published (11 March 1930) a condensed version of his article (even more virulently opposed to neo-plasticism). This response, dated 25 March 1930, was not published until a year later, in *Cahiers d'art,* but only after the passages accusing Tériade had been deleted ("Le Cubisme et la Néo-Plastique" 6, no. 1, January 1931, 41–43; Engl. tr. Harry Holtzman and Martin S. James in Piet Mondrian, *The New Art—The New Life* [Boston, 1986], 236–241). The allusion to the bathroom is found in René Jean, "Les expositions," *Comoedia,* 21 May 1921, which reviews the first public appearance in Paris of Mondrian's neo-plastic canvases.

24. In fact, the above-mentioned authors discuss in passing the first two points, but unsystematically and without broaching the third point; the result being that the non-compositional logic of Kelly's work went unnoticed.

25. Quoted by Coplans 1971, 28–30. When Kelly wrote his "Notes from 1969," based on his interviews with Coplans, he rightly omits mention of the scarf.

26. See Werner Spies, "Reduktion als Widerstand," *Frankfurter Allgemeine Zeitung,* 5 February 1983. *Fresh Widow* only became part of the MOMA's collection in 1953 (a gift of Katherine Dreier). The fact that Kelly had no knowledge of this work is mentioned by Sims and Pulitzer 1983, 43. In fact, if he had heard about *Nude Descending a Staircase,* he knew practically nothing about Duchamp's ready-mades at the time (and if he had known of them, he would very probably have taken them for a sophomoric prank). According to Kelly, the first time he was directly exposed to Duchamp's work was during a visit he paid to Henri-Pierre Roché in 1951.

27. See his interview with Paul Taylor in *Interview,* June 1991, 102.

28. Kelly says that the title *Ubu* came to him because he thought the French word "hibou" [owl] was spelt that way. That said, he had heard of King Ubu's "crochet à merde."

29. The artist notably remembers his fascination with the collection of Japanese stencils amassed by Cage during numerous forays to the second-hand booksellers lining the banks of the Seine. Kelly (taken at his word by the musician who, having been through them all, bets there won't be any

left) nevertheless managed to track down the stencil that served as the basis of *White Relief* (1950), dedicated to Cage. The latter's enthusiasm for popular art greatly impressed Kelly at the time.

30. He states to Nathalie Brunet that the work was premature ("I had to wait until I developed the same idea with a different panel for each color before the idea became valid to me"), see the Chronology in this volume; he tells Jack Cowart that he destroyed the object when he realized he couldn't "improve" on the original (see Cowart's text in this volume); he tells me that "the result looked too much like someone else's painting." The multiplication of divergent explanations in my opinion confirms the existence of an essential knot, a blockage, which Kelly still feels the painful effects of today.

31. Letter of 4 September 1950, quoted in part here in the Chronology in this volume. Here Kelly speaks out against easel painting and the artistic institution ("I am not interested in painting as it has been accepted for so long—to hang on walls of houses as pictures. To hell with pictures . . . To hell with exhibitions, galleries, to hell with money!"). The idea of a mural art (which produced *Colors for a Large Wall* a bit later on) seemed to him at the time like the right solution, but he didn't have the wherewithal to go about it.

32. A translation assumes transcoding, the passage of a "neutral" code or the supposed absence of a code (here three-dimensional reality) into another code (here the two-dimensional pictorial surface); the transfer implies, at least theoretically, that there is no transcoding. Either through excess (hyper-realism) or through lack (the literal translation of a literary text), the translation tends toward the transfer.

33. According to the artist, all these works were based on "automatic" drawings (in the surrealist sense of traces made "without thinking," explored a few months later at Belle-Ile): there is good reason to believe that the very "Picassoesque" result led Kelly, after the fact, to be wary of this mode of graphic production, which is automatic in name only. Still on the Picasso model, it should also be noted that most of these black and white pictures are done in enamel (and are therefore shiny), like Picasso's works at the Palais Grimaldi, whose shine had impressed Kelly at the time. He was surprised to find them so matte when he saw them again a few years ago. The explanation is perhaps technical (the paint had dulled with age), but I would be inclined to see it as the memory overcompensating for historical reality: at the time, in the Ecole de Paris context in which they were situated, the "industrial" sheen of these Picasso works could well have seemed brighter than it seems today. A similar type of memory overcompensation concerned his own relief *Méditerranée* when Kelly saw it again in 1969: he remembered the relief elements in it as protruding much more.

34. On the *Vénus du Gaz* episode and its direct links with the Duchampian ready-made, see Françoise Gilot and Carlton Lake, *Life with Picasso* (New York, Toronto, and London, 1964), 322.

35. As a reminder, Charles Sanders Peirce, who invented this terminology, distinguished between three orders of sign on the basis of their mode of relation to their referent: symbols, which are arbitrary (verbal language, for example), icons, which are mimetic (for example, figurative painting), and indices, which, mimetic or not, have a relation of "dynamic (including spatial) connection" with their referent (a footprint in the sand, a photograph, smoke or shadows). See *Collected Papers of Charles Sanders Peirce, Vol. II: Elements of Logic,* ed. Charles Hartshorne and Paul Weiss (Cambridge, 1932, 2d printing 1960), heading 2.305 (book 2, chap. 3, section 5), 170.

36. In the same genre, Kelly did an extraordinary series of sketches of beach shacks during the summer of 1950. The holes and tears in the vertically striped cloth of these shacks had been repaired with bits of cloth bearing the same striped motif (but brand new, and sometimes in a different color). These aleatory and irregular patchings (often running horizontally instead of vertically) gave rise to "compositions" that Kelly set about "diagramming" with great meticulousness, noting the slightest accident. The series of drawings, unique in the set of works based on the transfer, only resulted in one collage, in which Kelly notes down only the disruptions in the stripe motif (without including the stripes themselves). If no painting came out of this collage, it was for the same reason (mentioned below) that led him to decide against making paintings out of certain collages based on chance.

37. The creator of the concept of *ostranenie* was Victor Shklovsky, in "Art as Technique," which appeared in 1917 (translated by Lee T. Lemon and Marion J. Reis in *Russian Formalist Criticism: Four Essays* [Lincoln, Nebraska, 1965], 5–24). But it was Roman Jakobson who first applied the concept to Picasso's cubism (even if he later very resolutely took his distance from Shklovsky) in "Futurism," a text that came out in 1919 (Engl. trans. in Roman Jakobson, *Language in Literature* [Cambridge and London, 1987], 28–33). On Picasso and his use of *ostranenie,* see my essay "Semiology of Cubism," to appear in the second volume of the catalogue of the exhibition *Picasso and Braque: Pioneering Cubism* (New York, 1992).

38. See the text by Alfred Pacquement in this volume.

39. Taylor 1991, 102. Actually, I quote from the original transcript which was shortened for the publication. Kelly was sitting down when he fainted, and came to still seated but bent over, his head between his legs and almost under the chair.

40. See Leo Steinberg, "Rodin," (1963), reprinted in *Other Criteria: Confrontations with Twentieth-Century Art* (London, Oxford, and New York, 1972), 361.

41. Kelly took a very early interest in the "de-realizing" role played by shadows, heavily exploited by surrealism in the wake of Chirico (see, for example, the small drawing done at the Tuileries in 1949, and reproduced in Upright 1987, plate 13). But, as he envisages it in 1950, the shadow itself is "de-realized": you just need to eliminate the referent (a tree, for example), and only provide the figure formed on the ground by the index (the shadow), in order to make it impossible to establish the connection between the sign and what it refers to.

42. Referring to this picture, Johns states to Michael Crichton: "What's interesting to me is the fact that it isn't designed, but taken. It's not mine." Quoted by Fred Orton, "Present, The Scene of . . . Selves, the Occasion of . . . Ruses," in *Foirades/Fizzles: Echo and Allusion in the Art of Jasper Johns,* Wright Art Gallery (Los Angeles, 1987), 169. Ironically, the transfer that Johns wished so much never took place: he had glanced at the Harlem wall from a taxi; he tried later, without success, to find it again so as to trace it. He had thus to reinvent it, which distressed him: "What I had hoped to do was an exact copy of the wall. It was red, black and gray, but I'm sure that it didn't look like what I did. But I did my best . . . If I could have traced it I would have felt secure that I had it right" (*idem*). The procedure is very close to Kelly's. The artist's statement on the matter should thus be read as somewhat ironic: "I wanted an outdoor source rather than a personal handwriting like Johns and de Kooning, artists whose work I admire. I wanted to bring in the outside, to let nature be the decision maker" (quoted in Upright 1987, 14). Kelly has always insisted on the importance, for him, of impersonal technique.

43. The emblematic aspect of Johns' canvases from the 1950s has been remarkably well described by Leo Steinberg in "Jasper Johns: The First Seven Years of His Art" (1963), reprinted in *Other Criteria*, 1972, 17–54. Rauschenberg's indicial practice, from 1949 on, is described in detail (but examined critically only in using the "precursor" cliché) in Walter Hopps, *Robert Rauschenberg: The Early 1950s* (Houston, 1991).

44. See Rosalind Krauss, "Notes on the Index" (1977), reprinted in *Originality of the Avant-Garde and Other Modernist Myths* (Cambridge, 1985), 196–219.

45. This coathanger could be seen (as was the case later on with those of Johns) as an allusion to Duchamp's *Trébuchet* (a ready-made from 1917), but again, one would be taking a wrong turn.

46. It is interesting, in fact, to note the return to composition in *Moby Dick,* which concludes this series by going beyond it: the sketch is not a cutting-up and re-gluing, but a collage on a previously traced grid, and serving as a marker, a bit like the layouts used in the academic painting of the nineteenth century. This work follows *Talmont,* and it would seem that, from *Cité* to *Talmont,* Kelly realized that the fewer units you have, the greater the risk of composition, and that he again wanted, albeit momentarily, to check whether there mightn't actually be a reason to spare himself all the effort, and simply dive headfirst into composition.

47. In this respect Bill is less rigorous than Lohse and closer to Vantongerloo (of whom he would become the inheritor). Kelly paid a call on Max Bill in the summer of 1953, on the instigation of Gustav Zumsteg (the one who had commissioned the printed fabrics), in order to ask him for a job in the new school that he was then setting up in Ulm. No doubt Zumsteg knew *Sanary,* which *resembles* a systematic work, and therefore thought the two men had something in common (the painting had been done a year and a half earlier and exhibted at Maeght's in October 1952. In any case, Bill declined Kelly's services, and rightly so, one might say, since Kelly was miles away from his preoccupations.

48. The dummy of the book in question, *Line form and color,* is about forty pages long. It includes three series (lines, forms, colors), each time going from the simplest "elements" (a horizontal line, a vertical line) to the most complicated (in the case of lines and colors, to their combination). The book was never published, no doubt never even finished, since, in working on it, the artist had realized the inanity of the enterprise.

49. Kelly had met Morellet through the Brazilian artist Almir Mavignier, who got them both to contribute to a group exhibition he organized in Nantes in January–February of 1952. Morellet never hid the fact that he was very impressed by *Cité* and the Kelly paintings he had seen at the Maeght Gallery in October 1952, at a time when he himself was hardly using chance in his work (this started in 1958). Morellet started to develop his own concept of systematic art in 1952. A work like *No. 18,* from 1954, seems to be the "systematic" transcription of *Gironde,* one of Kelly's paintings he had seen at Maeght's. Each of these two works is a modular grid whose units consist of white squares traversed by yellow lines. In Morellet's canvas, the thickness and arrangement of the lines in each unit, like the disposition of the units themselves, were determined by a preestablished rule; in Kelly's painting, all this is left to chance.

50. For a description and a longer analysis of Kelly's modular grids, see Cowart's text in this volume.

51. Judd and Stella don't directly raise the question of color in their interview with Bruce Glaeser ("Questions to Stella and Judd," 1966, reprinted in Gregory Battcock, *Minimal Art* [New York, 1968], 148–164), but they do—Judd especially—in other interviews. If I refer to Glaeser's publication, it is because it provides the best definition of what Stella calls "relational" painting.

52. Let me incidentally note that, contrary to the claims made here and there (further evidence of the impressionist reading of Kelly's oeuvre), the panchromaticism of these works and the intense colors in those that followed don't have much to do with the fact that some of them were done in the south of France during the artist's last stay there (neither the color range of the gummed paper, nor the use of primary colors has anything to do with the light in Provence).

53. On this point, see my essay entitled "Descriptions, Situations and Echoes: On Richard Serra's Drawings," in *Richard Serra: Drawings Zeichnungen 1969–1990* (exh. cat. Maastricht and Berne, 1990), 17–30.

54. On the chessboard as a basic metaphor in contemporary art (particularly in Duchamp), see Hubert Damisch, "La défense Duchamp," *Duchamp: colloque de Cerisy,* Jean Clair, ed. (Paris, 1979), 65–99.

55. On the one hand, not having to paint the panels, Kelly eliminated a stage in the process and thus carried out a still greater fusion of "conception" and "execution"; on the other hand, the color is here *directly,* irrevocably industrial—without the color range of the gummed paper being transferred to oil. True, since the invention of the tube, all oil painting is industrial, as Duchamp pointed out, but this aspect has been naturalized, neutralized since impressionism: Duchamp's remarks on this subject, the implications of which are analyzed in detail by Thierry de Duve, are a true instance of *ostranenie,* a deautomatization of our perception. See Thierry de Duve, "The Readymade and the Tube of Paint," *Artforum,* May 1986.

56. In this sense, *Red Yellow Blue White* is more closely connected to Tatlin's *Corner Reliefs* than to the polyptych in three separate paintings done by van Doesburg in 1920 (*Composition XVIII*) and which remained a centralized composition, as Mondrian quickly realized. See the letter he wrote to van Doesburg on this subject, quoted by Carel Blotkamp, "Theo van Doesburg," in *De Stijl: The Formative Years* (Cambridge, 1982), 27.

57. On this point, I again take the liberty of referring to one of my own essays, "Perceiving Newman," reprinted in *Painting as Model* (Cambridge, 1990), 187–213.

58. On the visually uncontrollable, anti-gestaltist aspect of the distribution of the monochrome panels in this work, see Coplans' excellent analysis (1971, 52–53). That said, I don't agree with the way in which Coplans contrasts *Red Yellow Blue and White* with Mondrian's oeuvre (the contrast doesn't hold if one takes account of the late Mondrian). The reproduction of this work in the present catalogue is erroneous: while each square panel measures 12" x 12", the overall width of the piece is supposed to be 148", with 22" spaces between parts. In other words, the gap separating the "columns" is more than the width of each column (but less than double that width), and the total width of the piece far greater than as reproduced. For an exact reproduction as far as proportions are concerned (but not for the colors), see Coplans, 1971, plate 80.

59. The Mondrian paintings were unknown in Paris at the time (Michel Seuphor, for example, does not reproduce any of the nine modular canvases Mondrian did in 1918–1919 in his 1950 book, *L'Art abstrait: ses origines, ses premiers maîtres,* which was a first [Paris]). Although one or the other of the two so-called *"Checkerboard" Compositions en damier* was exhibited several times after the war (in Amsterdam and Basel in 1946, in New York in 1949 and 1953), they went completely unnoticed and each time returned to their owner, Solomon Slijper, without anybody writing anything about them. For his part, Kelly called on Slijper in late 1953 to see his enormous collection of Mondrians, but, irritated by the young painter's impatience with the early, pre-neo-plastic canvases, the old dragon sent him packing without showing him the master's abstract pictures. The partial configurations of Mondrian's checkerboard compositions are briefly analyzed by William Rubin in *Frank Stella* (New York, 1970, 24, a book that, regrettably, makes only a passing, somewhat tendentious allusion to Kelly's Parisian work—118).

60. I owe this remark to Coplans (1971, 49) and, without wanting to play down this critic's merits (his book remains remarkable), it is not impossible that he in turn owes it to the artist.

61. Ellsworth Kelly, untitled statement published in *Art Now: New York*, 1, no. 9, November 1969, unpaginated. In the same vein, Kelly stated to Diane Upright that "My art is always about counting parts" (1987, 26). The color of the left panel of *Painting for a White Wall* is in fact a very dark blue, but this nuance, hard to perceive even in normal viewing conditions, probably could not have been grasped from the street.

62. Krauss, "Notes on the Index," 1985, 198. Rauschenberg's two *Rebus* from 1955 could be added to the file (each one of which constitutes a small anthology of the index), where the artist stuck commercial color charts straight onto the canvas.

63. See Thierry de Duve, *Nominalisme pictural: Marcel Duchamp, la peinture et la modernité* (Paris, 1984), particularly the chapter entitled "La couleur et son nom," 175–210.

64. Sol LeWitt: "In a logical thing, each part is dependent on the last. It follows in a certain sequence as part of the logic. But, a rational thing is something you have to make a rational decision on each time . . . You have to think about it. In a logical sequence, you don't think about it. It is a way of not thinking. It is *irrational*." Quoted in Frances Colpitt, *Minimal Art: The Critical Perspective* (Ann Arbor, 1990), 58. On this aspect of LeWitt's art see Rosalind Krauss, "LeWitt in Progress" (1977), reprinted in *The Originality of the Avant-Garde*, 1985, 245–258. Kelly's "statistical" collage would have been closer to conceptual art if the artist had exhaustively stated all the possibilities. Asked why he stopped before such a completion, Kelly answered: "I ran out of paper." This is yet another version of the "anything goes" (to accept shortage of materials as an uncontrollable, external given), and as such is totally foreign to the conceptual problematic.

65. Morellet published little before 1971 but since then the majority of his writings deal either directly or indirectly with the question of anti-composition. He often shows that choice can never be entirely eliminated, that there is always "a compositional residue": all the artist can do is limit the number of decisions to be made. Just as Kelly's oeuvre was important for Morellet in 1951–1952, so, it seems to me, the French artist's simultaneously humorous and analytic spirit was a support for Kelly, bolstering his own anti-subjectivist position by pushing it to the limit. But, paradoxically, it was partly Morellet's rigor that brought Kelly to doubt the possibility of escaping from arbitrariness, invention, et cetera, and led to the change of course on arriving in New York. To give an example of the tone of Morellet's texts, I shall quote a recent article (1980) concerning *16 Squares*, a picture from 1953 that gives every indication of having successfully abolished all composition (it is like tiling: a white square is divided regularly into sixteen squares by three black horizontal lines and three black, vertical lines). Of course, we are dealing with a recapitulation, well after the fact, but there is every reason to think that the artist's half-rigorous, half-sceptical attitude was there from the beginning. I quote: "[This picture] came out of a certain number of choices: the choice of format, of the elements in it, of their distribution, the choice of colors, of material.

The Format: I chose the square because it's a figure that is defined by a single arbitrary decision (instead of two for a rectangle). The decision: a side of 80 cm is, of course, subjective, but heavily "diluted," since it was applied to nine-tenths of my output in the 1950s—which makes 2 decisions (a square + 80cm).

The elements in it: I chose lines, because, given a plane (the canvas), a line is only defined, theoretically, by its direction (for example, the angle it forms with the horizontal, here, the two extremes of 0 and 90 degrees) and practically also by its thickness (here 2mm). Another arbitrary decision—their number (here, 6). Thus, 5 decisions (line + 0 degrees + 90 degrees + 2mm + 6).

Distribution: I chose the most uniform, that is, the same space between each line (20cm)—which makes 1 decision.

Colors: I chose the two extremes of absorption and refraction of light, black and white—which makes 2 decisions.

Material: I chose a smooth material (since in geometry a surface can only be flat)—which makes 1 decision. Which gives in all $2 + 5 + 1 + 2 + 1 = 11$ decisions" ("Pourquoi ai-je été incapable d'écrire un article dans *Quad*," quoted in Serge Lemoine, *François Morellet* [Zurich, 1986], 92).

66. Ellsworth Kelly, untitled statement written for the Museum of Modern Art in New York on the occasion of the purchase *of Running White*. The text by Alloway is "Heraldry and Sculpture," 1962.

67. See Richard Serra, *Interviews, Etc. 1970–1980*, 136–137 (interview with Barnard Lamarche-Vadel), 167 (interview with Douglas Crimp); and "Interview" with Peter Eisenman, *Skyline*, April 1983, 14–15.

68. On the "quantity equals quality" equation in Matisse, see my essay "Matisse and Arche-drawing," in *Painting as Model,* 1992, 3–63.

69. In the letter to Cage mentioned above, Kelly writes: "To hell with pictures—they should *be* the wall—even better—on the outside wall—of large buildings. Or stood up outside as billboards or a kind of modern 'icon.'" The idea of the canvas as a notice board, as an advertising logo, is directly linked to the notion of the emblem, the blason, and in this sense one could detect a further tie between Kelly's art and that of the early Jasper Johns—the notable difference being once again that Johns' emblems are figurative and directly recognizable as such. Still on this same subject, in his 1959 statement for the Museum of Modern Art (already quoted), Kelly points out that "spectacle" is an essential element in his canvases.

70. On *Plant I,* see Coplans, 1971, 21–24.

71. From 1959, in his MOMA statement, Kelly notes that if the figure and ground are inseparable, "the form [is] usually in slight dominance over the ground." This dominance is progressively accentuated until 1965, after which, and very abruptly, it stops altogether.

Method and Motif: Ellsworth Kelly's "Chance" Grids and His Development of Color Panel Paintings, 1948–1951

Jack Cowart

The years 1948 to 1951 formed one of the most important experimental periods in the artistic life of Ellsworth Kelly. It was then that the artist discovered and perfected a visual and intellectual process for rendering deeply personal and idiosyncratic impressions of the figural world in an "anonymous," nonfigurative way. In Paris and then Sanary, a small Mediterranean fishing village near Toulon, Kelly found his empirical schemes to confront, and, ultimately, "improve" on, the history of abstraction. He would also discover and stake permanent claim to a new palette and system of colors for paintings constructed of individual panels, first arranged by "chance" selection and set into grid or checkerboard patterns. The inherent contradictions of these methods and motifs have invigorated and distinguished his art ever since. The historical record of Kelly's early use of grids, his first stages of contact with European abstraction, his breaking through its geometrical confinements, and his arrival at a high level of persuasive and evocative artistic expertise are the focus of this essay.

During a three-year period the artist was increasingly fascinated by the structure and compositional variations offered by the grid. Beginning in late 1948, the dominance of his drawings, sketchbooks, and collages by grids showed an interest bordering on obsession. Yet, by early 1952, Kelly felt he had exhausted the immediate possibilities, or proved what he needed to prove. Keeping some of the method, he began to leave the motif. His last few checkerboard grids were made in 1954.

Although this body of gridded work, compelling and discrete, has been discussed in other monographs,[1] expanded access to previously unpublished work, more observations from the artist, and records resulting from the precise theme of our exhibition are incorporated here. Misdatings of major collages are here corrected, as are image sources, which are also here connected to subsequent paintings and reliefs. Thus it is possible only now to plot this rapid revolution in Kelly's personal style.

Considering the grid's "discovery" and active use by the cubists, Malevich, Mondrian, and the De Stijl artists, and by so many other profoundly influential vanguard artists, some might say grids are *the* distinctive part of the art of our century. Krauss writes, "There are two ways in which the grid functions to declare the modernity of modern art. One is spatial; the other is temporal. In the spatial sense, the grid states the absolute autonomy of the realm of art. Flattened, geometricized, ordered, it is anti-natural, anti-mimetic, anti-real. It is what art looks like when it turns its back on nature In the temporal dimension, the grid is an emblem of modernity by being just that: the form that is ubiquitous in the art of our century. . . ."[2] Thus the very "ubiquitousness" of the grid allows us to see Kelly's adoption of it, for a brief period of three years, as a kind of formal and stylistic litmus test to gauge his progressive aspirations to modernity.

The story of Kelly's gridded art is at once more and less complicated than one might expect. This becomes, therefore, the paradigm of Ellsworth Kelly, person and artist. Kelly's years in France caused him to embark not on a binge of theoretical abstraction, as it might appear superficially, but, rather, on a decisive, detailed analysis of his observed world. The grid would be his matrix for this investigation, building on the extensive history of grid patterns and use throughout Western civilization. Kelly remembers the color chip systems of the gridded Munsell color theory charts used by his teacher at Pratt Institute[3] and readily acknowledges the compositional grids of Paul Klee, whose works he knew in Boston.

Perhaps, too, the gridding effects of the pattern overlays and weaving patterns of Oznaberg "fishnet" canopies, seen by Kelly while he was attached to a camouflage unit in the Army, were subconsciously incorporated in his gridded paintings.[4] The artist himself states that the more pervasive and lasting influence came from the topographical "grids" formed by networks of plowed and cultivated fields in northern France. His watercolors from 1945 show broad, quiltlike patterns, seen from hilltops, reminding us of his lifelong predisposition toward phenomena that are first observed and justified in nature, especially if it is a nature altered by human action.[5]

Grids are human marks, orthogonals of life, set up as rational and scientific schemes for mapping, charting, and quantifying. Their horizontal lines imply our landscape horizon as their verticals suggest growth, nature, and the figure. They satisfy needs for display of various information, control, order, and boundary. For Kelly, grids would aid his development of an "all-over," impersonal and generalized composition.

fig. 1. *Sketch from Old Tiles,* 1949, graphite, 7⅝ x 5¼ inches

fig. 2. *Sidewalk Grill, Place Maubert,* 1949, ink, 8¼ x 5⅛ inches

Kelly was trained as a realist and returned to Europe in 1948 to expand his classical experience of the history of Western culture. But in Paris, a new and strange city where he felt freed from outside obligations, his interests shifted away from Beaux-Arts studio practice and museum masterpieces. He admits to having become intoxicated by the city's many structures—not by official, formal, and familiar buildings like the Louvre, Eiffel Tower, and Notre Dame, but by the informal, irregular, and sometimes transient substructures, infrastructures of walks, walls, windows, quais, shadows, and reflections. His sketchbooks are filled with hundreds of vignettes of these encountered fragments of Paris: patterns of sidewalk repairs; pavers; the chance arrangement of posters in the Metro; the gridlike traces left on building walls after attached floors, walls, and ceilings were pulled down; drawn shutters; the inherent grids of building stones and their grout lines; and the gridding of Metro ventilation grills, among so many more. Working freely from encountered "chance" materials that led him to abstracted or geometrical solutions placed Kelly between the current governing Parisian non-figurative styles, so-called *abstraction chaude* and *abstraction froide.* The former artists and critics favored expressive, "hot," abstract gestures, while the latter insisted on a more geometrical, remote, or "cold," abstraction. Others were caught in this bind as well. Among those also using Paris as their source for "found" subject matter were those of the *affichiste* group, Raymond Hains and Jacques de la Villeglé. They had made their first *décollage* in 1949, removing public posters from the streets, altering them, and presenting them as objects.[6] Knowing Hains and their works, Kelly still preferred and drew from such posters in their original, impersonal, and architectural state.[7]

Kelly says that living in France for him was "voluptuous."[8] Yet it was not his goal to make a personal catalogue of Parisian architectural incidents. Rather, from things found in nature he took the actual look and composition of his own paintings and sculpture. Kelly wanted to lose his autographic, gestural "self" in Paris, to achieve an autonomous, anonymous art larger than himself and, ultimately, larger than Paris, or any other place, for that matter.

Some of the earliest drawings of gridded, found objects are from Kelly's 1948/1949 *Sketchbook 6*, containing details from a moored barge. One page focuses on a criss-crossed plank structure, and, another, on a combination of colored tiles on the stern (fig. 1). This surprising grid of tiles, arranged "by chance," or, at least, presumably outside any conscious awareness of aesthetic theory, stimulated the artist to attempt a replica painting. Kelly destroyed the canvas when he found that his single canvas with flat rectangles drawn on it lacked complexity and was not an improvement on the original object.[9]

Still, Kelly's abandonment of the barge tile painting in 1949 is a defining moment, for it shows the artist challenging his art to transform and transcend the original subject. With this first effort at a grid, he admits that he wasn't yet able to pass that test, it was "too early."[10] Kelly would later join multiple panels together in polyptych fashion and, by this, substantially increase the power of the component lines, colors, and mass. Several other 1949 sketchbooks (Paris *Sketchbooks 9, 10, 11*) and notebook sheets, some of them on quadrill paper, record other gridded, found objects: window mullions, paving patterns, posters arranged on Metro walls, and, in particular, ventilation grills. Kelly drew from the Metro sidewalk grates of Place Maubert (fig. 3), modifying the structures vertically and horizontally, looking for what interested him. In another sheet, he transformed part of the grate into a simplified robotic head and shoulder form, not unlike the tribal, Romanesque, Cycladic, or Etruscan objects that he had been sketching in the Paris museums (fig. 2).

The artist made doodles, connecting random lines into rectilinear constructions, and in Paris *Sketchbooks 11* and *14* produced a number of "automatic" drawings made with a ruler for random straight lines, but with his eyes closed. Curiously, some of the resulting drawings still arrange themselves in gridded patterns, proving the point that the grid remained for him a ubiquitous subconscious design. The idea of automatism and its relationship to "chance" would figure in Kelly's grid collages and paintings over the next two years.

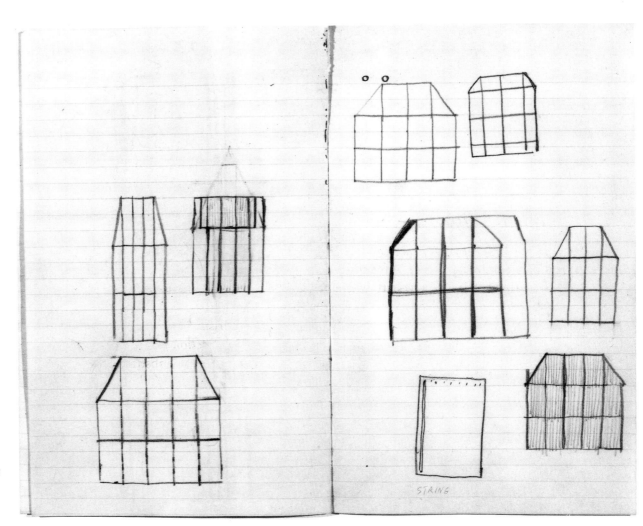

fig. 3. *Sidewalk Grill/Studies for Wood Cutouts with String*, 1949, graphite, 7¼ x 10⅛ inches

39

fig. 4. Study for *Window I*, 1949, ink and gouache, 7⅞ x 5¼ inches

the mullions and the gray window frame create the obvious positive space. But Kelly can invert the logical relationship because his whites always retain an equivalent, palpable weight. This fosters a structural ambiguity, where parts alternate between visual positives and negatives, advancing, one way, and receding, the other. The exterior window frame will disappear in subsequent drawings and paintings, leaving just the black central cross-bars, yet the white zones, in their role as notional color, stay evident and in balance.

In his later spectrum grids, Kelly reduced the process further: the squares of straight-cut color blocks, the "panes," persist without any drawn grid armature. However, from the strict alignment of their edges we infer a dominant skeleton and, again, all is in clear equilibrium. Contained within this play of (rational) grid structure against (imaginative) color is the classical dialectic in the history of thought: reason versus passion; head versus heart; the Apollonian versus the Dionysian. By extension, it is by the grid that Kelly devises his own personal way to study the effects of permanence versus change.

Reflections are among nature's most transient effects. The depiction of light shimmering on water has long served as an ultimate test of artistic skill. In 1950 Kelly submitted to the difficult pleasure of trying to capture this ephemeral effect. In one series of Paris sketches he uses a post-impressionist scheme of markings but in a loosely gridded fashion. He dispersed rectangles of ink across drawing sheets, their substructures set by a network of horizontal and vertical lines, subsequently erased. The white ground reads as water, the black blocks as flickering light, allowing the artist to create a frozen equivalent of an intellectual reflection. Kelly, contrary to modernist credos, did not employ the grid to turn his back on the visible world or to take his work to a pure and abstract stage. Rather, he used the format as that tool he felt best suited to convey his impressions of nature. The grid was his balance between order and disorder, between the whole and its fragment, employed to break up images into equalized forms.[12]

At the same time, the artist began more comprehensive experiments with chance and randomness. Kelly was already aware of automatist principles and the so-called "laws of chance." He continued to expand its possibilities through his contacts with Jean Arp, the striking "anonymous" qualities of Sophie Taeuber-Arp's works,[13] the residual influences of post-cubist collage, dada, and surrealism, and through discussions with his close friend Ralph Coburn. He was excited by John Cage's example of open aesthetic operations by which art could be made, found, or declared, freely based on chance experiences.[14] Here, as with the dadaists, where "chance was conceived of as a means by which the work of art could 'happen' without the intervention of the artist,"[15] Kelly would pursue the idea of art without a personal imprint, even if such a proposition of absolute impersonality was compromised. "In no case can the artist

As articulated by Jean Arp, chance as *accident* had always been present in life, but chance as a *compositional principle* in art, especially in dada and surrealism during the twenties, was new. "Chance became an operative means of depicting."[11] Kelly would treat his own early years in Belle-Ile, Paris, Sanary, and elsewhere in France as extended opportunities for indeterminate, "chance" operations. While seeking to have natural forms suggest the image of his art, Kelly's self-assigned role was to recognize the potentials and adjust the elements. But it was by his strenuous objection to signature "touch and style" that he wished to place the artistic causality outside of the artist.

Kelly's summer 1949 studies from the window mullions of his Belle-Ile cottage intensify his observations of the geometric grid (fig. 4). The white window panes may be formally viewed as transparent and, thus, a negative space. The black lattice of

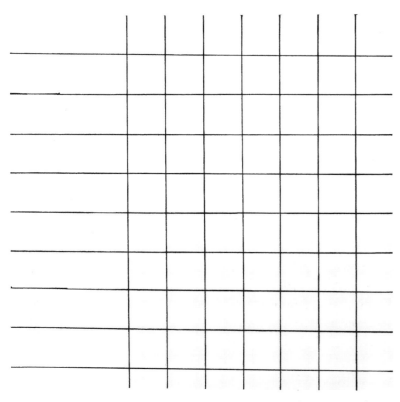

fig. 5. *Grid Lines* (from *Line, Form and Color*), 1951, ink, 7½ x 8 inches

layer of subjectivity that would reveal itself only in the fortuitous, 'accidental' conjunction."[17] Coburn gave him a red and yellow canvas checkerboard pattern, which he cut up into strips and repositioned in this collaboration with his friend, "according to the laws of chance" (pl. 59). Kelly's subsequent works would, however, restore such checkerboard grid structures. The grid allowed him to scatter and generalize a design equally without a center of interest.[18] It was only the internal color units that Kelly would place "by chance." Kelly wrote to Cage in September 1950, "[my] collages are only ideas for things much larger—things to cover walls. In fact all the things I've done I would like to see much larger. I am not interested in painting as it has been accepted for so long—to hang on walls of houses as pictures. To hell with pictures—they should *be* the wall—even better—on the outside wall—of large buildings. Or stood up outside as billboards or a kind of modern 'icon.' We must make our art like the Egyptians, the Chinese & the African & Island primitives—with their relation to life. It should meet the eye—direct. . . ."[19]

The artist's breakthrough to a more complex use of grids and manipulated, ordered "chance" began in the spring of 1951 when he had a compelling dream. In it, he and his students were on a scaffold, making a large, square-paneled wall painting.[20] This seems a unique blend of the collective unconscious of surrealist dreaming with the geometric idealism of De Stijl. Following the dictates of this dream, Kelly made a brushstroke drawing, cut it into twenty squares, and then arranged the squares randomly in a grid. The painting *Cité* (pl. 68), with twenty panels, previously titled *Rêve* (Dream), was made from this drawing turned upside down. But before joining the panels together Kelly still tried to modify the arrangement using various juxtapositions, testing the dreamt chance arrangement against his wakeful consciousness. In the end, he accepted the first subconscious motif of the grill, grid, or scaffold, filled in by methods of chance as "best." He began to trust his instincts, and numerous other cut-up brushstroke drawings and related paintings followed.[21]

in league with chance in the process of creation be totally passive. The fact that he has chosen to create in this fashion makes him a causal factor in the whole process; he intervenes, even if only to designate the material that is to be subjected to random influences and to recognize any random object, pattern, or event as suited to his own artistic ends."[16]

In a number of provocative works from 1950 Kelly used randomly flipped magazine pages, found objects, children's leftovers, and torn and cut-up drawings to make works composed "by chance." At this stage, Kelly may have been like the earlier dadaists, whose experiments "were an attempt to reach a new

fig. 6. Study for *Seine,* 1951, graphite and ink, 4¾ x 14 inches

The gridded black ink drawing created for a page in his projected book of pictorial elements, *Line, Form, Color,* returns us to the artist's least inflected line and form (fig. 5). This dominant grid sets the fundamental scheme for a subsequent series of drawings that would, again, be used to present the artist's observations of light reflected off water. It seems odd, in that pre-Fractel/computer/digitizing world of 1951, to try to geometricize irregular organic ephemera, even if Kelly does appear to be picking up where Mondrian's 1913/1914 pier and ocean paintings had left off. Yet Kelly's black and white painting *Seine* (pl. 71) and its preliminary drawing, Study for *Seine: Chance Diagram of Light Reflected on Water,* (fig. 6) do just that. In addition, it was for *Seine* that the artist devised his first formal system to fill in the grid by "chance." He then concocted various more complex formulae for other works. Some of these are logical, following evident mathematical progressions, but others are so intuitive, spontaneously manipulated, or numerically awkward that their methods cannot be reconstructed easily. Goossen documented this first study for *Seine,* which began with a hand-gridded drawing, twice as long as high (82 units by 41 units). The artist put forty-one numbered slips of paper into a box, and, starting with the second vertical row, drew a slip. He then shaded the rectangle corresponding to that number with pencil, returning the slip to the box. For the next row, two numbers were drawn, boxes shaded in, then three, four, et cetera until, in the forty-first row, all the boxes were filled. The process was reversed for the second half of the painting. This system "assured (1) equal areas of black and white, (2) an overall, principled organization, and (3) minimum subjectivity in the manner of execution."[22]

Conceived and executed in Paris, this study and painting are black and white. Monochrome, or at most two-color, paintings and reliefs dominated Kelly's oeuvre until November 1951, when he returned to Sanary. Before leaving Paris the artist went to a supply store for colored paper. He found two types: one the traditional, matte construction type in a limited range of mute colors, and the other a striking group of glossy, pre-pasted, and highly colored papers. Admiring their industrial quality and wide spectrum of nearly twenty different hues, he bought everything available.

Fueled by these papers, his work reached a remarkable chromatic explosion. He made, within a six-month period, at least eight very large and complex spectrum checkerboard collages, numerous smaller sketchbook arrangements, and his masterpiece painting of sixty-four panels: *Colors for a Large Wall* (pl. 74). Kelly's most profound and scintillating fusion of geometric color with gridded form on a large scale began in Paris but would come to its grandest achievement in Sanary.

The full-color counterpoint to *Seine* is the collage *Spectrum Colors Arranged by Chance I* (see page 168). Begun in Paris, its variegated squares of twenty colors replace the earlier work's rectangles of black and white. The squares are dispersed in an equivalent pattern moving from sparse left and right sides to a filled center. This work no longer alludes to reflections of cold city lights on the Paris river but to something hot and multichrome. It anticipates a Provençal theme, full of Mediterranean light bouncing off painted and decorated tile buildings, red roofs, yellow awnings and shutters, colored boats, riotous vegetation and flowers, trees, rocks, land, azure sky, blue-green waters. Kelly's grid system pushed his art away from literal presentation, not to a less nature-related state, but to a more self-justified objectivity. The grids were a functional paradox where the artist plausibly excused himself from the natural image while keeping its natural content as a part of his meaning. The collages also reflect the passage of time, the "progress" of building each structure. From the acquisition of the paper, to its cutting, to its selection and final gluing, we find an explicit, predictable sequence.

The artist's palette has now expanded to an unprecedented range. After Sanary, he would never again make compositions in so many colors or make collages as large as the Spectrums. Instead, from then until the present moment, Kelly would take carefully selected details of these collages, with their remarkable juxtapositions of colors, selected and arranged by "chance," and convert these parts into independent panel paintings, diptychs, triptychs, or polyptychs.

Previous literature has confused the Sanary period and the evolution and dating of the large Spectrum collages. But closer study of these works, plus related smaller collages, the Sanary *Sketchbooks 15, 17,* and *18* (fig. 7) and recent discussions with the artist and Ralph Coburn, have added substantial supporting evidence toward attributing much more of the notable expansion of the role of color, grids, "chance," and panels in Kelly's painting to his experience in the south of France.

The artist decided the size of the individual color square by dividing the overall collage dimension by the number of desired rows, usually forty. He would then laboriously cut the thousands of shiny squares, making equivalents of the brilliant colored glass *tesserae* he so admired in Byzantine mosaics. Kelly was both a "machine" executing endless repeated and tedious actions and an artist who was, he admits, in a state of intense anticipation. His grid projects were purposefully experimental and if they "hit the mark" it was through a combination of luck and his manipulation of the system. After colors were chosen to fill the grid system, all of one color would be glued down before another, so the work changed radically for the artist from stage to stage.

The grid for Kelly remained flat and anonymous, "map[ping] the surface of the painting itself."[23] The edges of the color squares created the "lines" of the grid, however subtly. Despite the invisible armature that allowed the color to float, Kelly had no desire for his designs to be seen in a kind of perceptual or notional space. They were not visible three-dimensional scaffolds

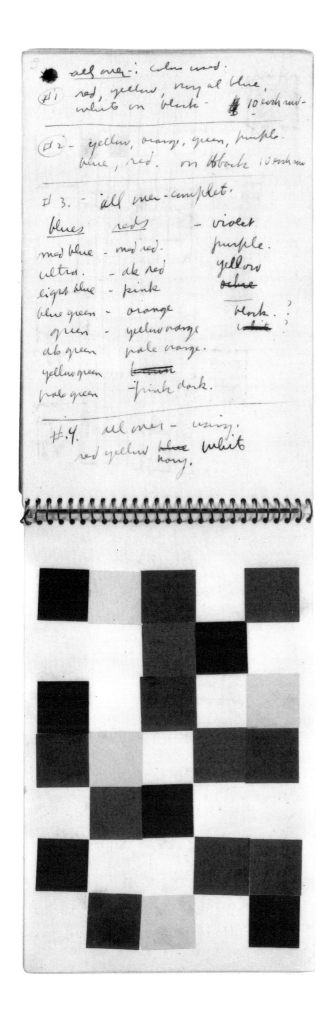

filled with advancing or receding colors. He wanted the planar characteristic to dominate throughout with a balance of value and hue. Yet, by chance, if two or three of the same color were progressively chosen and had to be beside each other, unbalanced, that had to be, as well. He was consciously ignoring the previous classical history of color and aesthetic theory. While interested in the architectural use of color to articulate volume, as he had seen in the distribution of colored walls on the façade of Le Corbusier's Unité d'Habitation in Marseille,[24] Kelly still wanted his color grids to stay as elements on a literal flat surface, retaining their mystery of how they came to be and how curiously they worked.

Spectrum Colors Arranged by Chance II (see page 168) is the first of a group of three works whose color selection systems were manipulated to effect a dominant central density with diminished numbers of squares at the corners or along all the sides. The clustering was achieved by Kelly working the arrangement first vertically, then horizontally. For *Spectrum Colors Arranged by Chance III* (see page 168) the artist tightened the dispersion to the center. *Spectrum Colors Arranged by Chance IV* (see page 169) is on black mounting paper and was designed from a solid center spiraling outward in a progressive system adding increased blocks of black.

Spectrum Colors Arranged by Chance V, VI, VII (see pages 169–170) all followed a construction pattern from the center out but with increasing density toward the perimeter. In each, different values of colors were established. The only painting directly related to these spectrum collages was based on the Sanary *Spectrum VI* (see page 170). In its collage of 1,444 units, 722 positions were drawn for black squares, then twenty other colors were drawn and plotted into the remaining spaces, making a work that was half black and half multi-color, with equal background, equal dispersion. *Spectrum Colors Arranged by Chance VII* is a solid, all-over piece, with a discernible shift to pastel colors because of a preponderance of pinks and light blues. *Spectrum Colors Arranged by Chance VIII* (see page 170) has intentionally larger color squares arranged for three internal spectrums of green, yellow, and blue transitions between three purple ranges. Again, these spectra were experimental in their origin as Kelly worked out ideas and speculations, especially about his exploration of the limits of color and its functions.[25] The artist rarely knew beforehand what they would look like when arranged by his "chance" procedures.

fig. 7. *Sketchbook 18*, pages 42, 43, 1950–1952, collage and ink, 8¼ x 5¼ inches

The artist's Sanary sketchbooks are filled with various other esoteric schemes of grid layouts. In *Sketchbook 18,* for example, one finds a plan for eighteen colors on a pink background, or eighteen colors on black, plus small pages of collaged checkerboards with color listings or pages removed, with a twenty-nine block grid or a striking double page of one hundred blocks. A remarkable and subtle collage (fig. 1, page 12) was stimulated by a "found" tile pattern in Kelly's Sanary hotel. Three off-white squares are set in an arrangement of eight squares and two rectangles. The seven quadrilaterals are pure white and all are surrounded by thin brown collage lines, suggesting grout. Ignoring the anecdotal reference, this white-on-white composition is of the utmost purity and distinction. It is both regular and varied, mundane and esoteric.

In page 90 of *Sketchbook 17* a complex gridded sketch is marked "Idea for an Exhibition." In it the artist imagined exhibiting paintings of forty-nine squares, in eight successive developments. *Sketchbook* page 92 continues with a plan for showing collages at various stages of development of a large color square of twenty colors. There were to be small paintings in oil, as well, all leading to one large completed painting. Several other documentary drawings illustrate the artist's constant and energetic pursuit of evolving number sequences, designs to be revealed by manipulated indeterminancy, distribution curves, and unceasing notation.[26] The remarkable efforts put into these operations should, at the very least, convince one that Kelly hardly authorized so-called "pure" chance to dictate his art and life. Rather, he indulged in a pseudo-scientific search for seemingly anonymous and superficially less planned ways to help make his art happen.

The central painting project during the visit to Sanary was the grand *Colors for a Large Wall* (pl. 74). Based on a small gridded collage, said to be composed of the exact number of remaining color squares after the Spectrum series,[27] this ambitious polyptych is the most successful checkerboard grid painting of Kelly's early years in France. While fully dependent upon the many "chance" operations and the prevalent structure of the Spectrums, the arrangement of color blocks in this work was made entirely by the artist. Kelly intended to work on a large scale in Sanary but knew that it meant shipping problems for a return to Paris. Thus the design of this work in sixty-four small panels not only permitted economical transport but also enhanced the artist's use of line, form, and color. The panel edges cast shadows by their separation, thus signifying line. The multi-panel form is related to the long history of art as well as twentieth-century grids. The colors are both manufactured commercial colors and equivalent signifiers of the special ambience of Mediterranean Sanary.

After Sanary, Kelly would produce several checkerboard variations but more especially, numerous important panel paintings of various sizes. These latter works would not have been the same without the extensive preparation and achievements offered by his major collages and early polyptychs of 1949–1951, when various "chance" methodologies and grid motifs obsessed and stimulated the artist at every turn. And finally, within the environment of Kelly's grid-derived panel paintings, the "laws of chance" continue their decisive play. The artist still uses select compositions of juxtaposed colors that he has discovered embedded in his early *Spectrum* and sketchbook grid collages. Thus, by this ultimate, renewing "chance," and through these grids, Kelly has been able to depend on these unique resources for viable new invention, from the early 1950s to today and tomorrow.

1. E. C. Goossen, *Ellsworth Kelly,* exh. cat. The Museum of Modern Art, New York, 1973; John Coplans, *Ellsworth Kelly,* New York, 1971; Diane Waldman, *Ellsworth Kelly Drawings, Collages, Prints,* Greenwich, Conn., 1971; Diane Upright, *Ellsworth Kelly: Works on Paper,* exh. cat. The Fort Worth Art Museum, among others.

2. Rosalind Krauss, *Grids, Format and Image in 20th Century Art,* exh. cat. The Pace Gallery, New York, 1978, 2.

3. See, for example, Albert H. Munsell, *A Grammar of Color,* New York, 1969.

4. See Goossen 1973, 115.

5. In response to author questionnaire, 7 August 1991.

6. See Benjamin H. D. Buchloh, "From Detail to Fragment—Décollage Affichiste," *Décollage: Les Affichistes,* exh. cat. Zabriski Gallery, New York and Paris, 1990, 3–7, and Daniel Abadie, *et al, Les Années 50,* exh. cat. Centre Georges Pompidou, Paris, 1988, 284.

7. Response to author questionnaire, 7 August 1991.

8. Interview with the artist, 9 September 1991.

9. Interview with the artist, 29 January 1991.

10. See chronology in this volume.

11. Harriett Ann Watts, *Chance—A Perspective on Dada.* UMI Research Press, 1975/1980, 2.

12. In response to author questionnaire, 7 August 1991.

13. In response to author questionnaire, 7 August 1991. Kelly visited Jean Arp in Meudon three times and was impressed when shown works by Sophie Taeuber-Arp. Of particular relevance are the Sophie Taeuber and Jean Arp *Duo-Collages* of 1918, which are remarkable checkerboards. Her watercolors and other painting compositions frequently established rhythmic grids, especially those of the *Composition Aubette* group. See Sandor Kuthy, *Sophie Taeuber-Hans Arp Kunstlerpaare-Kunstlerfreunde,* exh. cat. Kunstmusem Bern, 1988, especially 108–130.

14. Interview with the artist, 28 January 1991.

15. Watts 1975/1980, 156.

16. Watts 1975/1980, 156.

17. Watts 1975/1980, 106.

18. In response to author questionnaire, 7 August 1991.

19. Letter Ellsworth Kelly to John Cage, 4 September 1950.

20. A more complete recounting of this dream is found in the Chronology in this volume.

21. Some of the most important of these would be: *Study for Gironde* (EK51.69, 16 squares); *Study for Meschers* (EK51.73, 25 squares); *Study for Talmont* (EK51.81, 10 squares); *Brushstrokes Cut into Twenty-four Squares and Arranged by Chance* (EK51.71); *Brushstrokes Cut into Twenty-seven Squares and Arranged by Chance* (EK51.74); *Brushstrokes Cut into Forty-*

fig. 8. *Chance Drawing on a Grid,* 1952, graphite, 10½ x 10⅛ inches

fig. 9. *Numbered Counting Sheet,* 1952, graphite, 10⅛ x 8½ inches

nine Squares and Arranged by Chance (EK51.71); and *Brushstrokes Cut into Thirty Squares and Arranged by Chance* (EK51.78) as well as the drawings EK51.80, EK51.89, among others.

22. Goossen 1973, 30–32.

23. Krauss 1978, 2.

24. See William J. R. Curtis, *Le Corbusier: Ideas and Forms,* New York, 1986, especially 169–174.

25. Goossen 1973, 32.

26. Several drawings on gridded paper remain as complex artistic experiments with numerical progressions, notably *Chance Drawing on a Grid,* (fig. 8) and *Chance Division of White Center to Black.* The artist's files also contain many sheets where he drew planning grids (fig. 9), did his math and counting sequences, and, in one case, even constructed a long plotting of a distribution between filled and unfilled squares, which he then modified to achieve his desired result.

27. Goossen 1973, 45.

Jours de fête

Alfred Pacquement

In the Paris métro, abstract geometric compositions alternate with advertisements mounted in frames. These colored-paper panels, which consist of two or three juxtaposed monochrome surfaces, look like "ready-mades"—minimal, common-enough-looking works resembling in a strange way Ellsworth Kelly's work of the fifties and sixties.

Like any coincidence, this one perhaps is not entirely fortuitous. When Kelly was in Paris after the war, among the many motifs he noticed were the advertising posters in the métro. A drawing of 1949 (fig. 1) shows the parts of a poster coded by dominant color, reassembled (a method of observation of which Kelly provides numerous examples), as if such a large, multicolored composition could be deconstructed into so many monochromatic, autonomous, geometric fragments. Of course, it was at that time that Hains and Villeglé began creating their ready-made abstractions from the remains of layers of posters glued on top of one another. And if Dubuffet's work from 1943 is taken into account, that particular universe that is the Paris métro begins to take form as a theme in the paintings of the period.

The métro was only one theme among many that Kelly used during the years when his abstract work was taking shape. Almost all of his paintings from 1949, 1950, and part of the following year are based on images from the world around him—whether it is the urban world, or that of the countryside when he leaves the capital for Belle-Ile, Sanary, or Meschers. In his own way Kelly resumes the French tradition of *plein air* painting—he finds his subjects in his surroundings—and in like manner his chromatic scale is strongly influenced by the light of the Mediterranean during his stay in Provence. The walls of the city and in a general way its architecture constitute a preferred source for such motifs as the window, which is the subject of six paintings. Ordinary, often quite banal objects, as well as plants, are themes to which Kelly remains faithful in his drawings, while his painted work becomes radically abstract. Finally, other paintings and a rather large number of drawings are based on works of art that Kelly saw in museums, monuments that he visited, or even artistic objects diverted from their apparent use: *White Relief* (pl. 48), for example, springs from a Japanese stencil.

This intense way of seeing, which seems to settle on any theme that provides a pretext for simplification of form and contour, sooner or later had to encounter the photographic lens to—as Roland Barthes said—"exorbitate" at what you see. Yet while Kelly fills his notebooks with sketches, he almost never uses photographs until his stay at Meschers in the summer of 1950. Except for a few snapshots, only one view, a frontal and rather ordinary one, of Notre-Dame-la-Grande, made on the bicycle trip in the spring of 1949, functions as a photographic record: the same monument inspired *Mandorla* (pl. 27), painted the same year.

The astonishing works, as numerous as they are diverse, from Kelly's years in France leaves the impression of a frenetic visual appetite, enthusiastic yet lighthearted, as the photographs will reveal more clearly. It is a very young man whose work takes form: At the age of twenty-five, his precocious maturity equal to his creative ardor, Kelly arrives in Paris. With each step through the city, Kelly detects motifs that are so many possible pictures. Sustained by the artistic encounters that Paris reserved for the young artist in those days—the visits to Brancusi's and Monet's studios, the contacts with Arp and Vantongerloo, and even more so with his contemporaries John Cage and Merce Cunningham, and artists of kindred spirit like Jack Youngerman and François Morellet—Kelly is plunged into an exceptionally favorable environment. Of course, living is not easy, the paintings don't sell, but at least Kelly can exhibit publicly on several occasions and arrange for his work to be seen, if not understood, by some of the great figures of this century, Le Corbusier, for example. In this sense, without a doubt, Paris after the war remains an exceptional locus of cultural exchange.

From the summer of 1950, at Meschers, Kelly employs photography regularly without ever merging it with his painting or drawing, as has been mentioned rather than commented upon.[1] His work reaches a turning point: the preceding summer at Belle-Ile, the foundations had been laid for Kelly's abstractions based on his observations of reality. A kilometer marker, a window, seaweed stuck to a door thus have become, according to Kelly's method, abstract forms in which only the graphic structure and possibly color are preserved. A year later Kelly goes further in this direction, yet he is also gradually distancing himself from it. Under the influence no doubt of Jean Arp, whom he had recently met, he will employ a strategy of random choice in

fig. 1. *Métro Posters,* 1949, pencil on paper, 9¼ x 13¼ in

collages of simple squares or rectangles of color, collages that will result in his great compositions of 1952.

One of the pivotal works of this transitional period has its source in Kelly's stay at Meschers: *La Combe I* (pl. 66) was the outcome in fact of several drawings—some of them made on the same leaf of Kelly's notebook—tracing the shadows cast on a metal stairway, seen from above (fig. 3), a perspective rather cinematic in its framing. Several studies interpret variations according to time of day, a quasi-conceptual strategy that brings to mind diagrams of shadows made by artists of the succeeding generation (Dibbets, for example; fig. 4). Kelly was interested in the effects of projected light, and had actually made use of them once before in *Window V* (pl. 35).

In the drawing and in the collages that follow, Kelly translates this motif in two dimensions without attempting to achieve a sense of depth or convey visual distortion. The stairs are rendered on only one plane, the rectangles of equal dimension indicated only by the staccato rhythm of the lines of the shadow.

Alongside this important group of studies leading to the first painting of a series that was finally to number four works, Kelly's only photograph of the same theme appears quite mod-

est. Kelly uses it to commit the subject to memory. Here, as elsewhere, the painting will not be made from the photograph; in fact, the photograph always comes *after* the preliminary drawings, as an *aide-mémoire.* The photographic image informs us on several points that the drawing did not make clear, so much an abstraction was it already of its subject; the latter, for example, is tilted from an original vertical version to the horizontal in order to express better the idea of a series. A gouache of 1950, *Awnings Avenue Matignon,* and the large multipaneled work of 1952, *Red Yellow Blue White* (pl. 77) illustrate Kelly's predilection for horizontal progressions whether the painting is composed of juxtaposed fragments or not. Kelly also erased a linear, diamond-shaped pattern that covered the steps of the stairway, the oblique lines of which would undoubtedly have conflicted with those of the shadows. He also ignores, beginning with the first studies, the half of each stair essentially left in shadow by the one above it. His way of seeing as translated in the drawing, and then in the painting, is that of an artist who reduces and simplifies what he sees to essentials. He respects reality: he uses the same number of steps, for example, though he distorts the pattern of shadows to achieve a better, or at least more complex, graphic effect. The photograph, though last in line, helps us to

understand how and why the theme was "sighted," as a site is focused in on when shooting a picture—what he had in reserve to bring a certain view into sight.

In Meschers Kelly is entrusted with a Leica camera by his hostess, Mrs. Henri Seyrig. The few images that are the result of his stay (he certainly didn't take more than two or three rolls of film) are resolutely creative. They bespeak a rather cheerful state of mind, a tender and poetic view of the French countryside, which, undoubtedly because these photographs were not realized with the same ambition as his paintings, perhaps reveal the Kelly of the 1950s in a different light. By connecting certain themes—the trapeze and rings (fig. 6), the little dog who seems to hold up the unstable brick wall (fig. 7), the patched-together shanties at Nonnes beach (figs. 9, 10)—there emerges a universe

à la Tati; and if Kelly hadn't had a chance to see *Jour de Fête* when it came out the preceding winter, he was soon bound to appreciate *Les Vacances de Monsieur Hulot*. (Note, moreover, that it is also from a fleeting appearance in the cinema newsreel that he will take the motif, inaccurate as it is, of the tennis court painted at Belle-Ile.)

Better than a notebook full of sketches, the photographs allow us to follow Kelly step-by-step on his walks: the buildings in shadows, hastily patched walls, and wobbly fencing are some of his favorite themes, chosen undoubtedly just for the pleasure of framing a fragment of reality seen occasionally as the possible subject of a painting, when it is not imperative to isolate form, to stress surface. Some are the subjects of more extended investigations in the drawings, which once again the photographs will

fig. 2. *Window, Museum of Modern Art, Paris,* 1967, photograph, 10 x 8 in

fig. 3. *Shadows on a Staircase, La Combe (#2), Meschers,* 1950, photograph, 10 x 7 in

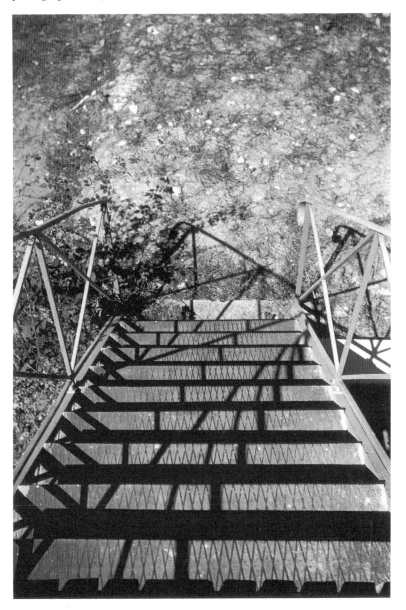

only serve to reinforce: the pencil sketch for the beach shanty mentioned above (fig. 8) notes with an almost obsessive precision the colors used in the sewn pieces and the strategy of layering thereby achieved. Several collages of narrow vertical bands of the same year (1950) will take up the same principle without ever precisely adhering to the model. Another, more numerous, group of drawings, and other photographs, have their source in the twisted, rusted reinforcing rods sticking out of the shelled bunkers on the beach at Meschers (figs. 13, 14). Kelly made these "automatic drawings" of tangled-stem motifs without actually looking—"automatic drawing"—which is surprising because, in a way, the accuracy of the line drawing is verified by the photograph. He uses the same strategy with tree branches (fig. 11), but there again he will sometimes simply frame the photographic image. This is in fact one of Kelly's favorite themes. The linear, monumental drawings span all of his painted works. The photographs of the summer of 1950 stress the linear, graphic, contrasty character of a detail of foliage. (One of these trees, whose branches evoke mobiles, was named the "Calder tree" by Delphine Seyrig and Jack Youngerman.)

From nature to town: the other photographic sequence, rather sparse as well in quantity of images, was made in Paris somewhat later, probably during the last months of 1950. Kelly no longer remembers how he got hold of a camera, but in any case he did not purchase one, nor did he make any photographs other than these or those from Meschers, during his stay in France. It is interesting that the subjects of several important paintings and reliefs of this period, though taken directly from walls of buildings, do not appear among photographs. It is only much later, in 1967, when Kelly is again in Paris, that he photographs the window of the Museum of Modern Art (fig. 2), the wall of the rue Saint-Louis-en-l'Ile (fig. 17), the window of Le Corbusier's Swiss Pavilion at Cité Universitaire, the arch of Tournelle bridge. Thus he reveals, after the fact, the sources of several of his most important paintings, which he certainly was not prepared to do at a time when the split between abstraction and figuration appeared to be almost a question of ideology. It is doubtful that Kelly could have exhibited at Réalités Nouvelles—the salon of orthodox abstraction—in 1950 and 1951, if his method had been so clearly revealed.

fig. 4. Study for *La Combe I*, 1950, pencil on paper, 8¼ x 10⅛ in

The Paris photographs of 1950 are therefore a disconnected series of images that are concentrated within a very limited area along the quais of the Seine. Taken together, these images are evidence of the pull that Paris had on the young Kelly, and of the fantastic reservoir of motifs that he discovered there day after day. He walked where many before him had painted, at the very spot where the studio window of Matisse opened onto the street. He is particularly interested in the details of walls on the rue Saint-Louis-en-l'Ile, and emphasizes textures as before at Meschers, even though the painters of his generation had refused to acknowledge such things. Kelly is involved at this time in making his first reliefs, made with cardboard cutouts or wood (fig. 5). And though he is interested in surface detail, he also focuses in on cutout forms—no less for their pictorial potential, as can be ascertained in the drawings, and all the more so in the works in relief—also to emphasize the cutouts' aleatory character at a time when chance plays an important part in the way his work is made. It is this latter aspect that accounts for his frequent use of shadows, as in the *La Combe* series of paintings as well as in his photographs (fig. 12): the curve of a boat on the Seine or the projections of the artist's own cutout reliefs. Elsewhere, confirming that it is indeed the eye of the painter that is looking through the lens, Kelly fixes his gaze on motifs having no apparent esthetic value. Yet the wall at the end of a courtyard, whose central section is slightly pushed-in, seems to reappear in much later works as a monumental triptych.

Kelly attaches relatively little importance to these photographs. He only had small-format prints made; he waited twenty years to publish several of them; and he only first agreed to show them in the exhibition devoted to his years in France some forty years after he had taken them. Their function—I repeat—was secondary in relation to the drawings and sketches. The photographs allowed him to retrace the vision and not to induce it. In like manner, when he resumed contact with photography at the end of the sixties, it was in order to recall those preferred motifs from Paris, or to display among the forms of Long Island configurations similar to those of his paintings or reliefs. It is in the architectural details, the openings, pieces of walls, that Kelly captures those fragments of reality that bring forth works that have erased every direct reference to them. Sometimes the photographs mark the trail of that operation that has successively deconstructed and reconstructed the form. Quoting Edward Weston, Kelly applies to his own account the definition of photography as "signification of facts." Inversely, his painting could be characterized as a visual investigation around those very facts.

fig. 5. *Wood Cutout with String II, 1949, 1950,* photograph, 14 x 11 in

1. Diane Waldman, *Ellsworth Kelly: Drawings, Collages, Prints* (Greenwich, 1971), 19.

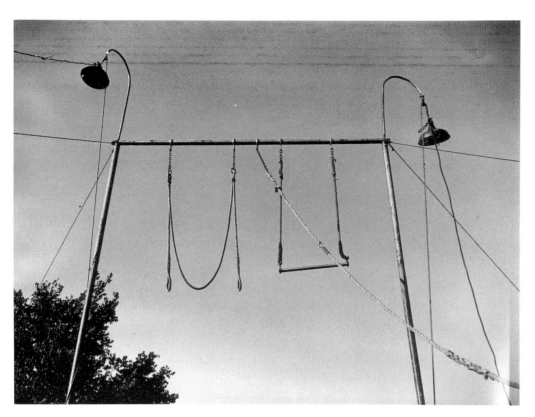

fig. 6. *Trapeze Swings, Meschers,* 1950,
photograph, 11 x 14 in

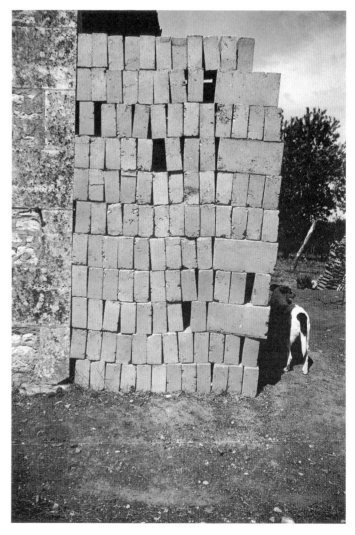

fig. 7. *Bricks, Meschers,* 1950,
photograph, 14 x 11 in

fig. 8. *Sketches of a Beach Cabana*, 1950,
pencil on paper, 10⅛ x 8¼ in, each drawing

fig. 9. *Beach Cabana (#3), Meschers*, 1950,
photograph, 14 x 11 in

fig. 10. *Beach Cabana (#1), Meschers*, 1950,
photograph, 14 x 11 in

fig. 11. *Leaves, Meschers*, 1950, photograph, 11 x 14 in

fig. 12. *Shadows from a Balcony, Villa La Combe, Meschers*, 1950, photograph, 11 x 14 in

54

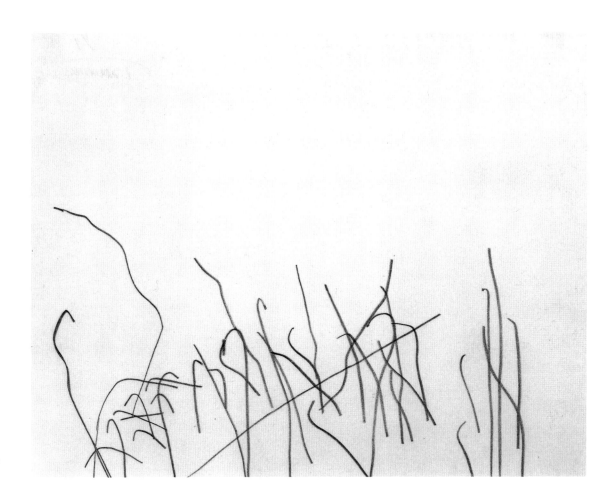

fig. 13. *Automatic Drawing: Shelled Bunker,* 1950, pencil on paper, 10⅛ x 13⅛ in

fig. 14. *Shelled Bunker (#7), Meschers,* 1950, photograph, 11 x 14 in

fig. 15. *Façade, Rue de Montfauçon, Paris,* 1950,
photograph, 14 x 11 in

fig. 16. *Pont Marie, Paris,* 1950,
photograph, 11 x 14 in

fig. 17. *Wall, rue Saint-Louis-en-l'Ile, Paris,* 1967,
photograph, 11 x 14 in

fig. 18. *Wall, Courtyard, rue Saint-Louis-en-l'Ile, Paris,* 1950,
photograph, 11 x 14 in

Paintings and Reliefs, France, 1948–1954

I. Plates

1. *Byzantine Head II*, 1948, 15¼ x 11 in, cat. 2

2. *Byzantine Head I*, 1948, 15 x 15 in, cat. 1

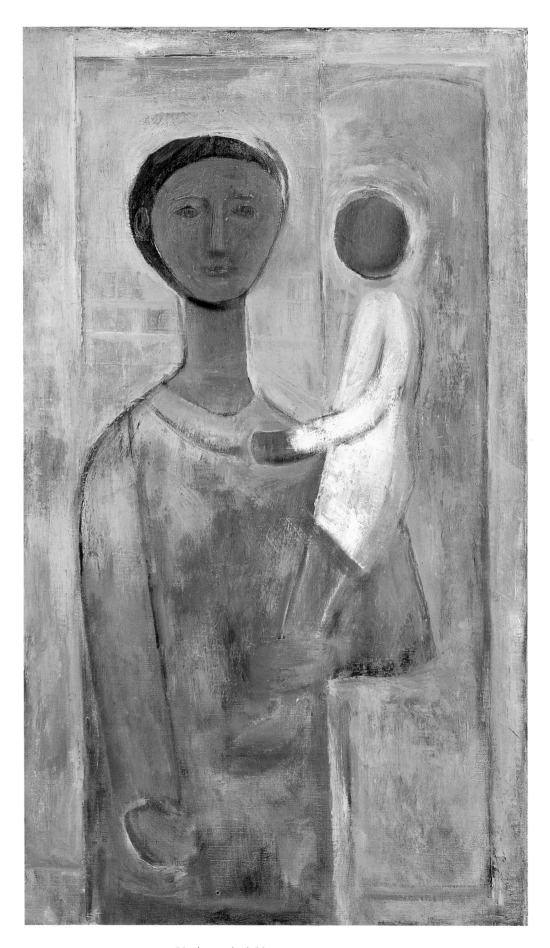

3. *Mother and Child*, 1948, 29 x 17 in, cat. 4

4. *Byzantine Head III*, 1948, 19½ x 12¼ in, cat. 3

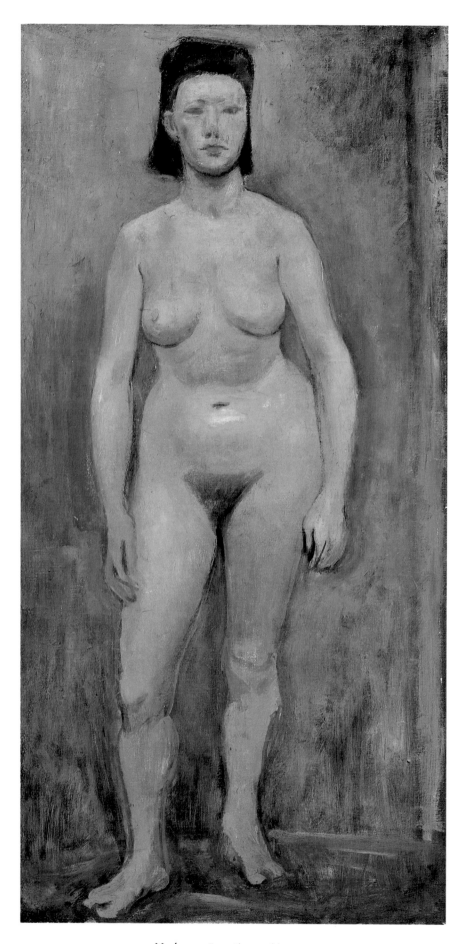

5. *Nude*, 1948, 39⅛ x 19½ in, cat. 5

6. *Egyptian Woman*, 1948, 24 x 19½ in, cat. 10

7. *Figure with Yellow and Blue*, 1948, 24 x 17 in, cat. 11

8. *Poitiers*, 1949, 23⅞ x 18⅛ in, cat. 12

9. *Chuan-Shu*, 1948, 35½ x 28 in, cat. 6

10. *Faceless Head*, 1948, 21 x 15 in, cat. 9

11. *Lazarus*, 1948, 20 x 15½ in, cat. 7

12. *Baptism*, 1948, 39¼ x 19⅛ in, cat. 8

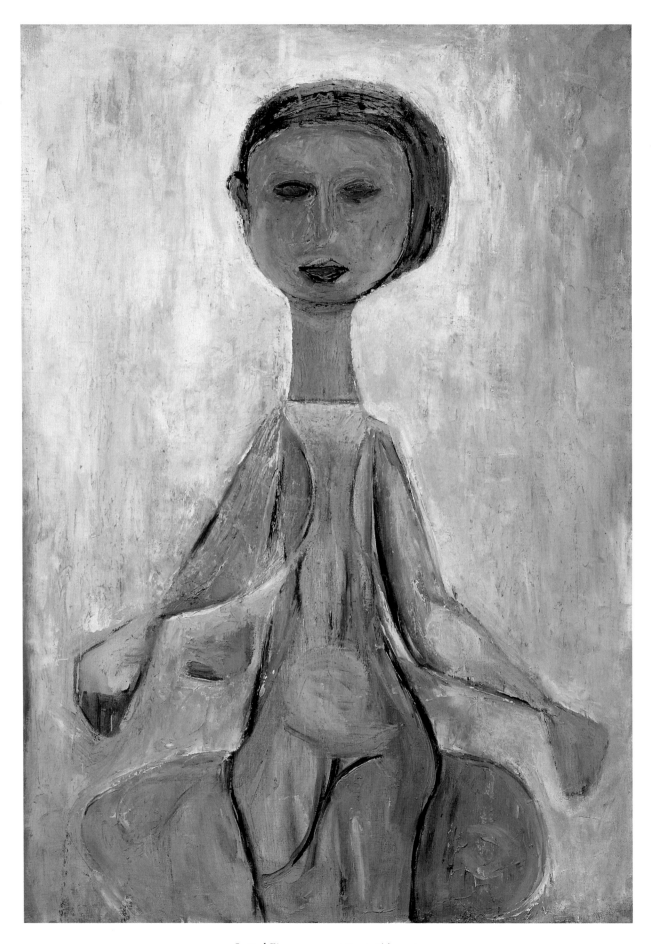

13. *Seated Figure*, 1949, 36 x 25½ in, cat. 14

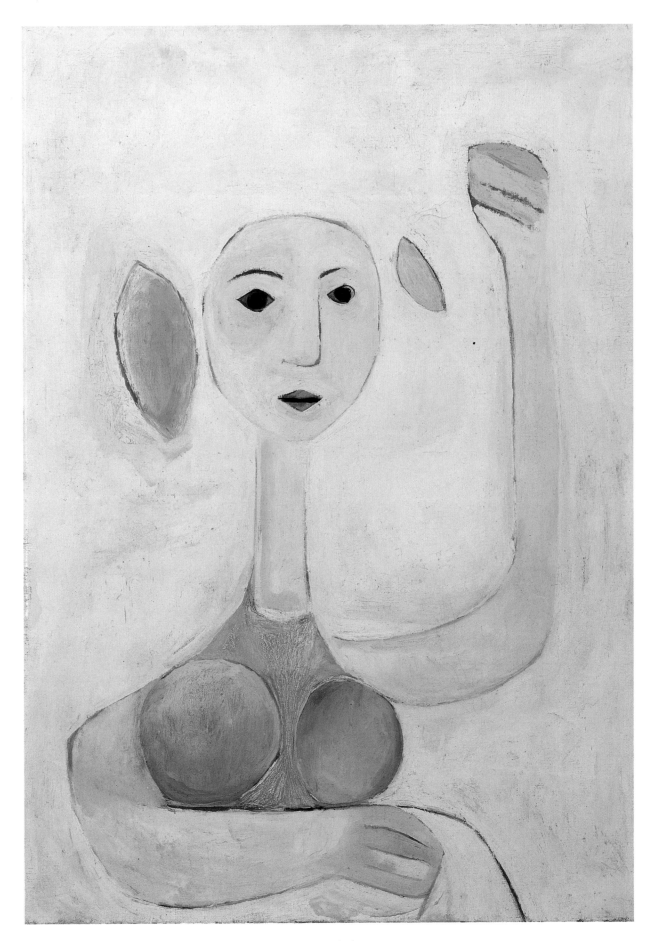

14. *Woman with Arm Raised*, 1949, 36 x 24 in, cat. 13

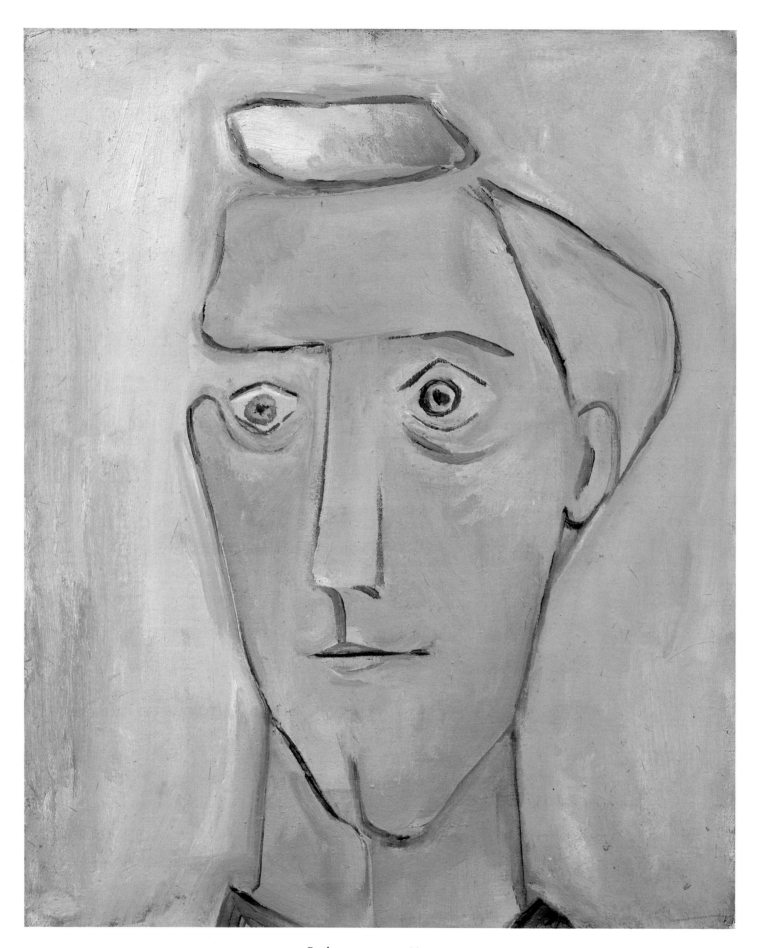

15. *Paul*, 1950, 24 x 19¼ in, cat. 43

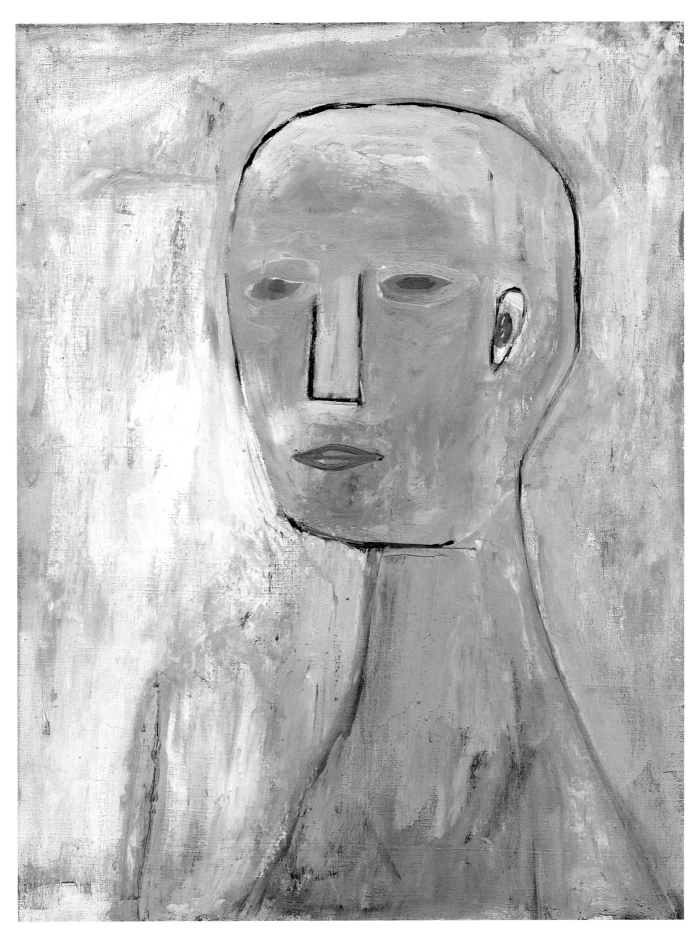

16. *Tavant*, 1949, 25⅛ x 19¾ in, cat. 22

17. *Plant I*, 1949, 14 x 11 in, Rijksmuseum Kröller-Müller, Otterlo, The Netherlands (formerly collection Geert-Jan Visser), cat. 16

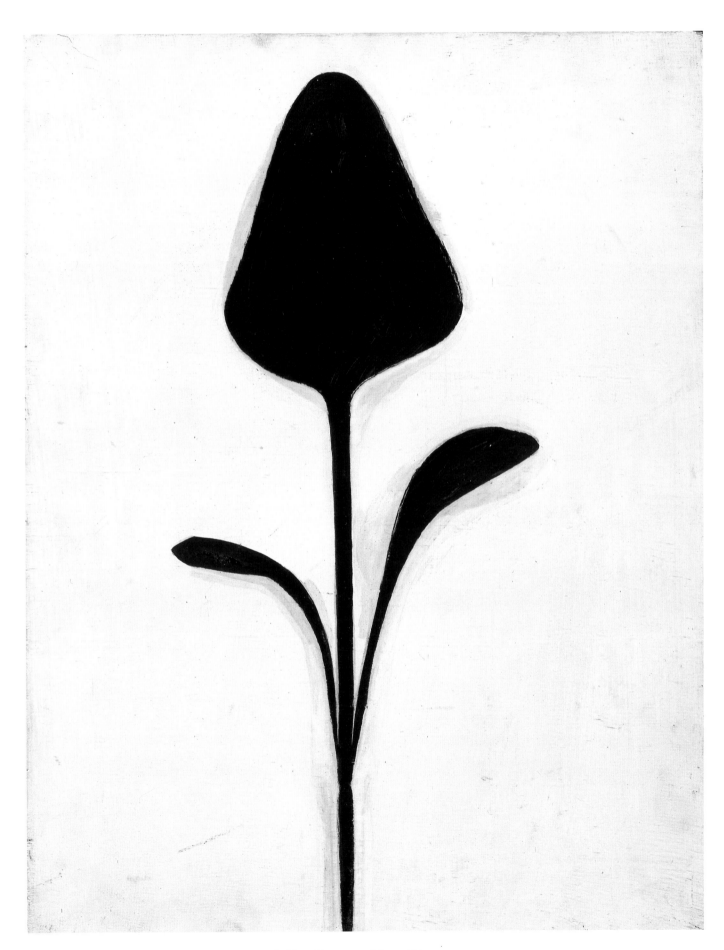

18. *Plant II*, 1949, 16½ x 12⅞ in, cat. 20

19. *Roofs*, 1949, 21¼ x 28¼ in, cat. 15

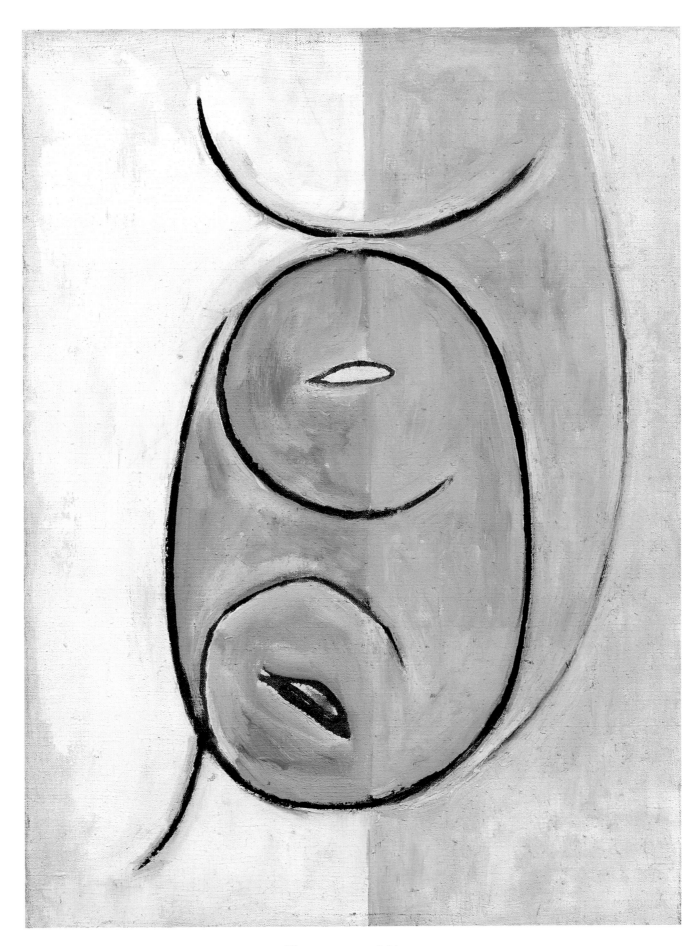

20. *Ubu*, 1949, 24 x 18¼ in, cat. 19

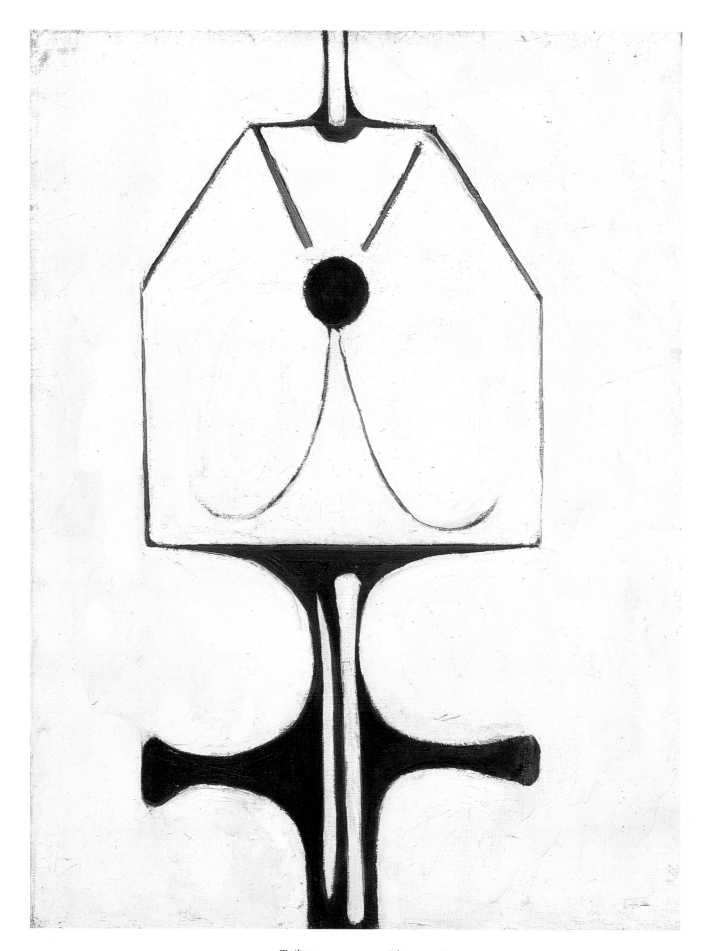

21. *Toilette*, 1949, 24 x 18 in, cat. 18

22. *Kilometer Marker*, 1949, 21½ x 18 in, cat. 27

23. *Yellow Face*, 1949, 28¼ x 21¼ in, cat. 26

24. *Face of Stones*, 1949, 18 x 14¼ in, cat. 25

25. *Monstrance*, 1949, 24 x 19¾ in, cat. 23

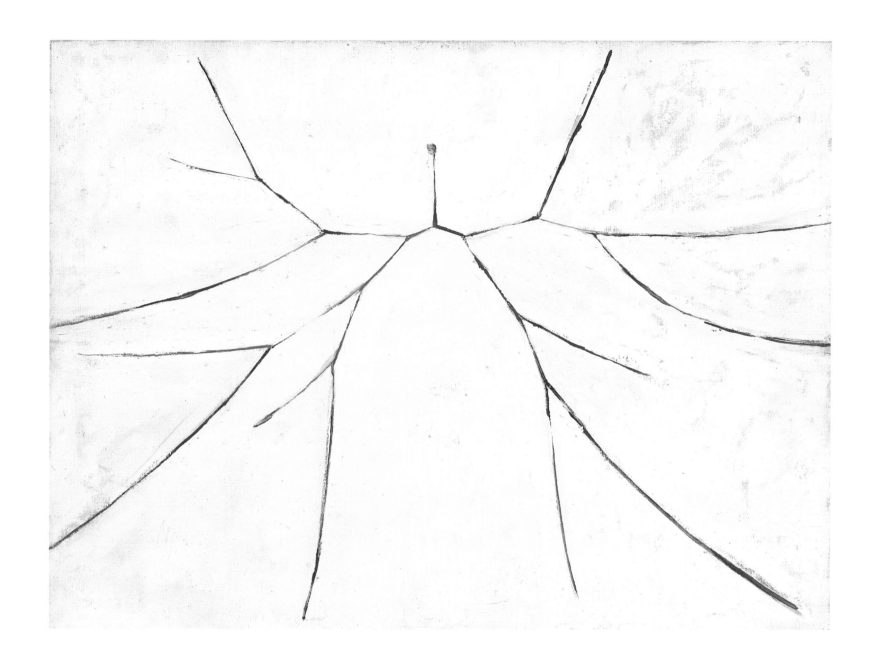

26. *Seaweed*, 1949, 28½ x 39½ in, cat. 29

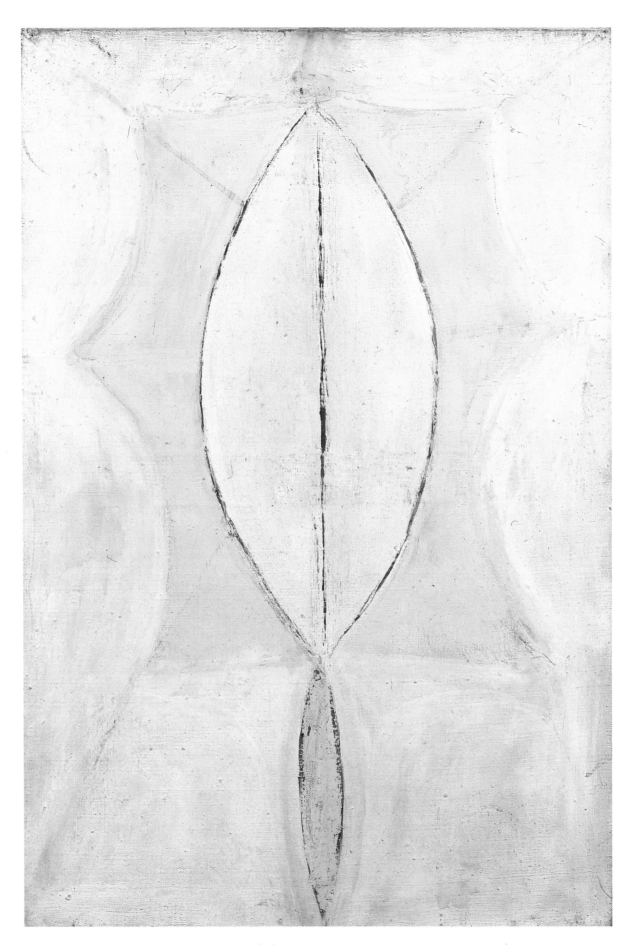

27. *Mandorla*, 1949, 28¼ x 19¼ in, cat. 28

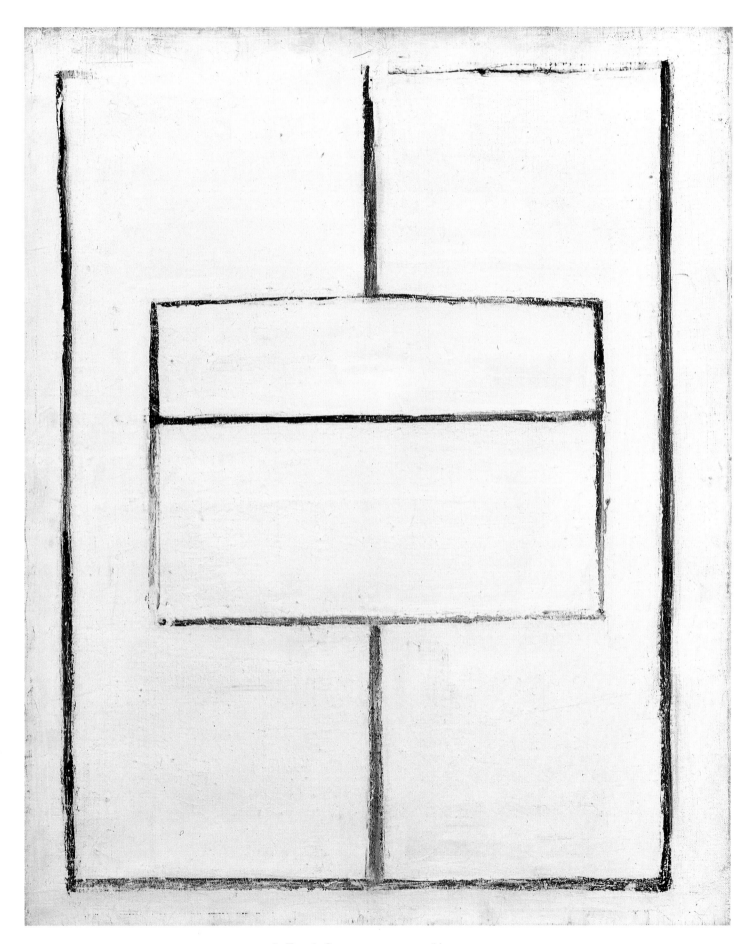

28. *Tennis Court*, 1949, 24 x 19¼ in, cat. 30

29. *Window II*, 1949, 24 x 19¼ in, cat. 31

30. *Window I*, 1949, 25½ x 21 in, cat. 24

31. *Window III*, 1949, 32 x 39½ x 1 in, cat. 32

32. *Wood Cutout with String III*, 1949, 41 x 7½ x ½ in, cat. 35

33. *Wood Cutout with String I*, 1949, 28 x 7⅛ x ¼ in, cat. 33

34. *Wood Cutout with String II*, 1949, 28 x 7⅛ x ¼ in, cat. 34

35. *Window V*, 1950, 27½ x 7¼ x ½ in, cat. 40

36. *Window, Museum of Modern Art, Paris,* 1949,
50½ x 19½ x ¼ in, cat. 36

37. *Deesis I*, 1950, 33 x 13⅛ in, cat. 37

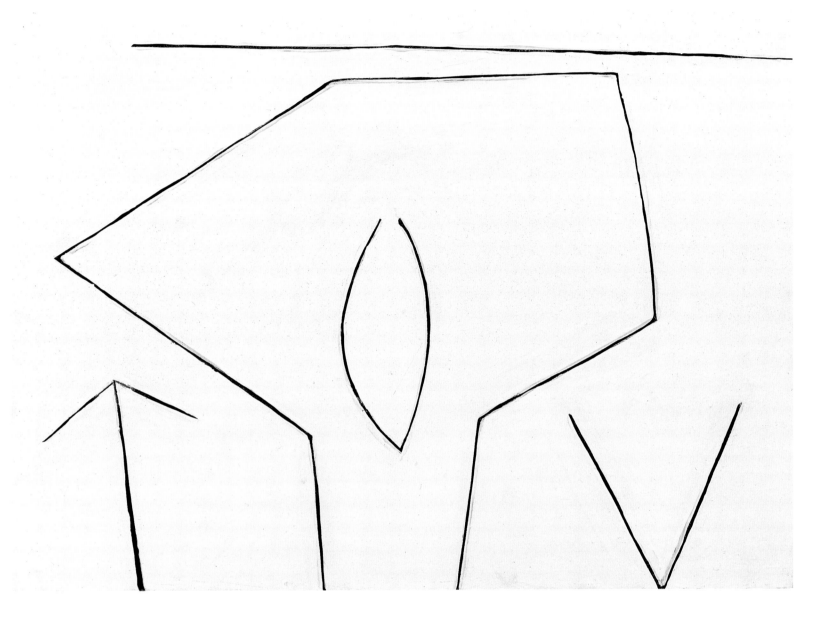

38. *Deesis II*, 1950, 19½ x 27¼ in, cat. 38

39. *Romantic Landscape*, 1950, 19⅛ x 39⅛ in, cat. 46

40. *Medieval Landscape*, 1950, 25½ x 36 in, cat. 47

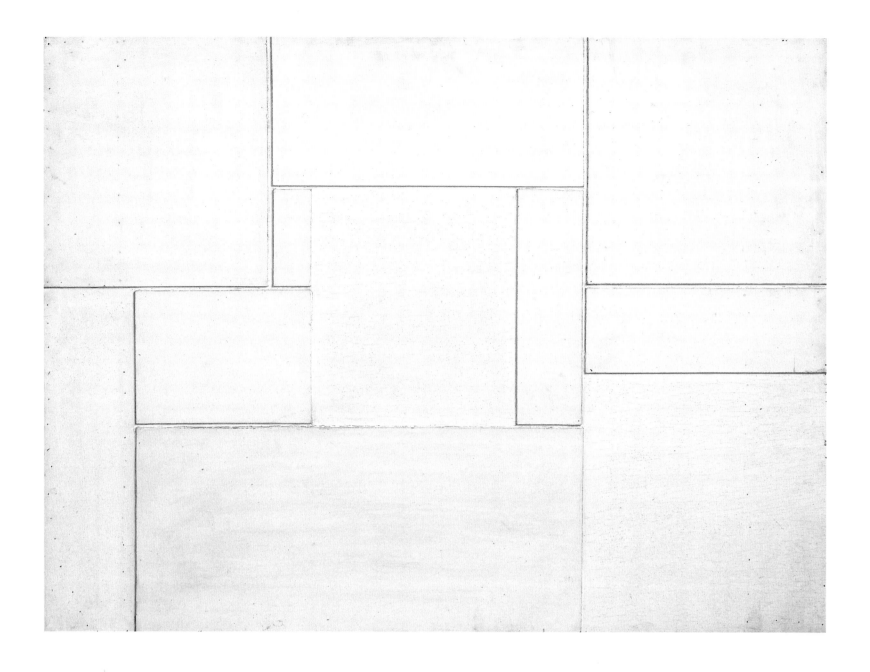

41. *Neuilly*, 1950, 23 x 31⅛ x 1½ in, cat. 41

42. *Gate-Board*, 1950, 26¼ x 35¼ x ⅛ in, cat. 39

43. *Saint-Louis I*, 1950, 12 x 27 x 1 in, Collection of Anne Weber, cat. 44

44. *Saint-Louis II*, 1950, 22 x 39¼ x 1 in, cat. 45

45. *Célestins Relief*, 1950, 39¼ x 14 x ⅞ in, cat. 49

46. *Cutout in Wood*, 1950, 15 x 6¼ x ⅞ in, cat. 42

47. *Relief with Blue*, 1950, 44⅞ x 17½ x 1¼ in, cat. 50

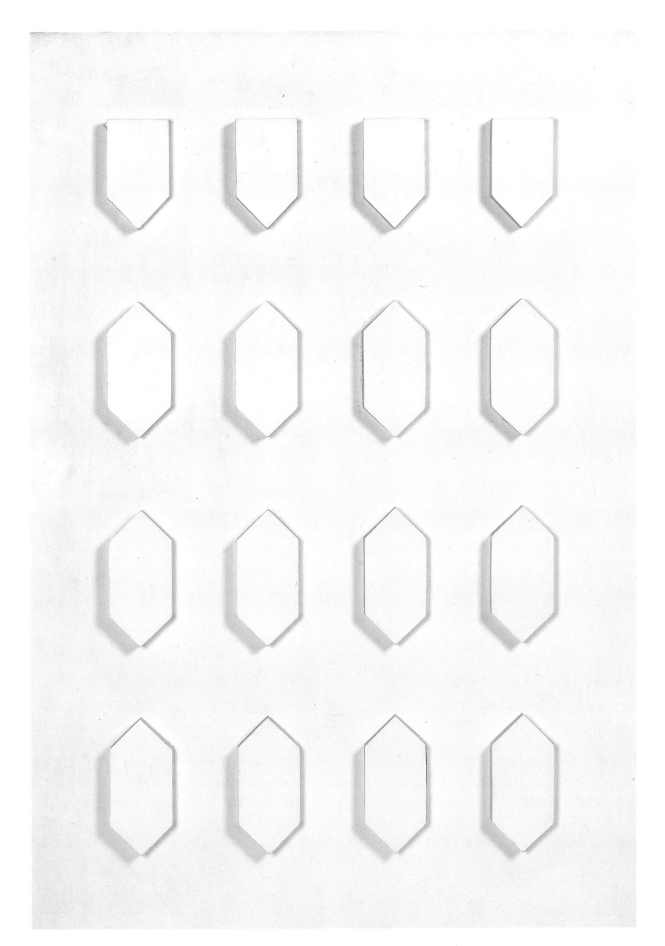

48. *White Relief*, 1950, 39⅛ x 27⅞ x 1¼ in, cat. 48

49. *Study for Antibes*, 1950, 13 x 19⅛ in, cat. 52

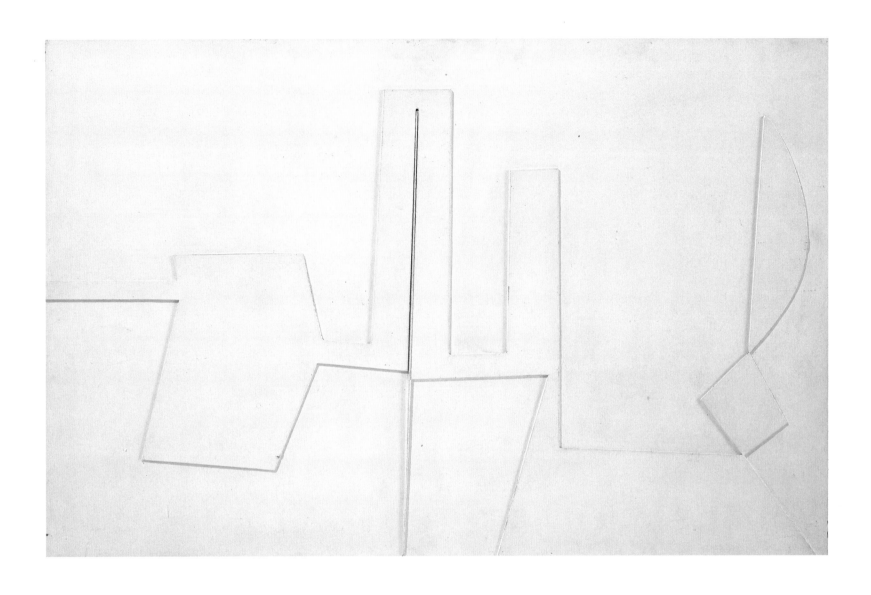

50. *Antibes*, 1950, 25½ x 39⅛ x ½ in, Private collection, Switzerland, cat. 51

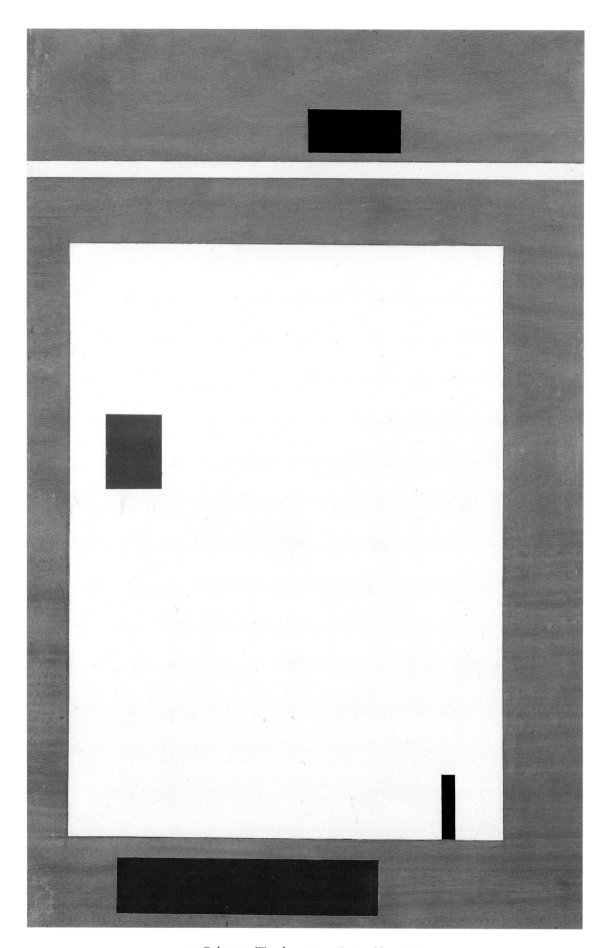

51. *Colors on Wood,* 1950, 39¼ x 25½ in, cat. 63

52. *Window VI*, 1950, 26 x 62⅞ in, cat. 53

53. *Fond Rouge*, 1950, 13¼ x 39¼ in, cat. 56

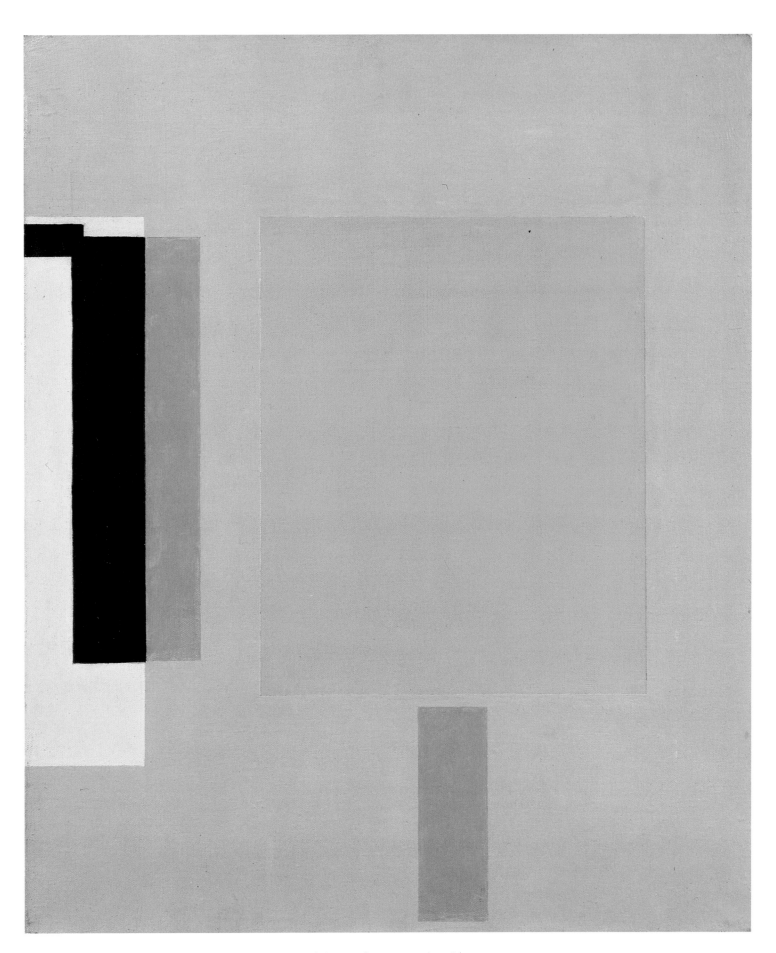

54. *Pink Rectangle*, 1950, 21¼ x 18 in, cat. 54

55. *Fond Jaune*, 1950, 44¼ x 57½ in, cat. 57

56. *Fond Noir*, 1950, 57⅛ x 44¼ in, cat. 62

57. *Rouleau Bleu*, 1951, 17½ x 117 in, Collection of Henry Persche, Ghent, New York, cat. 67

58. *Ormesson*, 1950, 33 x 88¼ in, cat. 60

59. *Red Yellow and Blue*, 1951, 45 x 60 in, Private collection, Caracas, cat. 65

60. *Royan*, 1950, 24 x 108 in, cat. 61

61. *November Painting*, 1950, 25½ x 34 in, cat. 59

62. *Moby Dick*, 1951, 13 x 16⅛ in, Collection of Louis Clayeux, Paris, cat. 73

63. *La Combe III*, 1951, 63½ x 44½ in, cat. 66

64. *La Combe II*, 1950–1951, 39 x 46½ x ¼ in, cat. 64

65. *La Combe IV—Collaboration with a Twelve-Year-Old Girl*, 1951, 39¼ x 60¼ in, cat. 68

66. *La Combe I*, 1950, 38 x 63½ in, cat. 58

67. *Meschers*, 1951, 59 x 59 in, cat. 71

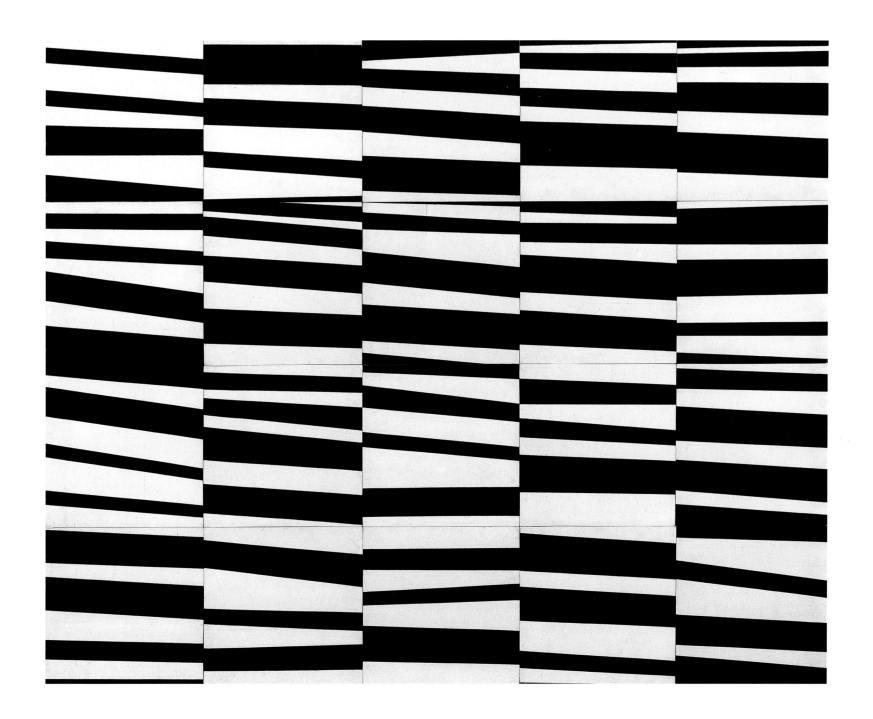

68. *Cité*, 1951, 56¼ x 70½ in, cat. 69

69. *Talmont*, 1951, 26 x 64¼ in, cat. 72

70. *Gironde*, 1951, 45½ x 45½ in, cat. 70

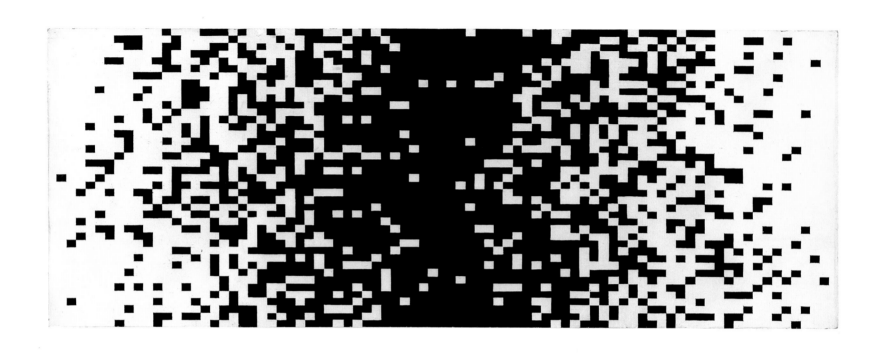

71. *Seine*, 1951, 16½ x 45¼ in, cat. 74

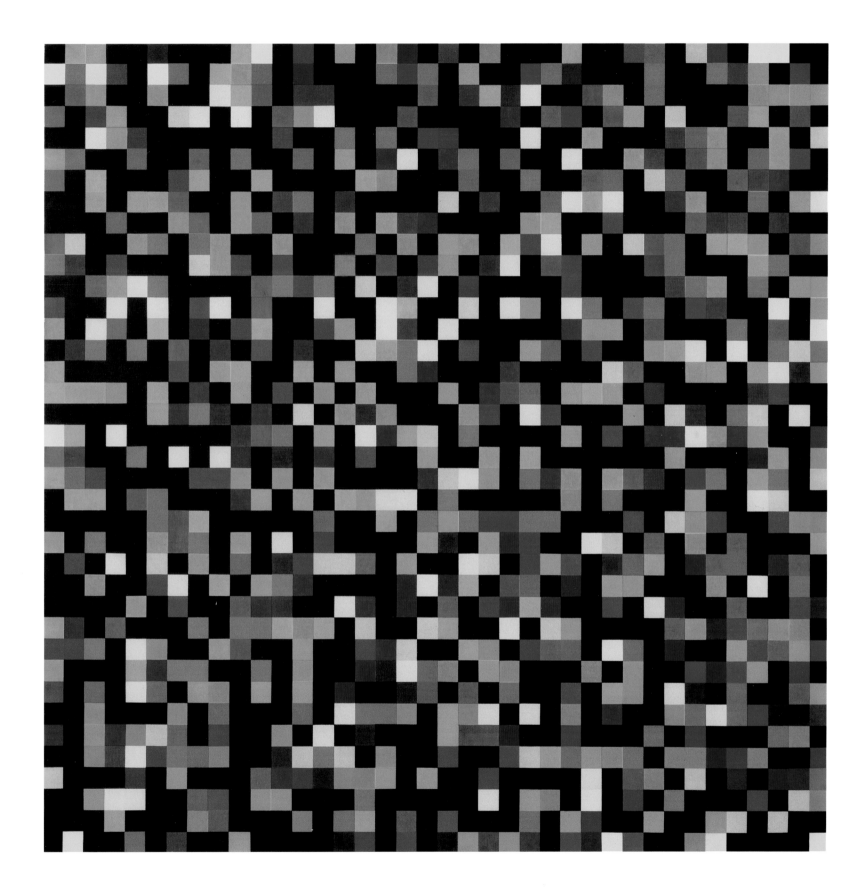

72. *Spectrum Colors Arranged by Chance*, 1951–1953, 60 x 60 in, cat. 92

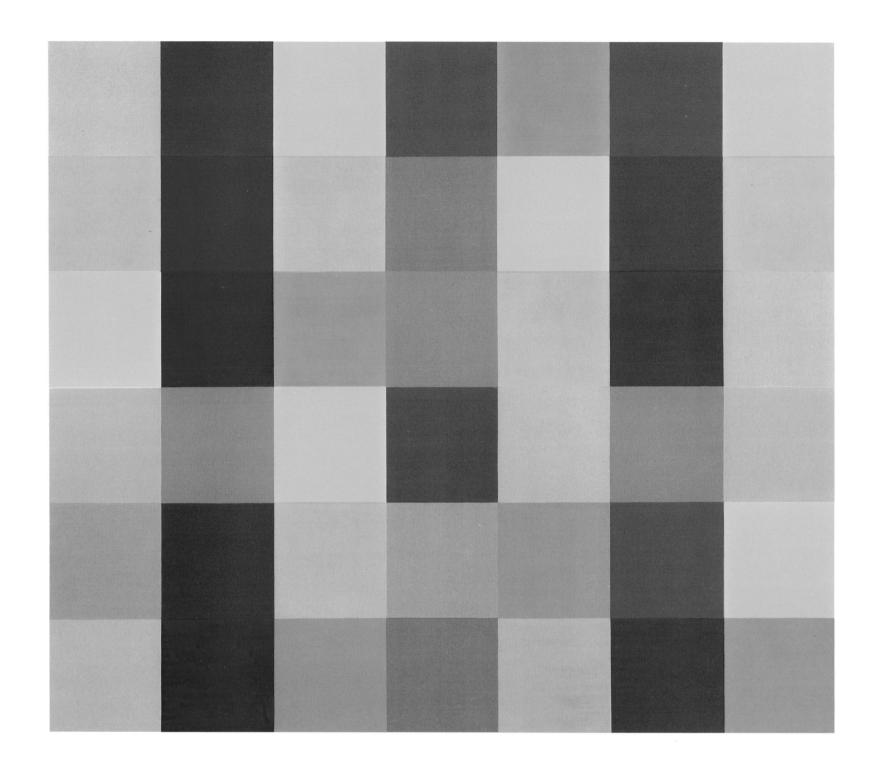

73. *Sanary*, 1952, 51½ x 60 in, cat. 77

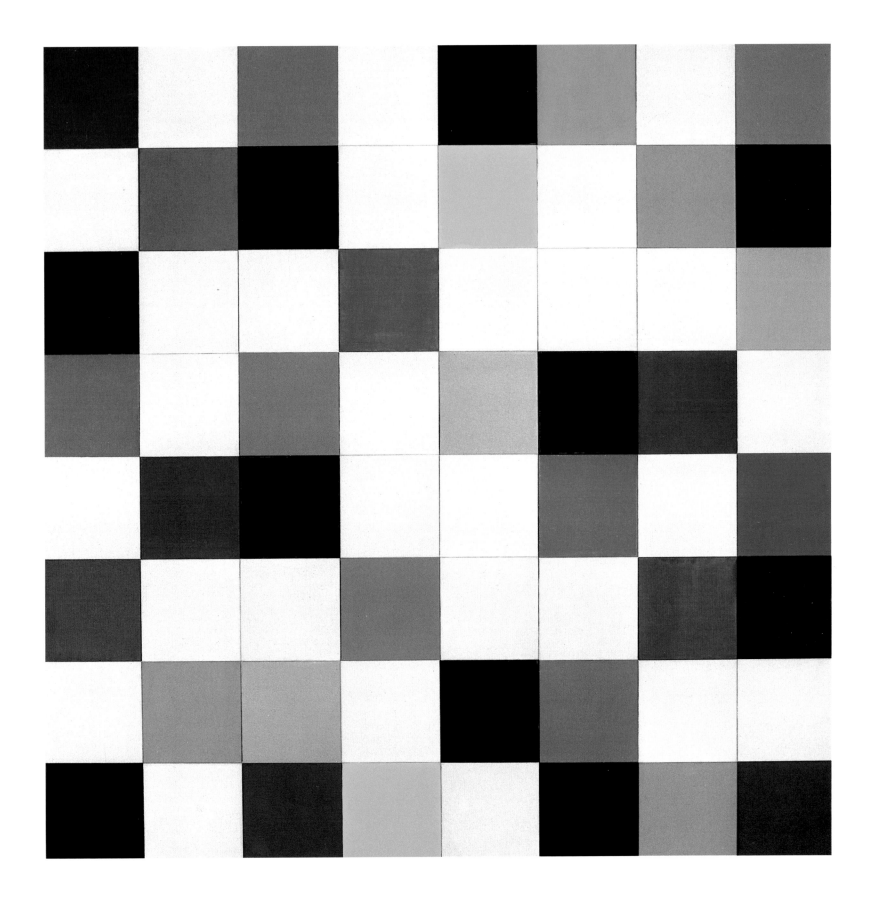

74. *Colors for a Large Wall*, 1951, 94¼ x 94½ in,
The Museum of Modern Art, New York, Gift of the artist, cat. 75

75. *Méditerranée*, 1952, 59 x 76¼ in, cat. 76

76. *Two Yellows*, 1952, 59 x 59 in, cat. 81

77. *Red Yellow Blue White*, 1952, 60 x 148 in, overall,
25 panels (each 12 x 12 in) arranged in 5 columns
(each 60 x 12 in) with 22-in spaces between columns,
cat. 79

78. *Dominican*, 1952, 38¼ x 25⅝ in, cat. 84

79. *Fête à Torcy*, 1952, 45½ x 38 in, cat. 78

80. *Train Landscape*, 1952–1953, 43½ x 43½ in, cat. 90

81. *Painting for a White Wall*, 1952, 23½ x 71¼ in, cat. 83

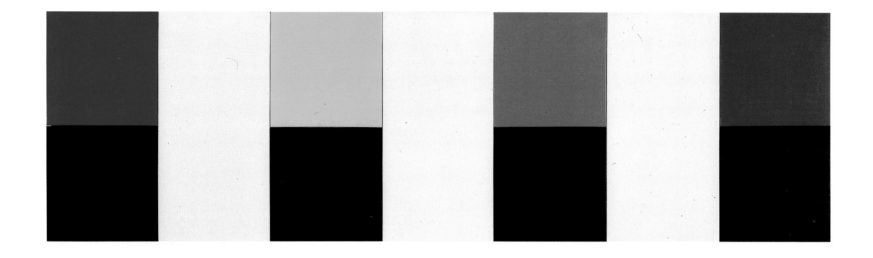

82. *Kite II*, 1952, 31½ x 110¼ in,
Musée National d'Art Moderne, Centre Georges Pompidou, Paris, cat. 82

83. *Kite I*, 1952, 39¼ x 91½ in, cat. 80

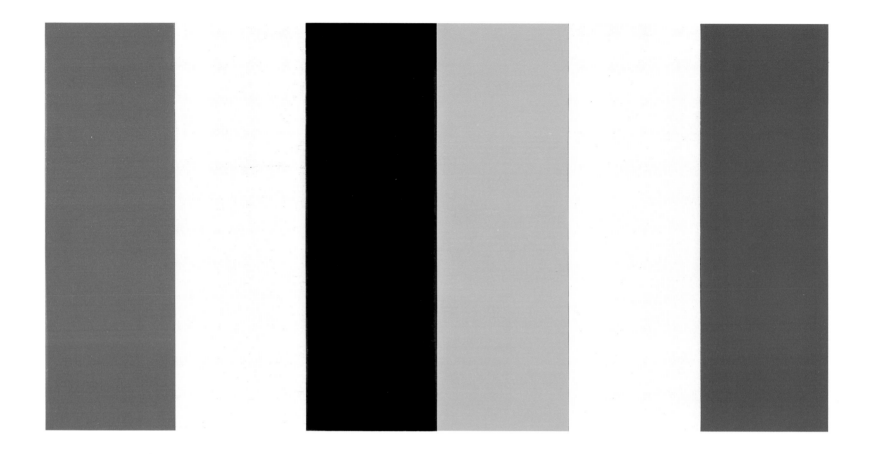

84. *Red Yellow Blue White and Black*, 1953, 19¼ x 38⅞ in, cat. 85

85. *Tiger*, 1953, 80¼ x 85½ in, cat. 89

86. *Red Yellow Blue White and Black with White Border*, 1953, 41¼ x 155 in, cat. 86

87. *Red Yellow Blue White and Black*, 1953, 39 x 138 in, cat. 87

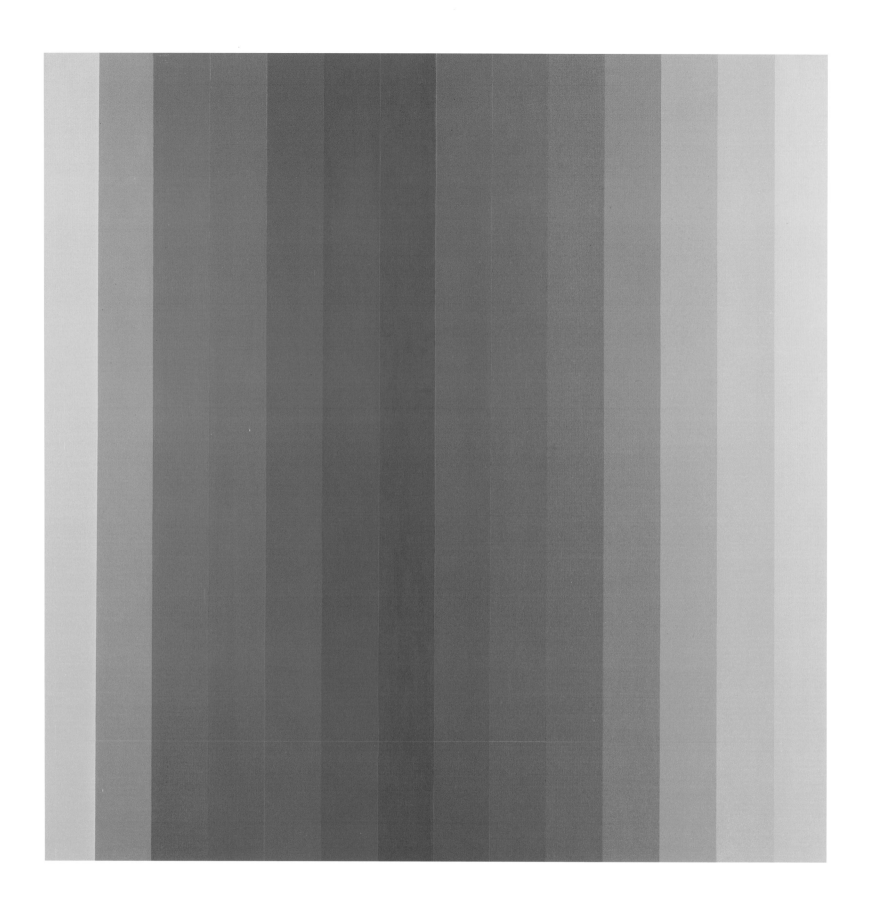

88. *Spectrum I*, 1953, 60 x 60 in, cat. 88

89. *Tableau Vert*, 1952, 29¼ x 39¼ in, cat. 91

90. *Black Square*, 1953, 43¼ x 43¼ in, cat. 94

91. *White Square*, 1953, 43¼ x 43¼ in, cat. 93

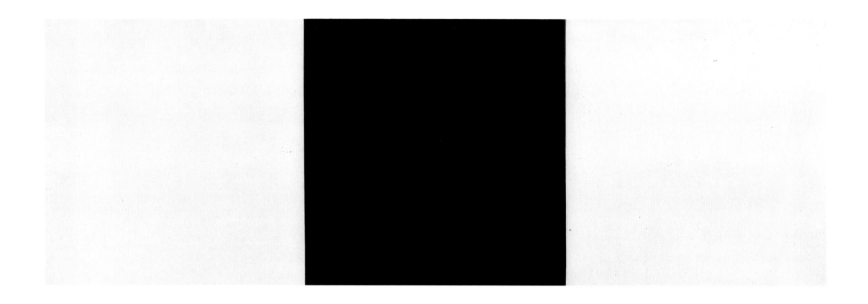

92. *Black, Two Whites*, 1953, 23½ x 70¼ in, cat. 97

93. *White, Two Blacks*, 1953, 23½ x 70¼ in, cat. 96

94. *Yellow Relief*, 1954–1955, 24 x 24 in, cat. 100

95. *White Plaque: Bridge Arch and Reflection*, 1951–1955, 64 x 48 x ½ in,
Private collection, cat. 99

Paintings and Reliefs, France, 1948–1954

II. Documentation

Note to the Reader

This catalogue includes all verified information available through September 1991 on the paintings and reliefs that Ellsworth Kelly made during his time in France, from 1948 to 1954. It includes works executed in Europe as well as works that were in progress during his time in France but completed after his return to the United States in July 1954.

TITLE

All titles are those recognized by the artist. If a different title has appeared in the past, it is noted in parentheses. Citations for the literature and exhibition history indicate variations in the title of a work.

DATE

The works are arranged chronologically. Dates in previous publications may differ from the ones provided here; any variations have been noted.

MEDIUM

With two exceptions, all paintings were executed in oil on wood or canvas. Wood was also the primary material used in the reliefs, with the occasional addition of string.

DIMENSIONS

Height precedes width, which, in the case of the reliefs, precedes depth. Dimensions are given in inches, followed by centimeters in parentheses. Whenever possible, new measurements were taken for this catalogue. In cases where the painting is on an unstretched canvas, the dimensions of both the canvas and the image have been recorded. When the dimensions indicated in the literature differ significantly from those in the catalogue, this is duly noted.

INSCRIPTIONS

All inscriptions recorded here appear on the verso. Labels and marks made by persons other than the artist have been omitted from the catalogue entries.

EK NUMBER

Almost from the beginning of his career Ellsworth Kelly assigned consecutive inventory numbers to his works. Kelly's student works from New Jersey and Boston are included in the "X" and "B" series of numbers (see Appendix), while the "A" series includes work from Belle-Ile as well as Paris.

CREDIT LINE

Unless otherwise indicated, all works are in the collection of the artist.

LITERATURE

References are listed chronologically. When more than one publication appeared in a single year, references are listed alphabetically within that year. Full citations appear in the Bibliography at the back of this catalogue.

EXHIBITION HISTORY

References are listed chronologically and, within a single year, alphabetically. Full citations may be found in the Bibliography. Venues that substantially changed either the exhibition or the catalogue have been listed as separate references.

PROVENANCE

Provenance is listed chronologically and is given only for those objects whose current owners obtained them from a source other than the artist himself.

Cat. 1 (pl. 2)
Byzantine Head I, 1948
oil on canvas
15 x 15 (38.1 x 38.1)
Inscriptions, verso: upper right, #A–1; upper stretcher bar, right,
A–1 1948
EK A.1

LITERATURE
New York 1973, 107, fig. 12 (as Head)

Cat. 2 (pl. 1)
Byzantine Head II, 1948
oil on canvas, unstretched
15¼ x 11½ (40 x 29.2)
Inscriptions, verso: lower left, A2; lower right, EK 48
EK A.2

Cat. 3 (pl. 4)
Byzantine Head III, 1948
oil on canvas, unstretched
19½ x 12¼ (49.5 x 31.1)
Inscriptions, verso: lower left, A3 1948
EK A.3

Cat. 4 (pl. 3)
Mother and Child, 1948
oil on canvas
29 x 17 (73.7 x 43.2)
Inscriptions, verso: upper stretcher bar, left, A4; middle stretcher bar,
PARIS EK 1948; lower stretcher bar (upside down), MOTHER & CHILD
EK A.4

Cat. 5 (pl. 5)
Nude, 1948
oil on canvas
39⅜ x 19½ (100 x 49.5)
Inscriptions, verso: middle stretcher bar, A5 EK 1948
EK A.5

Cat. 6 (pl. 9)
Chuan-Shu, 1948
oil on canvas
35½ x 28 (90.2 x 71.1)
Inscriptions, verso: upper stretcher bar, right, A8
EK A.8

Cat. 7 (pl. 11)
Lazarus, 1948
oil on canvas
20 x 15½ (50.8 x 39.4)
Inscriptions, verso: upper stretcher bar, A9 31 RUE ST LOUIS-EN-L'ILE /
PARIS IVᵉ; middle stretcher bar, 20 x 15½ EK 48
EK A.9

Cat. 8 (pl. 12)
Baptism, 1948
oil on canvas
39¼ x 19⅝ (99.7 x 49.9)
Inscriptions, verso: middle stretcher bar, 8–10 PARIS EK 1948
EK A.10

Cat. 9 (pl. 10)
Faceless Head, 1948
oil on canvas
21 x 15 (53.3 x 38.1)
Inscriptions, verso: lower left, A–11 1948
EK A.11

Cat. 10 (pl. 6)
Egyptian Woman, 1948
oil on canvas
24 x 19½ (61 x 49.5)
Inscriptions, verso: upper right, EK; middle stretcher bar, NUDE KELLY 1948
EK A.12

LITERATURE
Nordness 1962, 394 (repr., as *L'Egyptienne*)
Coplans 1971, 18, pl. 39

Cat. 11 (pl. 7)
Figure with Yellow and Blue, 1948
oil on canvas
24 x 17 (61 x 43.2)
Inscriptions, verso: upper right, EK; middle stretcher bar, WOMAN IN
YELLOW 1948—A–13
EK A.13

LITERATURE
Coplans 1971, 18, pl. 41
New York 1973, 113, fig. 48 (as *Figure in Yellow and Blue*)

Cat. 12 (pl. 8)
Poitiers, 1949
oil on canvas
23⅞ x 18⅛ (60.6 x 46)
Inscriptions, verso: middle stretcher bar, A–14 EK 1949
EK A.14

LITERATURE
Coplans 1971, 20 (as *Woman of Poitiers*)

Cat. 13 (pl. 14)
Woman with Arm Raised, 1949
oil on canvas
36 x 24 (91.4 x 61)
Inscriptions, verso: upper stretcher bar, right, 31 RUE ST LOUIS-EN-L'ILE / PARIS IVᵉ
EK A.15

LITERATURE
New York 1973, 104, 106; fig. 10 (as *Female Figure*)
Amsterdam 1979, fig. 3 (as *Female Figure*)
Baden-Baden 1980, fig. 3 (as *Female Figure*)
Paris 1980, fig. 3 (as *Figure de Femme*)

Cat. 14 (pl. 13)
Seated Figure, 1949
oil on canvas
36 x 25½ (91.4 x 64.8)
Inscriptions, verso: upper right, KELLY; upper stretcher bar, A26 [crossed out] A16 31 RUE ST LOUIS-EN-L'ILE / PARIS IVᵉ; middle stretcher bar, A26 [crossed out] A16 1949
EK A.16

Cat. 15 (pl. 19)
Roofs, 1949
oil on canvas
21¼ x 28¾ (54 x 73)
Inscriptions, verso: upper stretcher bar, A–17 EK17; middle stretcher bar, A–17 1949
EK A.17

LITERATURE
Fort Worth 1987, 10

Cat. 16 (pl. 17)
Plant I, 1949
oil on canvas
14 x 11 (35.6 x 27.9)
EK A.18
Rijksmuseum Kröller-Müller, Otterlo, The Netherlands (formerly collection Geert-Jan Visser)

LITERATURE
Eindhoven 1968, 23, 26 (repr., as *Black Flower*)
Coplans 1969, 54 (repr.), 55
Coplans 1971, 21, 24–25, 54, 56, 60, pl. 5
Baden-Baden 1980, 92 (repr.)
Schmidt 1980, 11
Fort Worth 1987, 10
Rudenstine 1988, 721
Hindry 1990, 90 (repr.), 94

EXHIBITIONS
Eindhoven 1968, no. 26

PROVENANCE
Mr. Geert-Jan Visser, Antwerp

Head of a Woman, 1949 (cat. 17)

Cat. 17
Head of a Woman, 1949
oil on canvas
13¾ x 10¾ (34.9 x 27.3)
EK A.19
Private collection, Gloucester, Massachusetts

Cat. 18 (pl. 21)
Toilette, 1949
oil on canvas
24 x 18 (61 x 45.7)
Inscriptions, verso: upper right, EK 1949; middle stretcher bar, A–20 KELLY
EK A.20

LITERATURE
Coplans 1971, 20–21, pl. 47
Baker 1973, 32
New York 1973, 23
Amsterdam 1979, 9, 11, fig. 13
Baden-Baden 1980, 16, fig. 13
Paris 1980, 15, fig. 13
Fort Worth 1987, 193
Storr 1988, 19

Cat. 19 (pl. 20)
Ubu, 1949
oil on canvas
24 x 18¼ (61 x 46.4)
Inscriptions, verso: upper right, EK 49; upper stretcher bar,
center, A–21; middle stretcher bar, UBU
EK A.21

LITERATURE
Coplans 1971, pl. 46

Cat. 20 (pl. 18)
Plant II, 1949
oil on wood
16½ x 12⅞ (41.9 x 33)
Inscriptions, verso: upper center, EK '49; lower center, A–22
EK A.22

LITERATURE
Coplans 1969, 55 (repr.)
Coplans 1971, 21, 24, pl. 6 (as 30 x 24 in)
Baden-Baden 1980, 93 (repr.)
Paris 1980, 31 (repr.)
Schmidt 1980, 11
Fort Worth 1987, 8 (repr.)

Cat. 21
Nude, 1949
oil on canvas, unstretched
42¼ x 21⅛ (107.3 x 53.7)
EK A.23

Cat. 22 (pl. 16)
Tavant, 1949
oil on canvas
25⅛ x 19¾ (65.1 x 50.2)
Inscriptions, verso: upper right, EK 49; upper left, 15P;
middle stretcher bar, A–24 GRAY HEAD (TAVANT)
EK A.24

LITERATURE
Coplans 1971, 18, 20, pl. 44
New York 1973, 113, fig. 49 (as *Tavant Head*)
New York 1982b, 39, 85, fig. 48
Duffy 1983b, H 5

Cat. 23 (pl. 25)
Monstrance, 1949
oil on wood
24 x 19¾ (61 x 50.2)
Inscriptions, verso: upper left, KELLY / A–25 /
SUN 1949 — BELLE-ISLE
EK A.25

Nude, 1949 (cat. 21)

Cat. 24 (pl. 30)
Window I, 1949
oil on wood
25½ x 21 (64.8 x 53.3)
EK A.26

LITERATURE
Coplans 1971, pl. 53
New York 1973, 22 (repr.), 23, 106, 107
Blisténe 1980, 20
Purchase 1986, 45 (repr. as 34¾ x 30¼ in)

EXHIBITIONS
Purchase 1986

Cat. 25 (pl. 24)
Face of Stones, 1949
oil on wood
18 x 14¾ (45.7 x 37.5)
Inscriptions, verso: upper left, A 27 / EK 49
EK A.27

LITERATURE
Hartford 1962, no. 54
Nordness 1962, 303
Coplans 1971, 21, pl. 45

EXHIBITIONS
Hartford 1962

Cat. 26 (pl. 23)
Yellow Face, 1949
oil on canvas
28¾ x 21¼ (73 x 54)
Inscriptions, verso: middle stretcher bar, A–28 KELLY 49
EK A.28

Cat. 27 (pl. 22)
Kilometer Marker, 1949
oil on wood
21½ x 18 (54.6 x 45.7)
Inscriptions, verso: upper left, A–29;
upper right, EK 49
EK A.29

LITERATURE
Nordness 1962, 393
Coplans 1971, 21, 26, 30, 60, 77, pl. 49 (as *Milestone*)
Baker 1973, 32 (as *Milestone*)
Masheck 1973, 55
New York 1973, 21 (repr.), 73, 107
Peters 1979, 29
Paris 1980, 30 (repr.)
New York 1982b, 103, fig. 65
Fort Worth 1987, 21 (repr.)
Russell 1987, 200

EXHIBITIONS
New York 1973

Cat. 28 (pl. 27)
Mandorla, 1949
oil on canvas
28¾ x 19¾ (73 x 50.2)
Inscriptions, verso: upper right, EK 49; middle stretcher bar,
VARNO A–30 KELLY
EK A.30

LITERATURE
Coplans 1971, 20, pl. 51

Cat. 29 (pl. 26)
Seaweed, 1949
oil on canvas
28½ x 39½ (72.4 x 100.3)
Inscriptions, verso: upper stretcher bar, left, A–31; middle stretcher bar,
SEAWEED 1949 A–31 29" X 39" KELLY
EK A.31

LITERATURE
Coplans 1971, 21, pl. 50
Baden-Baden 1980, 90 (repr.)

Cat. 30 (pl. 28)
Tennis Court, 1949
oil on canvas
24 x 19¾ (61 x 50.2)
Inscriptions, verso: upper right, EK 49; middle stretcher bar, A32
EK A.32

LITERATURE
Coplans 1971, 21, pl. 48
Baker 1973, 32
Masheck 1973, 55
Baden-Baden 1980, 95 (repr.)
Schmidt 1980, 11

Cat. 31 (pl. 29)
Window II, 1949
oil on canvas
24 x 19¾ (61 x 50.2)
Inscriptions, verso: upper right, EK 49
EK I

LITERATURE
Coplans 1971, 21, pl. 52

EXHIBITIONS
Paris 1951a (as *Peinture en blanc et noir*)

Cat. 32 (pl. 31)
Window III, 1949
oil and string sewn on canvas
fabricated by the artist
32 x 39½ x I (81.3 x 100.3 x 2.5)
Inscriptions, verso: upper right, EK 1949; middle stretcher bar, #2
32" X 39½" KELLY
EK 2

LITERATURE
New York 1970, cat. 7
New York 1982b, cat. 1; 16, 39 (repr.), 40, 47
Russell 1987, 200

EXHIBITIONS
Paris 1951a (as *T. III*)
New York 1970

Cat. 33 (pl. 33)
Wood Cutout with String I, 1949
oil on wood with string
fabricated by the artist and a local carpenter
28 x 7⅜ x ¼ (71.1 x 18.7 x .7)
Inscriptions, verso: bottom, KELLY #3
EK 3

LITERATURE
Combat 1951, 4
New York 1973, 24 (repr.)
Paris 1980, 35 (repr.)
New York 1982b, cat. 2, 40, 41 (repr.), 47, 51
Russell 1987, 200

EXHIBITIONS
Paris 1950b (titled with EK4 as *Objets*)
Paris 1951a (titled with EK4 as *Paire d'objets avec ficelle noire*)

Cat. 34 (pl. 34)
Wood Cutout with String II, 1949
oil on wood with string
fabricated by the artist and a local carpenter
28 x 7⅛ x ¾ (71.1 x 18.7 x .7)
Inscriptions, verso: center, KELLY #4
EK 4

LITERATURE
Combat 1951, 4
New York 1973, 24 (repr.)
Paris 1980, 35 (repr.)
New York 1982b, cat. 3, 19 (repr.), 40, 41 (repr.), 47, 51
Russell 1987, 200
Buffalo 1989, 57 (repr.)

EXHIBITIONS
Paris 1950b (titled with EK3 as *Objets*)
Paris 1951a (titled with EK3 as *Paire d'objets avec ficelle noire*)

Cat. 35 (pl. 32)
Wood Cutout with String III, 1949
oil on wood with string
fabricated by the artist and a local carpenter
41 x 7½ x ½ (104.1 x 19.1 x 1.3)
Inscriptions, verso: top, ELLSWORTH KELLY / # 5 1949; lower right,
41 x 7½"
EK 5

LITERATURE
Coplans 1971, 33, pl. 55 (as *Figure with String*, 47 x 7½ in)
New York 1973, 24 (repr.)
Baden-Baden 1980, 105 (repr.)
Paris 1980, 35 (repr.), 37 (repr.)
New York 1982b, cat. 4, 19 (repr.), 40, 41 (repr.), 47, 51, 56, 87
Debs 1983, 123 (repr.)
Duffy 1983a, H 5 (repr.)
Raynor 1983, 57 (repr.)
Fort Worth 1987, 195 (repr.)
Russell 1987, 200
Buffalo 1989, 57

EXHIBITIONS
Paris 1950a (as *Construction*)
Paris 1951a (as *Objet avec ficelle noire*)
New York 1982b

Cat. 36 (pl. 36)
Window, Museum of Modern Art, Paris, 1949
oil on wood and canvas
two joined panels
fabricated by the artist
50½ x 19½ x ¾ (128.5 x 49.5 x 2) overall
Inscriptions, verso: upper left, # 6; upper right, KELLY 1949; upper
stretcher bar, 6 50½ x 19¼"; middle stretcher bar, ELLSWORTH KELLY /
30 RUE ST LOUIS-EN-L'ILE / PARIS IVᶜ #6
EK 6

LITERATURE
Battcock 1968, 44 (repr., upside down), 47
New York 1968, cat. 16, 13 [repr., as *Window (Museum of Modern Art, Paris)*]
Drweski 1969, 50 (repr.)
Los Angeles 1970, 16
Coplans 1971, 26, 28, pl. 8, 292 (repr.)
Elderfield 1971, 47 [as *Window (Museum of Modern Art, Paris)*]
Waldman 1971a, 16, 21
Waldman 1971b, 54
Baker 1973, 31–32
Goossen 1973, 33, 35
Halasz 1973, 42
Hughes 1973, 72
Masheck 1973, 55
New York 1973, 17 (repr.), 23 (repr.), 30, 45, 61, 108, fig. 41
Rose 1973, 209
Rosenberg 1973, 117
Tuchman 1974, 55–56, 60
Paris 1977, 558 (repr.)
Amsterdam 1979, 5, 7, 9, 11, 30, figs. 2, 5
Anderson 1980
Baden-Baden 1980, 3, 11, 16, 38, 89, figs. 2, 5
Graevenitz 1980a, 12
Graevenitz 1980b, 126
Halder 1980, 89
Michel 1980, 20 (repr.)
Paris 1980, 8, 15, 30 (repr.), fig. 5, back cover (repr.)
Shepherd 1980, cover (repr.)
Paris 1981, no. 349, 284 (repr.)
New York 1982b, cat. 5, 15 (repr.), 16–17, 33, 42 (repr.), 43
Russell 1982, C 24 (repr.)
Duffy 1983a, H 5 (repr.)
Hernon 1983, E 3, as *Window*
Rubin 1983, F 5
Spies 1983, 25
Trenton 1983, 65–66
Wasserman 1985, C 8
New York 1986b, 40
Purchase 1986, 22; 44 (repr., as 60 x 30 x ¾ in)
Boston 1987
Fort Worth 1987, 5 (repr.), 9–10, 11 (repr.), 193
Kutner 1987, C 2
Russell 1987, 184, 200
Dorsey 1988, P 3
Rudenstine 1988, 719–720, 719 (repr.), 722, 725
Buffalo 1989, 55 (repr., as *Window, Musée d'Art Moderne, Paris*)
Donohue 1989, 17

EXHIBITIONS
Paris 1951a (as *Construction—relief en blanc, gris et noir*)
New York 1968
New York 1973
Paris 1981
New York 1982b
Purchase 1986

Cat. 37 (pl. 37)
Deesis I, 1950
oil on wood
33 x 13⅛ (83.8 x 34)
Inscriptions, verso: upper left, 7; upper right, EK 1950
EK 7

Cat. 38 (pl. 38)
Deesis II, 1950
oil on wood
19½ x 27¼ (49.5 x 69.2)
Inscriptions, verso: upper left, 8; upper right, EK 1950
EK 8

Cat. 39 (pl. 42)
Gate-Board, 1950
oil on wood with string
fabricated by the artist
26¾ x 35¼ x ⅛ (68 x 89.5 x .4)
Inscriptions, verso: upper right, EK 1950; upper left, 9
EK 9

LITERATURE
New York 1970, cat. 8 (repr., as *Gate*)
Coplans 1971, 30–32, pl. 54
New York 1973, 24 (repr.)
New York 1982b, cat. 6, 44 (repr.)

EXHIBITIONS
Paris 1951a (as *Planche avec ficelle noire: Sanary 1*)
New York 1970

Cat. 40 (pl. 35)
Window V, 1950
oil on wood
fabricated by the artist
27½ x 7¼ x ½ (69.9 x 18.4 x 1.3)
Inscriptions, verso: upper left, 10; upper right, EK '50
EK 10

LITERATURE
Coplans 1971, 32–33, pl. 60
New York 1973, 50
New York 1982a, 12 (repr.)
New York 1982b, cat. 7, 16–17, 19 (repr.), 45 (repr.), 159
Purchase 1986, 45 (repr., as 41 x 23¾ in)
Axsom 1987, 187
Fort Worth 1987, 195 (repr.)
Buffalo 1989, 57 (repr.)

EXHIBITIONS
Paris 1951a (as *Lignes noires et une ficelle blanche: Sanary II*)
New York 1973
New York 1982a
New York 1982b
Purchase 1986

Cat. 41 (pl. 41)
Neuilly, 1950
gesso on cardboard mounted on wood
fabricated by the artist
23 x 31⅛ x 1½ (58.4 x 79.7 x 3.8)
Inscriptions, verso: upper left, 11; upper right, EK 1950
EK 11

LITERATURE
Coplans 1971, 30–32
New York 1971, cat. 14 (as *Neuilly Relief*), not exhibited
New York 1982b, cat. 8, 46 (repr.)

EXHIBITIONS
Paris 1951a (as *Relief: Blanc sur blanc I*)

Cat. 42 (pl. 46)
Cutout in Wood, 1950
gesso on wood
fabricated by the artist
15 x 6¼ x ⅞ (38.1 x 15.9 x 2.3)
Inscriptions, verso: upper left, #12
EK 12

LITERATURE
Rubin 1963, 33 (repr.)
Coplans 1971, 292 (repr.)
New York 1973, 17, 24 (repr.)
Paris 1977, 558 (repr.)
Amsterdam 1979, 2, fig. 2
Baden-Baden 1980, 2, fig. 2
Paris 1980, fig. 2, 35 (repr.), back cover (repr.)
Shepherd 1980, cover (repr.)
New York 1982b, cat. 9, 19 (repr.), 47 (repr.)
Debs 1983, 123 (repr.)
Duffy 1983a, H 5
Axsom 1987, 37
Fort Worth 1987, 5 (repr.)
Buffalo 1989, 55 (repr.), 57 (repr.)

EXHIBITIONS
Paris 1951a (as *Objet en bois blanchi*)
New York 1982b

Cat. 43 (pl. 15)
Paul, 1950
oil on canvas
24 x 19¾ (61 x 50.2)
Inscriptions, verso: upper right, EK 1950; middle stretcher bar,
13 PAUL DESMARAIS
EK 13

Cat. 44 (pl. 43)
Saint-Louis I, 1950
oil and gesso on wood
fabricated by the artist
12 x 27 x 1 (30.5 x 68.6 x 2.5)
Inscriptions, verso: upper left, 14; upper right, EK '50
EK 14
Collection of Anne Weber

LITERATURE
New York 1982b, cat. 10, 48, 49 (repr.)
Fort Worth 1987, 12
Russell 1987, 200

EXHIBITIONS
Paris 1951a (as *Triptyque—relief: Lignes oranges*)

Cat. 45 (pl. 44)
Saint-Louis II, 1950
oil on cardboard mounted on wood
fabricated by the artist
22 x 39¼ x 1 (55.9 x 99.7 x 2.5)
Inscriptions, verso: top center, 22 x 39½ / ST. LOUIS; upper left, 15;
upper right, EK '50; lower right, KELLY
EK 15

LITERATURE
Coplans 1971, 30–31, pl. 57
Goossen 1973, 32–33
Masheck 1973, 55
New York 1973, 24, 25 (repr.), 30, 50, 61
Tuchman 1974, 55, 60
Baden-Baden 1980, 97 (repr.)
New York 1982b, cat. 11, 48, 49 (repr.)
Duffy 1983a, H 5
Trenton 1983, 66
New York 1986a, cat. 10, 20, 21 (repr.)
Fort Worth 1987, 12
Russell 1987, 200

EXHIBITIONS
New York 1973
New York 1982b
New York 1986a

Cat. 46 (pl. 39)
Romantic Landscape, 1950
oil on canvas
19⅝ x 39⅜ (49.9 x 100)
Inscriptions, verso: upper stretcher bar, 16 EK 1950
EK 16

Cat. 47 (pl. 40)
Medieval Landscape, 1950
oil on canvas
25½ x 36 (64.8 x 91.4)

Inscriptions, verso: upper right, EK 50; upper stretcher bar, KELLY
(in pencil) MEDIEVAL LANDSCAPE KELLY; middle stretcher bar,
MEDIEVAL (in pencil) 25½ x 36
EK 17

EXHIBITIONS
Paris 1951a (as *Paysage médiéval: Sanary III*)

Cat. 48 (pl. 48)
White Relief, 1950
oil on wood
fabricated by the artist and a local carpenter
39⅛ x 27⅝ x 1¼ (100 x 70.2 x 3.2)
Inscriptions, verso: upper left, #18; upper right, EK '50
EK 18

LITERATURE
Coplans 1971, 30–32, pl. 61
Hunter 1973, fig. 752 (as *White on White*)
New York 1973, 26 (repr.), 27, fig. 41
Amsterdam 1979, 11, fig. 14
Baden-Baden 1980, 16, fig. 14
Paris 1980, 15, fig. 14
Paris 1981, no. 350, 284 (repr., as *White Reliefs*)
New York 1982b, cat. 12, 51 (repr.)

EXHIBITIONS
Paris 1951a (as *Relief: Blanc sur blanc II. Pour John Cage*)
New York 1973
Paris 1981
New York 1982b
Washington 1988

Cat. 49 (pl. 45)
Célestins Relief, 1950
oil on wood with string
fabricated by the artist and a local carpenter
39¼ x 14 x ⅝ (99.7 x 35.6 x 1.6)
Inscriptions, verso: top, ELLSWORTH KELLY / 31 ST LOUIS-EN-L'ILE /
PARIS 4ᵉ; center, KELLY 1950
EK 19

LITERATURE
Coplans 1971, 292 (repr.)
New York 1973, 17 (repr.), fig. 41
Paris 1977, 558 (repr.)
Amsterdam 1979, 2, 5, fig. 1 (as *Wood Cut-out with Relief and String*)
Baden-Baden 1980, 9, figs. 1 (as *Wood Cut-out with Relief and String*), 2
Paris 1980, 7, figs. 1 (as *Bois découpé avec relief et ficelle*), 2, back
cover (repr.)
Shepherd 1980, cover (repr.)
New York 1982b, cat. 13 (as *String Relief*), 40, 47, 51 (repr.)
Fort Worth 1987, 5 (repr.)
Buffalo 1989, 55 (repr.)

EXHIBITIONS
Paris 1951c (as *Flamingo*)

Cat. 50 (pl. 47)
Relief with Blue, 1950
oil on wood
fabricated by the artist and a local carpenter
44⅞ x 17½ x 1¼ (114 x 44.5 x 3.2)
Inscriptions, verso: upper left, #20; upper right, KELLY 1950 /
EK / RELIEF WITH / BLUE 1950
EK 20

LITERATURE
New York 1969, cat. 174, 199 (repr., as *White Relief with Blue*)
Coplans 1971, 26, 30, 32, pl. 59
Goossen 1973, 34
Hughes 1973, 72, 73 (repr.)
New York 1973, 27 (repr.), 37, 54, 61, fig. 41
Amsterdam 1979, 11
Baden-Baden 1980, 16
Paris 1980, 15
New York 1982b, cat. 14, 17, 52 (repr.), 66, 71
Trenton 1983
Fort Worth 1987, 201 (repr.)
Russell 1987, 200

EXHIBITIONS
Paris 1950b (as *Tableau. Objet*)
Paris 1951a (as *Relief en bleu*)
New York 1956b
New York 1969
New York 1973
New York 1982b
Washington 1988

Cat. 51 (pl. 50)
Antibes, 1950
oil on cardboard with string mounted on wood
fabricated by the artist
25½ x 39⅜ x ½ (64.8 x 100 x 1.3)
Inscriptions, verso: KELLY
EK 21
Private collection, Switzerland

LITERATURE
Coplans 1971, pl. 58
New York 1973, fig. 41
Baden-Baden 1980, 100 (repr.)
New York 1982b, cat. 15, 17, 53 (repr.)

EXHIBITIONS
Paris 1950b (as *Objet*)
Paris 1951a (as *Relief: Blanc sur blanc III*)

PROVENANCE
Henri Seyrig
Delphine Seyrig

Cat. 52 (pl. 49)
Study for Antibes, 1950
oil on wood
13 x 19⅝ (33 x 49.9)
Inscriptions, verso: lower right, 21A
EK 21A

Cat. 53 (pl. 52)
Window VI, 1950
oil on canvas and wood
two joined panels
26 x 62⅞ (66 x 159.7)
Inscriptions, verso: upper right, EK 50; upper stretcher bar,
KELLY #22 26 X 62¼
EK 22

LITERATURE
New York 1973, 45, 108, fig. 35

EXHIBITIONS
Paris 1951a (as *Diptyque en bleu*)

Cat. 54 (pl. 54)
Pink Rectangle, 1950
oil on canvas
21¾ x 18 (55.3 x 45.7)
Inscriptions, verso: upper right, EK 50;
middle stretcher bar, 23
EK 23

LITERATURE
Los Angeles 1970, 12
New York 1973, 28

Cat. 55
City Landscape, 1950
oil on wood
25¼ x 36 (64.1 x 91.4)
Inscriptions, verso: upper left, 24 25¼" x 36;
upper right, EK 1950
EK 24

LITERATURE
Coplans 1971, 30

Cat. 56 (pl. 53)
Fond Rouge, 1950
oil on wood
13¼ x 39¼ (33.7 x 99.7)
Inscriptions, verso: upper right, EK 1950; upper left, 25
EK 25

EXHIBITIONS
Paris 1951a (*Peinture sur fond rouge*)
Caracas 1952

City Landscape,
1950 (cat. 55)

Cat. 57 (pl. 55)
Fond Jaune, 1950
oil on canvas
44¾ x 57½ (113.7 x 146.1)
Inscriptions, verso: upper right, EK 50; middle stretcher bar, #26
44¾ x 57½" FOND JAUNE
EK 26

LITERATURE
Baden-Baden 1980, 105 (repr.)
Paris 1980, 37 (repr.)

EXHIBITIONS
Paris 1951a (as *Peinture sur fond jaune*)

Cat. 58 (pl. 66)
La Combe I, 1950
oil on canvas
38 x 63½ (96.5 x 161.3)
Inscriptions, verso: upper right, EK 50
EK 27

LITERATURE
Alvard 1951, 25 (repr.)
Seuphor 1962, no. 445 (repr., as *Mural Panel in Black and White*)
Los Angeles 1970, 16
Coplans 1971, 36, pl. 62
Waldman 1971a, 20
Debs 1972, 73
Goossen 1973, 34
New York 1973, 27, 34 (repr.), 35, 38, 57, 109
Wechsler 1973, 6 (repr., as *Mural Painting in Black and White*)
Baden-Baden 1980, 105 (repr.)
Paris 1980, 37 (repr.)
New York 1982b, 54 (repr.)
Washington 1984, 260, no. 30.5 (repr.)
Buffalo 1989, 56

EXHIBITIONS
Paris 1951a
New York 1973

Cat. 59 (pl. 61)
November Painting, 1950
oil on wood
25½ x 34 (64.8 x 86.4)
Inscriptions, verso: upper left, NOVEMBER PAINTING 25½" x 34" 28;
upper right, EK 1950
EK 28

LITERATURE
Nordness 1962, 394 (repr.)
Los Angeles 1970, 12
Coplans 1971, 17–18, 33–34, 60, pl. 11
New York 1973, 32, 36 (repr.), 37
Baden-Baden 1980, 100 (repr.)

EXHIBITIONS
New York 1973

Cat. 60 (pl. 58)
Ormesson, 1950
oil on canvas
three joined panels
33 x 88¼ (83.8 x 224.2)
Inscriptions, verso: upper right, EK / ORMESSON NOV. 1950; upper
stretcher bar, right, 29
EK 29

LITERATURE
Harper's Bazaar 1956, 202–203 (repr.)
Coplans 1969, 48
Coplans 1971, 34, 36, pl. 15
Tuchman 1974, 55–56 (as *Three Panels: Ormesson*)

EXHIBITIONS
Paris 1951a (as *Triptyque: Ormesson*)
Paris 1951b

Cat. 61 (pl. 60)
Royan, 1950
oil on canvas
three joined panels
each panel, 24 x 36 (61 x 91.4)
24 x 108 (61 x 274)
EK 30
Missing in South America

EXHIBITIONS
Paris 1951a (as *Triptyque: Royan*)
Caracas 1952

Cat. 62 (pl. 56)
Fond Noir, 1950
oil on canvas
57⅛ x 44¾ (145.7 x 113.7)
Inscriptions, verso: upper right, EK '50; middle stretcher bar, #31
57½ x 44¾ FOND NOIR

EXHIBITIONS
Paris 1951a (as *Peinture sur fond noir*)

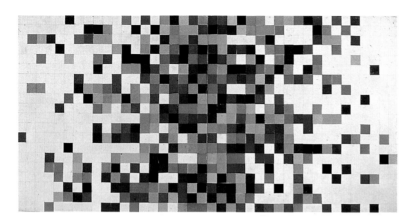

Spectrum Colors Arranged by Chance I, 1951
collage, 19¼ x 39 in

Spectrum Colors Arranged by Chance II, 1951
collage, 38¼ x 38¼ in

Spectrum Colors Arranged by Chance III, 1951
collage, 39 x 39 in

Cat. 63 (pl. 51)
Colors on Wood, 1950
oil on wood
39¼ x 25½ (99.7 x 64.8)
Inscriptions, verso: upper left, #33; upper right, DEC. 1950 / EK 50 / ©
EK 33

EXHIBITIONS
Paris 1951a (as *Couleurs sur fond bois*)

Cat. 64 (pl. 64)
La Combe II, 1950–1951
oil on wood
fabricated by the artist
folding screen of nine hinged panels, each panel 39 x 5 x ¼
(99.1 x 12.7 x .7)
39 x 46½ (99.1 x 118.1) [depth variable]
Inscriptions, verso: upper right, 34 EK 51
EK 34

LITERATURE
Paris 1951b, 44 (repr.)
McConathy 1964
Coplans 1969, 48 (repr., as 39 x 46 in)
Coplans 1971, 34, 36, pl. 65 (as *Nine Panels: La Combe II*)
Waldman 1971a, 20
Debs 1972, 73
New York 1973, 35 (repr.)
Tuchman 1974, 55
Baden-Baden 1980, 98 (repr.)
New York 1982b, cat. 16, 17, 32, 54, 55 (repr.)
Komanecky 1984, 88 (repr.), 90
Washington 1984, cat. 30, 198, 203, 259–263, 261 (repr.)
Fort Worth 1987, 195
Helman 1990, 93 (repr.)

EXHIBITIONS
Paris 1951a
Paris 1951b
Washington 1984

Spectrum Colors Arranged by Chance IV, 1951
collage, 39 x 39 in

Spectrum Colors Arranged by Chance V, 1951
collage, 39 x 39 in

Cat. 65 (pl. 59)
Red Yellow and Blue, 1951
oil on canvas
45 x 60 (114.3 x 152.4)
EK 35
Private collection, Caracas

EXHIBITIONS
Paris 1951a (as *Peinture d'été*)
Caracas 1952

Cat. 66 (pl. 63)
La Combe III, 1951
oil on canvas
63½ x 44½ (161.3 x 113.0)
Inscriptions, verso: upper right, EK 1951; middle stretcher bar, #36
63½ x 44½" KELLY 1951
EK 36

LITERATURE
Coplans 1971, 36, pl. 64
Waldman 1971a, 20
Waldman 1971b, 53
Debs 1972, 73
Washington 1984, 260, 30.6 (repr.)
New York 1986a, cat. 11, 22, 23 (repr.)
Buffalo 1989, 136 (repr.)

EXHIBITIONS
Boston 1951 (as 1948)

Paris 1951a
New York 1986a
Buffalo 1989

Cat. 67 (pl. 57)
Rouleau Bleu, 1951
acrylic(?) on unstretched cotton
17½ x 117 (43.8 x 297.2)
EK 37
Collection of Henry Persche, Ghent, New York

EXHIBITIONS
Paris 1951b

Cat. 68 (pl. 65)
La Combe IV—Collaboration with a Twelve-Year-Old Girl, 1951
oil on wood
39¼ x 60¼ (99.7 x 153)
EK 39

LITERATURE
Coplans 1971, 36
Debs 1972, 73
Goossen 1973, 34
New York 1973, 37

EXHIBITIONS
Paris 1951b

Spectrum Colors Arranged by Chance VI, 1951
collage, 37¼ x 37¼ in

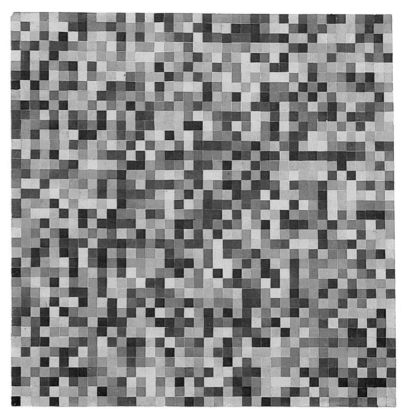

Spectrum Colors Arranged by Chance VII, 1951
collage, 39 x 39 in

Cat. 69 (pl. 68)
Cité, 1951
oil on wood
twenty joined panels
56¼ x 70½ (142.9 x 179.1)
Inscriptions, verso: upper left, #40 56½ x 70½ CITE; upper right, EK
JULY '51 MESCHERS
EK 40

LITERATURE
Art in America 1957, 21 (repr.)
Seuphor 1960, 52 (repr.)
Coplans 1969, 48 (repr.)
Coplans 1971, 38, pl. 69 (as *Twenty Panels: Cité*)
Waldman 1971a, 20–21
Waldman 1971b, 53
Goossen 1973, 34
New York 1973, 38, 39 (repr.), 40
Perreault 1973, 30
Paris 1981, no. 352, 284 (repr.)
New York 1982b, 60, fig. 26
Washington 1984, 260, no. 30.7 (repr.)
Fort Worth 1987, 14, 15 (repr.)

EXHIBITIONS
Paris 1951c, no. 6 (as *Le Rêve I. Projet Mural*)
New York 1956a
New York 1962 (as oil on composition board)
New York 1973
Paris 1981

Spectrum Colors Arranged by Chance VIII, 1951
collage, 44 x 44 in

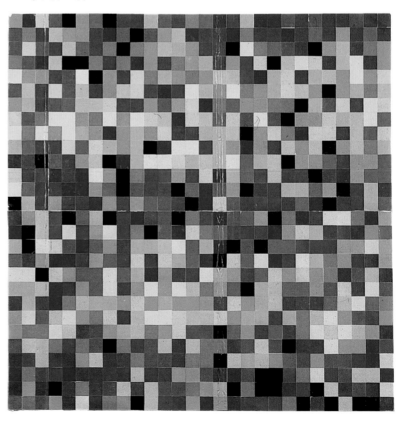

Cat. 70 (pl. 70)
Gironde (formerly *Yellow White*), 1951
oil on wood
45½ x 45½ (115.6 x 115.6)
Inscriptions, verso: upper left, #41; upper right, EK 51
EK 41

LITERATURE
Waldman 1971a, 13, 21
Waldman 1971b, 53
Goossen 1973, 34
New York 1973, 38

EXHIBITIONS
Paris 1951c, no. 7 (as *Le Rêve II: Entrée dans Bangor*)

Cat. 71 (pl. 67)
Meschers, 1951
oil on canvas
59 x 59 (149.9 x 149.9)
Inscriptions, verso: upper right, EK '51
EK 42

LITERATURE
Coplans 1971, 38, pl. 66
Goossen 1973, 34
Hughes 1973, 72, 73 (repr.)
New York 1973, 38, 40, 41 (repr.)
New York 1982b, 32, 54, 60, fig. 22
Fort Worth 1987, 14, 195

EXHIBITIONS
Paris 1951c, no. 9 (as *Le Rêve IV: Meschers*)
New York 1973

Cat. 72 (pl. 69)
Talmont (formerly, *Green White*), 1951
oil on canvas
26 x 64¼ (66 x 163.2)
Inscriptions, verso: upper right, EK 51
EK 43

LITERATURE
Waldman 1971a, 20
Waldman 1971b, 53
Goossen 1973, 34
New York 1973, 38
New York 1982b, 151

EXHIBITIONS
Paris 1951c, no. 8 (as *Le Rêve III: Été*; also reproduced on the
invitation to the exhibition)

Cat. 73 (pl. 62)
Moby Dick, 1951
oil on canvas
13 x 16⅛ (33 x 41)
Inscriptions, verso: KELLY 2/52
EK 44
Collection of Louis Clayeux, Paris

LITERATURE
Waldman 1971a, 20
Waldman 1971b, 53

Cat. 74 (pl. 71)
Seine, 1951
oil on wood
16½ x 45¼ (41.9 x 114.9)
Inscriptions, verso: upper left, 45; upper right, EK 51
EK 45

LITERATURE
Rickey 1967, 160 (repr.), 161
Coplans 1969, 51, 53 (repr.)
Coplans 1971, 18, 42, pl. 70
Waldman 1971a, 22
Waldman 1971b, 54
Seitz 1972, 72
Millet 1973, 12
New York 1973, 30, 31 (repr.), 32, 108, 109
Perreault 1973, 30
Baden-Baden 1980, 99 (repr.)
New York 1982b, 56
Larkin 1988, 22, fig. 2.11

EXHIBITIONS
New York 1973

Cat. 75 (pl. 74)
Colors for a Large Wall, 1951
oil on canvas, mounted on
sixty-four joined wood panels
94¼ x 94½ (239.3 x 239.9)
EK 46
The Museum of Modern Art, New York
Gift of the Artist, 1969

LITERATURE
New York 1968, cat. 17, 24 (repr.)
Coplans 1969, 51 (as *64 Panels*), 53 (repr.)
Coplans 1971, 43 (as *Sixty-Four Panels: Colors for a Large Wall*),
pl. 18
Waldman 1971a, 22–23 (as *64 Panels: Colors for a Large Wall*)
Waldman 1971b, 54 (as *Sixty-Four Panels: Colors for a Large Wall*)
MOMA 1972, 140
Seitz 1972, 72, 74 (repr.)
Goossen 1973, 36
New York 1973, 44 (repr.), 45, 46, 47, 52
MOMA 1977, 58
Paris 1977, 558 (as *64 Panels: Colors for a Large Wall*), 559 (repr.)

Blistène 1980, 20 (repr.), 21
Cologne 1981, 415 (repr.)
Armstrong 1987, 105
Axsom 1987, 115, 187, fig. 26
Boston 1987
Fort Worth 1987, 46 (repr.)
Lyon 1988, 149, 327 (repr.)
Hall 1991, 6 (repr., as 94 x 94¼ in)

EXHIBITIONS
Paris 1952
New York 1956a
New York 1968
New York 1973
Paris 1977
Cologne 1981, no. 455
Lyon 1988

Cat. 76 (pl. 75)
Méditerranée, 1952
oil on wood
nine joined panels, two in relief
59 x 76½ (149.9 x 194.3)
Inscriptions, verso: upper right, EK SANARY '51–52;
upper left, 47
EK 47

LITERATURE
Coplans 1969, 52, 53 (repr., as 59 x 76 in), 55
Coplans 1971, 46, 49 (as *Nine Panels: Méditerranée*), pl. 19
Goossen 1973, 36
New York 1973, 46, 47 (repr.), 61
New York 1978
Trenton 1983, 66

EXHIBITIONS
Paris 1952 (as *Southern Painting*)
New York 1978

Cat. 77 (pl. 73)
Sanary, 1952
oil on wood
51½ x 60 (130.8 x 152.4)
Inscriptions, verso: upper left, #48; upper right,
EK SANARY—'52
EK 48

LITERATURE
Harper's Bazaar 1956, 204 (repr.)
Coplans 1971, 46, pl. 73 (as 60 x 60 in)
Waldman 1971a, 22–23, 27
Waldman 1971b, 54
Baker 1973, 31 (repr.)
Goossen 1973, 36
New York 1973, 45, 46–47, 52, 53 (repr.)
Dantzic 1990, fig. 9.1

EXHIBITIONS
Paris 1952 (as *c: Place in the Sun*)
New York 1973

Cat. 78 (pl. 79)
Fête à Torcy, 1952
oil on canvas and wood
two panels separated by a wood strip
45½ x 38 (115.6 x 96.5)
Inscriptions, verso: upper right, KELLY '52 / 'LA FETE A TORCY' / #49;
middle stretcher of upper panel, A LA FETE DE TORCY 1952 ELLSWORTH
KELLY / 21 CITÉ DES FLEURS / PARIS 17ᵉ
EK 49

LITERATURE
Coplans, 1969, 55 (dated 1953)
Coplans 1971, 54 (as *Two Panels: Fête à Torcy*), pl. 21 (dated 1953)
Paris 1981, no. 354, 284 (repr., dated 1953)
Boston 1987, cat. 2

EXHIBITIONS
Paris 1952
Paris 1981
New York 1986c
Boston 1987

Cat. 79 (pl. 77)
Red Yellow Blue White (formerly *Bon Marché*), 1952
dyed cotton on panel
twenty-five panels in five parts
each panel 12 x 12 (30.5 x 30.5), with 22-inch-wide spaces
between parts
60 x 148 (152.4 x 375.9) overall
EK 50

LITERATURE
Coplans 1969, 54 (as *Red, Yellow Blue and White*, overall
60 x 129 in, with 17-inch-wide spaces between parts)
Coplans 1971, 52 (as *Twenty-Five Panels: Red Yellow Blue and White*),
pl. 80
New York 1973, 42, 43 (repr.)
Munich 1981, cat. 59
New York 1982b, 13 (repr.)
Fort Worth 1987, 12 (repr.)
Paris 1988, 176–177 (repr.)
St. Gallen 1988, 102 (as *Red, Yellow, Blue and White*)

EXHIBITIONS
Munich 1981
Paris 1988

Cat. 80 (pl. 83)
Kite I, 1952
oil on canvas
seven joined panels
39¼ x 91½ (99.7 x 232.4)
Inscriptions: upper right, EK TORCY—'52
EK 51

LITERATURE
Coplans 1969, 52 (repr., as 39 x 90 in)
Coplans 1971, 49, 53, 77 (as *Seven Panels: Kite I*), pl. 76
(as 39 x 90 in)
Goossen 1973, 35
Brenson 1982 (as *Seven Panels: Kite I*)
St. Gallen 1988, 102, 128 (repr.)
Buffalo 1989, 137 (repr.)

EXHIBITIONS
New York 1956a
Extended loan to the Dallas Museum of Art, January 1984–August 1989
Buffalo 1989

Cat. 81 (pl. 76)
Two Yellows, 1952
oil on canvas
twenty-five joined panels
59 x 59 (149.9 x 149.9)
Inscriptions, verso: upper right, EK 52
EK 52

LITERATURE
Coplans 1971, 46 (as *Twenty-five Panels: Two Yellows*), pl. 74
Waldman 1971a, 24
New York 1973, fig. 47

EXHIBITIONS
New York 1956a
Philadelphia 1972 (as *Twenty-five Panels: Two Yellows*, 59½ x 59½)

Cat. 82 (pl. 82)
Kite II, 1952
oil on canvas
eleven joined panels
overall, 31½ x 110¼ (80 x 280)
EK 53
Musée National d'Art Moderne, Centre Georges Pompidou, Paris

LITERATURE
Harper's Bazaar 1956, 202–203 (repr.), 205
Coplans 1969, 49 (repr.), 52
Coplans 1971, 49 (as *Eleven Panels: Kite II*), pl. 78
Waldman 1971a, 24 (as *Eleven Panels: Kite II*)
Goossen 1973, 35
New York 1973, 42 (repr.), 45
New York 1982b, 19 (repr.)
Buffalo 1989, 57 (repr.)

EXHIBITIONS
New York 1973
Paris 1981
Extended loan to the National Gallery of Art, Washington,
August 1984–July 1985

Cat. 83 (pl. 81)
Painting for a White Wall, 1952
oil on canvas
five joined panels
23½ x 71¼ (59.7 x 181)
Inscriptions, verso: far left panel, center, EK / TORCY / JULY 52; middle
support bar, PAINTING FOR A WHITE WALL KELLY #54
EK 54

LITERATURE
Kramer 1968
New York 1968, cat. 18, 25 (repr.)
Coplans 1971, pl. 3 (as *Five Panels: Painting for a White Wall*)
New York 1973, 42 (repr.), 52, 76
Tuchman 1974, 62 (as *Five Panels: Painting for a White Wall*)
Cologne 1981, 415 (repr.), not exhibited
Boston 1987, cat. 1 (as 23½ x 71¼ in)
Fort Worth 1987, 16 (repr., as 23½ x 71¼ in)
New York 1988, 1 (repr.)

EXHIBITIONS
New York 1968
New York 1973
Loan to the National Gallery of Art, Washington, for temporary
installation, "Seven American Masters," July 1985–July 1986
Boston 1987
Loan to Dallas Museum of Art for temporary installation,
"Paintings in Parts," September–November 1989

Cat. 84 (pl. 78)
Dominican, 1952
oil on canvas and wood
two joined panels separated by a wood strip
38¼ x 25⅝ (97.2 x 65.1)
Inscriptions, verso: upper right, EK '52
EK 55

LITERATURE
Coplans 1969, 55
New York 1973, 47
Colpitt 1979, 5 (repr., as 1953, 38½ x 25¼ in)
Northridge 1979 (as 1953, 38½ x 25¼ in)

EXHIBITIONS
Santander 1953 (as *Pintura en tapiz*)
Northridge 1979

Cat. 85 (pl. 84)
Red Yellow Blue White and Black, 1953
oil on wood
six joined panels
19¼ x 38⅞ (50.2 x 96.7)
Inscriptions, verso: upper left, 56; upper right, EK 1953
EK 56

LITERATURE
New York 1967a, cat. 1, page preceding checklist (repr., as *Six Panels:
Blue White Black Yellow White Red*)
Perreault 1967, 12 (as *Six Panels: Blue White Black Yellow White Red*)

Coplans 1969, 52, 53 (repr., as *Red White Black Yellow White Blue*)
Coplans 1971, 50 (as *Red White Black Yellow White Blue*)

EXHIBITIONS
New York 1956a
New York 1967a

Cat. 86 (pl. 86)
Red Yellow Blue White and Black with White Border, 1953
oil on canvas
seven joined panels
41¼ x 155 (106.1 x 393.7)
EK 57

LITERATURE
New York 1966, 13 (repr., upside down, as *Red Yellow Black Whites Blues*)
Coplans 1969, 49 (repr., as *Red, Yellow, Blues, Whites, White Black with Border*, 44 x 154 in), 52, 55
Coplans 1971, 49–50, 54 (as *Seven Panels: Red Yellow Blue White and Black with White Border*), pl. 83
Waldman 1971a, 24–25
Waldman 1971b, 55

EXHIBITIONS
New York 1967b

Cat. 87 (pl. 87)
Red Yellow Blue White and Black, 1953
oil on canvas
seven joined panels
39 x 138 (99.7 x 350.5)
Inscriptions, verso: upper right, EK '53; upper stretcher bar, right,
KELLY 1953
EK 58

LITERATURE
Coplans 1971, 50 (as *Seven Panels: Red Yellow Blue White and Black*), pl. 84

Cat. 88 (pl. 88)
Spectrum I, 1953
oil on canvas
60 x 60 (152.4 x 152.4)
Inscriptions, verso: upper left, #59; upper right, EK 1953
EK 59

LITERATURE
Harper's Bazaar 1956, 205 (repr.)
Coplans 1969, 55
Coplans 1971, 54, 82, 85
MOMA 1972, 174
Axsom 1987, 85

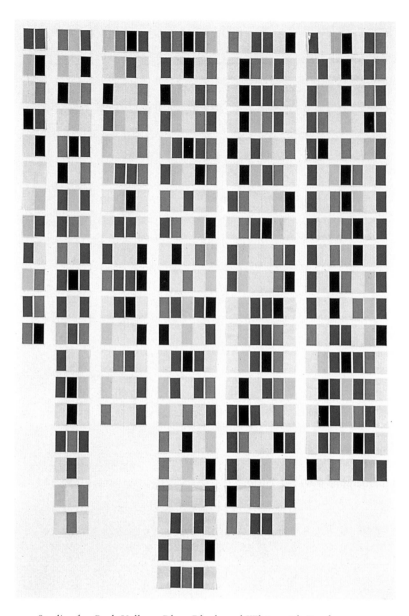

101 Studies for *Red, Yellow, Blue, Black and White with Border*, 1952
collage, 43⅞ x 29 in

Cat. 89 (pl. 85)
Tiger, 1953
oil on canvas
five joined panels
80¼ x 85½ (205.1 x 217.2)
Inscriptions, verso: upper left panel, center, EK PARIS 53; left support bar, #60 / TIGER
EK 60

LITERATURE
New York 1973, 48 (repr.), 52

EXHIBITIONS
New York 1956a
New York 1973
Extended loan to National Gallery of Art, Washington,
July 1986–December 1991

Cat. 90 (pl. 80)
Train Landscape, 1952–1953
oil on canvas
three joined panels
43½ x 43½ (110.5 x 110.5)
Inscriptions, verso: upper center, #61 KELLY
EK 61

LITERATURE
Coplans 1969, 50 (repr.), 55
Coplans 1971, 54 (as *Three Panels: Train Landscape*)
Hess 1973, 98 (repr., as 1953)
Perrone 1977, 62
Axsom 1987, 125, 156
Boston 1987, n. 5
Donohue 1989, 16

EXHIBITIONS
New York 1956a
Paris 1961 (as *Train Landscape, Nancy*)
New York 1973

Cat. 91 (pl. 89)
Tableau Vert, 1952
oil on wood
29¼ x 39¼ (74.3 x 99.7)
Inscriptions, verso: upper left, #62; upper right, EK '52; center, pencil
drawing of an architectural detail EK 62

LITERATURE
Amsterdam 1979, 18
Baden-Baden 1980, 22
Paris 1980, 19
Lyon 1988, 12, 18 (repr.), 321 (repr.)
Hindry 1990, 94 (as *Green Painting*)

EXHIBITIONS
Lyon 1988

Cat. 92 (pl. 72)
Spectrum Colors Arranged by Chance, 1951–1953
oil on wood
60 x 60 (152.4 x 152.4)
Inscriptions, verso: upper left, 63; upper right, EK 1952–53
EK 63

LITERATURE
Coplans 1969, 51, 52, cover (repr.)
Coplans 1971, 42, pl. 71 (as 1952–1953)
Goossen 1973, 36
New York 1973, 32, 33 (repr., as 1952–1953)
Perreault 1973, 30

EXHIBITIONS
New Haven 1957
New York 1973

Cat. 93 (pl. 91)
White Square, 1953
oil on wood
43¼ x 43¼ (109.9 x 109.9)
Inscriptions, verso: upper right, EK 1953 / 64
EK 64

LITERATURE
Coplans 1969, 55 (repr., as 43 x 43 in)
Coplans 1971, 56, pl. 88
Masheck 1973, 55
Baden-Baden 1980, 102 (repr.)
New York 1982b, 43, fig.7
Los Angeles 1986, 346 (repr.)

EXHIBITIONS
New York 1963
Los Angeles 1986
Washington 1988

Cat. 94 (pl. 90)
Black Square, 1953
oil on wood
43¼ x 43¼ (109.9 x 109.9)
Inscriptions, verso: upper left, 65; upper right, EK 1953
EK 65

LITERATURE
Coplans 1969, 55 (repr.)
Coplans 1971, 56, pl. 87
Masheck 1973, 55
Amsterdam 1979, 14
Baden-Baden 1980, 20
Paris 1980, 17
New York 1982b, 43, fig.8
New York 1986b, cat. 16, 3–4, 40, 41 (repr.)
Westfall 1986, 162
Lyon 1988, 146 (repr.), 322, 323

EXHIBITIONS
New York 1963
New York 1986b
Lyon 1988

Cat. 95 (not illustrated)
Six Squares, 1953
oil on canvas
six joined panels
46 x 71 (116.8 x 180.3)
EK 66

Cat. 96 (pl. 93)
White, Two Blacks, 1953
oil on canvas
three joined panels
23½ x 70¾ (59.7 x 179.7)
Inscriptions, verso: center, EK 54
EK 66A

LITERATURE
Coplans 1969, 54 (repr., as *Two Blacks and White*), 55
Coplans 1971, 56, pl. 89
Axsom 1987, 83

EXHIBITIONS
Hartford 1964

Cat. 97 (pl. 92)
Black, Two Whites, 1953
oil on canvas
three joined panels
23¼ x 70¾ (59.7 x 179.7)
Inscriptions, verso: left panel, upper right, EK 53–54; middle stretcher
bar, left, 66B
EK 66B

LITERATURE
Coplans 1969, 54 (repr., as *Two Whites and Black*), 55
Coplans 1971, 56 (as *Three Panels: Black, Two Whites*), pl. 90
New York 1986b, cat. 17, 3–4, 42, 43 (repr., as *Three Panels: Black Two Whites*)
Axsom 1987, 83
New York 1989 (repr., as *Three Panels: Black, Two Whites*)

EXHIBITIONS
Hartford 1964 (as *Black and Two Whites*)
New York 1986b

Cat. 98 (not illustrated)
Yellow Black and White, 1952–1955
oil on canvas
71¼ x 59⅛ (182.3 x 150.2)
Inscriptions, verso: upper right, EK 52–55
EK 69

LITERATURE
Coplans 1971, pl. 85

Cat. 99 (pl. 95)
White Plaque: Bridge Arch and Reflection, 1951–1955
oil on wood
fabricated by the artist and a local carpenter
two panels separated by a wood strip
64 x 48 x ½ (162.6 x 121.9 x 1.3)
EK 72
Private collection

LITERATURE
Tillim 1959, 150 (as *The Plaque*)
Ashton 1968, 92, 93 (repr., as *White Relief—Arch and Its Shadow* [*Pont de la Tournelle, Paris*], 1952–1955)
New York 1968, cat. 19, 23 (repr., as *White Relief—Arch and Its Shadow* [*Pont de la Tournelle, Paris*], 1952–1955)
Drweski 1969, 50
Coplans 1971, 62–63, 76, 93, pl. 10, 292 (repr., as 1954–1955)
Waldman 1971a, 21
Waldman 1971b, 54
Hunter 1973, 384 (as 1953)
Masheck 1973, 55 (as 1952–1955)
Millet 1973, 10 (as *Bridge Arch and Reflection*)
New York 1973, 50, 51 (repr.), 52, 59, 61, 87, 92, 112 (repr.)
Wechsler 1973, 6
Tuchman 1974, 56 (repr., as 1952–1955), 60
Baden-Baden 1980, 37, 38, 39 (repr., as 1954–1955)
Ratcliff 1981, 115 (repr., as *White Relief*)
New York 1982b, cat. 17, 18, 56, 57 (repr.), 83
Duffy 1983a, H 5
Armstrong 1987, 111 (repr., sideways, as 64 x 68 in)
Boston 1987, fig. 7
Fort Worth 1987, 19 (repr.)
Russell 1987, 200
Paris 1988, 178 (repr.)

EXHIBITIONS
New York 1956a
New York 1968 (as *White Relief—Arch and Its Shadow: Pont de la Tournelle, Paris*)
New York 1973
Paris 1988

PROVENANCE
Betty Parsons Gallery, New York
Sander Feldman, Philadelphia
Robert Fraser Gallery, London
The Locksley-Shea Gallery, Minneapolis

Cat. 100 (pl. 94)
Yellow Relief, 1954–1955
oil on canvas
two joined panels, left panel raised slightly
24 x 24 (61 x 61)
Inscriptions, verso: upper right, EK '55; support bar, 75 ELLSWORTH KELLY
EK 75

LITERATURE
Washington 1963, cat. 1 (as *Yellows*, 1955)
Coplans 1971, pl. 95 (as *Two Panels: Yellow Relief*, 1955)
New York 1973, 61
Sandler 1978, 222 (as 1955)
Los Angeles 1986, 346 (repr.)
Hindry 1990, 93 (as *Two Panels: Yellow Relief*, 1955)

EXHIBITIONS
Washington 1963
Annandale-on-Hudson 1985
Los Angeles 1986

Cat. 101 (not illustrated)
Gaza, 1952–1956
oil on canvas
four joined panels
90 x 79 (228.6 x 200.7)
Inscriptions, verso: upper right, KELLY
EK 96

LITERATURE
Goossen 1973, 37 (repr.)

EXHIBITIONS
New York 1963b
New York 1973

Chronology, 1943–1954

Nathalie Brunet

We would like to thank the many people who responded to our requests for help in reconstructing, step-by-step, Ellsworth Kelly's early years: Jean-Robert Arnaud, Harry Bellet, John Cage, Louis Clayeux, John Koenig, Georges Koskas, Jacques Laval, Nöel Lee, Franz Meyer, François and Danièle Morellet, Denise René, Joanna Wieder-Atherton, Jack Youngerman, and Gustav Zumsteg. We have benefited from the unerring memory and patience of Ellsworth Kelly, from the riches and perfect order of his files, from the extraordinary diligence of Henry Persche, and from the prudent counsel of Jack Shear.

We are indebted to E.C. Goossen, whose research for the catalogue of the Kelly exhibition at the Museum of Modern Art in New York in 1973 greatly facilitated the task of preparing this Chronology. The inexhaustible trove of information contained in the exhibition catalogue Paris-Paris/Créations en France: 1937–1957, Centre Georges Pompidou, 1981 was also especially helpful.

Quotations are from conversations between Ellsworth Kelly and Nathalie Brunet, May 1991 (EK/NB) or from the monograph by John Coplans (Coplans 1971). Other sources for quotations appear within parentheses, following quotations. Complete citations appear in the Bibliography. Although Kelly was relatively isolated while he lived in Paris, a certain amount of information about the cultural and political climate in France during those years has been included. One voice, that of the incomparable Delphine Seyrig, is missing here. To her memory we would like to pay tribute.

A Summary: the Years before 1948

Ellsworth Kelly is born 31 May 1923 in Newburgh, New York. In 1941–1942 he studies at the Pratt Art Institute, Brooklyn. World War II breaks out. He enlists and is mobilized 1 January 1943. He requests assignment to the 603rd Engineers camouflage battalion.

In June 1944, Kelly's unit is sent to France, where he participates in operations in Normandy and Brittany. In September, the battalion is stationed for two weeks at Saint-Germain-en-Laye. He visits Paris for the first time.

In 1946, Kelly qualifies under the G.I. Bill for financial aid, and resumes his studies at the Boston Museum School, dominated at the time by the German expressionist painter Karl Zerbe (1903–1972). Kelly studies drawing with Ture Bengtz. Max Beckmann is invited to lecture, but instead some letters he had written to a young artist are read aloud to the class, a "lesson" Kelly remembers well (New York 1973, 16): "Don't forget nature . . . through which Cézanne, as he said, wanted to achieve the classical. Take long walks and take them often, and try your utmost to avoid the stultifying motor car which robs you of your vision, just as the movies do, or the numerous motley newspapers. Learn the forms of nature by heart so that you can use them like the musical notes of a composition. . . . The impression nature makes upon you must always become an expression of your own joy or grief, and consequently in your formation of it, it must contain that transformation which only then makes art a real abstraction" (New York 1973, 104). The violent contrasts, strongly contoured characters in black, and multiple panels of Beckmann's paintings have a lasting influence on Kelly's work.

Philip Guston speaks on Piero della Francesca; Herbert Read, the English art historian, decrees that easel painting is finished and the next evolution will be a collaboration between art and architecture.

Kelly is attracted to Byzantine and Romanesque art, obtaining two volumes on the frescoes of

Self-Portrait, 1944, ink on paper, 8⅛ x 7 (photo: Jack Shear)

Saint-Savin and Tavant. Occasionally he goes to New York to visit the museums and galleries: the Museum of Modern Art for Klee and Picasso, and the Guggenheim for Kandinsky. The exhilarating recollection of the year spent in France during the war, the realization that Boston no longer has anything artistically relevant to offer him, the need for access to the European cultural heritage, the longing to be a "stranger" in a city—are all reasons for his decision to go to Paris, which is still in the eyes of artists of that era the center of modern culture, the place where the aesthetic revolutions had taken place (see Juan-Manuel Bonet, "Américains à Paris, les Années Cinquante," *Goya*, Madrid, November 1983). Kelly plans his trip in great detail, keeping a notebook (which he still has) in which he meticulously lists all places, monuments, museums, and collections that must be seen. He draws up lists and then checks off each place he has visited. These notes are written with unflagging attention to the facts. Although references to contemporary art are prac-

tically nonexistent, he includes a detailed plan of the monasteries of Mount Athos along with useful instructions for obtaining visitor's permits.

1948–1949

Ellsworth Kelly arrives in Paris in October 1948, and stays at the Hôtel Saint-George on rue Bônaparte. At the Boston Museum School Kelly had studied polyptychs, choosing the *Isenheim Altarpiece* of Matthias Grünewald (1455–1528) for a research topic. "Arriving in Paris, the first thing I did was to go to Colmar to see this famous altar. I preferred Grünewald to Dürer and I found him related in his expressionist technique to Picasso and Beckmann, the two artists I most admired at that time." (EK/NB)

Paris is enjoying an unprecedented influx of American students. Estimates put the number at 300; some speak of twice as many.

Law No. 346, the G.I. Bill of Rights, is passed: to continue their studies, G.I.s receive a monthly allowance of $75 for a period equivalent to the length of time served plus twelve months (see Harry Bellet, "Le Curieux Paris de Quelques Américains," *Cimaise*, Paris, no. 210, January-February-March 1991). In order to take advantage of this stipend, proof of full-time enrollment in a school or university is required. Under the bill, Robert Rauschenberg spends the year at the Académie Julian; Robert Breer enrolls there in 1949. In 1950 Frank Lobdell attends the Académie de la Grande-Chaumière; Sam Francis and Seymour Boardman study at the atelier Fernand Léger. Ossip Zadkine, who taught at Black Mountain College in 1945, draws a large number of Americans: Sidney Geist, Kenneth Noland, Jules Olitski, and Richard Stankiewicz, among others, are his students. "The Bill provided economic freedom, permitting one to eat, sleep and drink art, and, in a sense, become an artist in Paris through that kind of life. . . . It was a coming-of-age, the most liberating time of my life. Paris was a free-association graduate school with no classes and [one was] on a complete scholarship." (Al Held, in Northridge 1979)

Hôtel rue Bonaparte, 1948
ink on paper, 12¼ x 17⅛

In November, Kelly makes the rounds of the academies and ateliers of Paris. He decides to enroll at the Ecole des Beaux-Arts and paints the requisite nude (pl. 5). He seldom attends classes but spends time with Jack Youngerman, a young American artist who had arrived in Paris in 1947, and who is taking a course with Jean Souverbie: "For me it was an unbelievable return into the past. I was amazed that they could preserve a sense of atmosphere down to every detail. The way the professor looked—his dress and all his mannerisms were all very nineteenth-century . . .

And the studio that I was in—people told me it had been Toulouse-Lautrec's and that Van Gogh had also been a student there. As though it had been the day before yesterday. . . . There was only a little stove next to the model and the rest of the class was really freezing. There was no heat at all until December and then very little. And it was very over-crowded. . . . Most Americans, and myself after I first contacted the Beaux-Arts, just stayed and enrolled to draw the G.I. bill benefits but we worked on our own. I don't know of any Americans who went regu-

larly after the initial contact. . . . the French students on the whole weren't very hospitable. They were all somewhat on the defensive about all kinds of things. Not about art, because they owned art at that time and according to them we were obviously the philistines with our pockets loaded with dollars—I think most Americans felt that—But there was in general a kind of nationalist feeling and a sort of scorn for us. . . . in 1948, art was still French in everybody's minds. It was a French province." (Jack Youngerman, in "Interview: Jack Youngerman Talks with Colette Robert," *Archives of American Art Journal* 17, no. 4, 1977, 11, 12)

ABOVE: Stele of the Serpent King, from the Tomb of the Serpent King, Abydos, c. 3000 B.C. (1st dynasty)
Musée du Louvre, Paris

Matthias Grünewald, *Isenheim Altarpiece*, c. 1515
oil on panel, Musée d'Unterlinden, Colmar
(photo: O. Zimmermann)

Mosaic, Hagia Sophia, Istanbul, c. 1118

icons, which Kelly is authorized to study. "I soon realized after arriving in Paris in 1948 that figurative painting no longer interested me. Looking for a different way to continue, I spent days at the Louvre and the Guimet Museum where I studied the art of the Mediterranean and the East. The two things I admired most were an Egyptian stele in relief (Serpent King, 3000 B.C.) and a Greek headless statue of Hera (Hera of Samos, sixth century B.C.). I also studied Chinese ceramics and bronzes, the decorative objects and sculpture of Luristan, Suze, and the Cyclades. At the Byzantine Institute, I studied mosaics and early manuscripts." (Kelly, in Coplans 1971, 20)

Kelly paints three heads (pls. 1, 2, 4) inspired by Byzantine mosaics, and *Faceless Head* (pl. 10), which marks a decisive step: ". . . the head and neck look like a Cycladic sculpture. I was not satisfied with the face and I kept scraping it off and left it in that state—This is the first example of my trying to obliterate altogether the linear markings of the eyes, nose and mouth." (EK/NB)

In these first works the cutout begins to take shape and gradually emerges. Kelly undertakes a religious cycle, painting *Mother and Child* (pl. 3), *Lazarus* (pl. 11), and *Baptism* (pl. 12) in the spirit of frescoes of the twelfth century, but "with a contemporary technique." *Chuan Shu* (pl. 9) has its source in Chinese calligraphy and in the drawings of seals Kelly made at the Musée Cernuschi.

In December Kelly moves to the Hôtel Monsieur le Prince. He paints *Egyptian Woman* (pl. 6); he uses the same model as for his Beaux-Arts *Nude* (pl. 5): recognizing the young woman from his hotel window, he asks her to pose for him.

During these first six months in Paris, Kelly paints mostly half-length portraits that combine the influence of Picasso and Byzantine and Romanesque art. Searching for a new direction, Kelly does not think he is about to find it in contemporary art. He visits the museums of Paris, spends most of his time at the Louvre, the Musée de Cluny, the Musée Guimet, and the Musée Cernuschi. During the winter he is a regular visitor to the library of the Byzantine Institute in the rue de Lille, a Harvard University extension. Its founder and director, Thomas Whittemore, archeologist and friend of Gertrude Stein, had donated an important collection of ancient Greek and Russian manuscripts and

Haida Indians, Copper Plaque from the Queen Charlotte Islands (British Columbia), late 19th century (photo: Musée de l'Homme, Paris)

North-West Coast Indian Ceremonial Plaque, 1949 pencil on paper, 14¼ x 10¼

Drawings from 12th-century Manuscripts, 1949, pencil on paper, 7¾ x 10

He goes regularly to the Musée de l'Homme, where he draws from their ethnological collection, and to the Musée National d'Art Moderne; he paints his first abstract canvas in color and destroys it: "At first, before I started painting abstractions, my colors were dull and gray—I didn't use lively colors. During the winter of '48–'49 I had begun to make sketches of outdoor themes (architectural elements and found objects); I did a drawing of an ornamental plaque made up of twenty-four tiles that I had seen on the stern of an abandoned barge; I later tried to do an abstract painting of it in bright colors. It turned out to be premature. I had

Fresco from Saint-Savin (detail), 11th–12th century
(photo: Jean Mazenod, *L'Art roman* [Editions Citadelles])

Façade of Notre-Dame-La-Grande, Poitiers,
11th–12th century (photo: Ellsworth Kelly, 1949)

painted it on just one piece of canvas; it was only later, when I developed the same idea using a separate panel for each color that the idea became successful." (EK/NB)

During Easter vacation, Kelly travels by train and bicycle from Poitiers to Chauvigny, Saint-Savin-sur-Gartempe, Tavant, and Chinon, ending up at Mont-Saint-Michel: "I traveled to the Romanesque sites of Tavant, Saint Savin, and Poitiers, where I drew from twelfth-century frescoes and sculptures and especially from the stonework of churches. Notre-Dame-La-Grande in Poitiers has a circular gridwork on its west front façade that was used in *Poitiers* [pl. 8], the rings incised into the wet paint. On the same façade of the church is a scallop-shaped mandorla from which *Mandorla* [pl. 27] was derived. I became more interested in the physical structure of Paris, the stonework of the old buildings and bridges, and preferred to study and be influenced by it, rather than by contemporary art. The forms found in the vaulting of a cathedral or a splatter of tar on a road seemed more valid and instructive and a more voluptuous experience than either geometric or action painting. . . . Instead of making a picture that was an interpretation of a thing seen, or a picture of invented content, I found an object and presented it as itself alone." (Kelly, in Coplans 1971, 20)

The "found object" becomes an important stage in Kelly's work.

Back in Paris Kelly moves to the Hôtel Saint-André-des-Arts, where he paints *Poitiers* (pl. 8), *Seated Figure* (pl. 13), and *Woman with Arm Raised* (pl. 14), which he submits to an exhibition at the American Center, boulevard Raspail, but they are not accepted. Having learned that Thomas Whittemore is passing through Paris and is working on the restoration of the mosaics of Santa Sophia in Istanbul, Kelly offers him his services. Whittemore recommends that he stay in Paris and paint.

In April, Kelly visits the Musée Conde in Chantilly with Jack Youngerman. Their friendship deepens. Youngerman has just left the Hôtel de Bourgogne on the Ile-Saint-Louis, and suggests that Kelly should take his room, which he does. Kelly remains there for close to three years.

One spring day, Kelly buys a succulent plant along the quais and brings it back to his hotel room: "*Plant I* [pl. 17] is the first example of a

Jack Youngerman, 1949
pencil on paper, 14¼ x 10¼

white 'cutout' form against a black ground. Its inherent flatness is a negation of three-dimensionality, or three-dimensionality flattened. While *Plant I* is multisided, *Plant II* [pl. 18], completed in mid-July, is the first occurrence of a characteristic biomorphic form." (EK/NB)

The cutout forms of the drawings of plants lead directly to the collages, of which *Head with Beard,* cut from a newspaper and mounted, is the first.

Head with Beard, 1949
newspaper cutout on paper, 10¼ x 6¼
(photo: Gamma One Conversions, New York)

Ralph Coburn, 1949
ink on paper, 21⅛ x 17

Self-Portrait, 1949
ink on paper, 22¼ x 17

Self-Portrait in Brodouant Cottage, 1949
ink on paper, 13 x 8½

In May, Kelly paints *Toilette* (pl. 21) and *Ubu* (pl. 20). *Toilette* is a diagram of a Turkish-style toilet. It is the first work that is developed by simplifying an object, whereas *Ubu* was developed from an automatic drawing.

Ralph Coburn, a friend from Boston and colleague from the Boris Mirski Gallery (which had shown Kelly's work for the first time in Boston), arrives in Paris. Together they visit galleries and

become interested in various techniques used by the surrealists. They collaborate in making *cadavre exquis* and drawings with their eyes closed, and collages arranged by chance.

In Paris to meet Pierre Boulez and to perform at the Vieux-Colombier Theater with Tanaquil LeClercq and Betty Nichols (*Effusions avant l'heure* and *Amores*), Merce Cunningham and John Cage stay at the Hôtel de Bourgogne for

the month of June. They meet Kelly and visit his studio. Their meeting is important for Kelly, who corresponds with Cage until his own return to the United States. During a walk along the quais, Cage and Kelly both buy Japanese stencils. *White Relief* (pl. 48), dedicated to Cage, is based on one of those stencils.

On the fourth of July, Coburn and Kelly travel to Brittany, by way of Le Mans, to see the stained glass windows of the cathedral. On the cathedral square, Kelly draws the café tables piled one on top of the other (*Stacked Tables*).

They board the train again for La Baule, and hike along the coast to La Roche-Bernard, and from there they take the bus to Quiberon and then the boat to Belle-Ile. They stay at a hotel for a week. Kelly decides to spend the summer, rents a cottage by the sea, and returns to Paris for several days to close his room at the Hôtel de Bourgogne and put his works in storage.

In Paris the two pay a visit to Gertrude Stein's companion, Alice B. Toklas, and view the Stein collection. Kelly is struck by the Picasso collage *Etudiant à la Pipe* (1913–1914), especially by the form of the student's beret cut from brown paper. La Maison de la Pensée Française exhibits sixty-four recent works by Picasso, works in black and white in which Picasso, especially in *La Cuisine* (1948), eliminates all detail and outlines his forms in black. They return to see the Matisse exhibit at the Musée National d'Art Moderne and the Kandinsky exhibition at

Pablo Picasso, *La Cuisine*, Paris, November 1948
oil on canvas, 69 x 98½
The Museum of Modern Art, New York, Acquired through
the Nelson A. Rockefeller Bequest (photo: © SPADEM, 1992)

Ellsworth Kelly drawing Claude Drevet, Belle-Ile, 1949

Claude Drevet, 1949, pencil on paper, 22¼ x 17

Ellsworth Kelly and Ralph Coburn, Belle-Ile, 1949 (photo: Ellsworth Kelly)

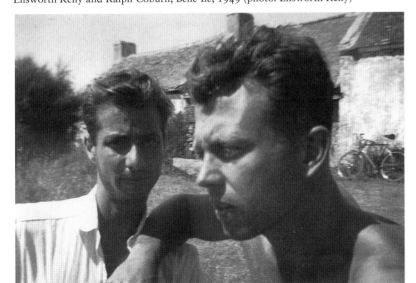

the palm of my hand. In making the painting of it, *Face of Stones* (pl. 24), the rectangle of the wooden panel became a yellow head. *Face of Stones,* because the panel itself is the head, is the first painting that is a literal form." (EK/NB)

Untitled, 1949, lithograph, 19¼ x 12⅛

René Drouin, both of which Kelly had particularly enjoyed, and they go to the Orangerie in the Tuileries where a huge Gauguin retrospective is on view. Kelly returns to Belle-Ile in August. His stay on the island is a rich moment in the development of his work.

Kelly paints *Tavant* (pl. 16): "This work was painted from drawings of a twelfth-century Romanesque head that I had seen in Tavant. A ridge of paint along the left side which formed a relief gave me the idea to sew some thread on the canvas of *Window III* (pl. 31). Then the drawings for the string pieces followed: *Wood*

Cutout with String I, II, and *III* (plates 33, 34, 32) and *Gate-Board* (pl. 42). *Antibes* (pl. 50) also has a line in relief formed by a piece of string. Here for the first time the line begins to disengage itself from the surface of the painting. Later, in the panel paintings, the "line" or "drawing" leaves the surface of the canvas and literally becomes the edge of the panel." (EK/NB)

Instead of inventing new forms, Kelly continues working, as with *Toilette* (pl. 21), from found objects: "During the summer and autumn of 1949 at Belle-Ile, I continued to look at things as objects. Five little white stones made a face in

Studies for *Wood Cutout with String II*, 1949
ink and pencil on paper
32¼ x 9; 14¼ x 10¼

Kelly continues to pursue elementary forms: *Tennis Court* (pl. 28), *Kilometer Marker* (pl. 22), *Seaweed* (pl. 26), *Window I* (pl. 30), and to draw constantly from life.

When he returns from Belle-Ile in October, he resumes residence at the Hôtel Bourgogne (Ralph Coburn has already left for Sanary). He sets to work on his Belle-Ile ideas: he paints and "sews" the string on *Window III* (pl. 31), which he considers his first relief. He goes about Paris collecting ideas in the form of sketches, which he will develop later: drawings of sidewalk grills, rows of chimneys on the sides of buildings, and subway posters.

Kelly makes his first lithograph on the press at the Ecole des Beaux-Arts.

In a letter addressed to John Cage, 4 September 1950, Kelly summarizes the year's work and refers to what he calls his "crazy banjos"—the three reliefs *Wood Cutout with String I, II,* and *III* (plates 33, 34, 32). Kelly has a cabinetmaker in the rue Saint-Louis-en-l'Ile make them, working from contour drawings.

In November, at the Musée National d'Art Moderne, Kelly notices the tall, narrow windows. As a result he forgets about the works he has come there to see and does a series of drawings of the windows, from which he constructs *Window, Museum of Modern Art, Paris* (pl. 36), the first "panel painting" (painting made of joined panels): "Panel paintings were the result of my wanting to completely abandon making lines or marks on the canvas, to eliminate a personal signature through brushwork, and because I clearly no longer wanted to do easel paintings. It seemed to me that painting since the Renaissance had always been some kind of window in which a portrait or landscape was depicted. When you make a line or mark on a panel, you are involved in depiction, and what I wanted expressed was the form of the painting itself. I had been aware of German expressionism, Picasso and the School of Paris, the sculpture of Brancusi, Jean Arp's reliefs, and Schwitters' collages, but I wanted to make a less personal art. Reliefs always interested me, especially Greek and Egyptian. The panel paintings were an outcome of my own reliefs. The paintings became painted reliefs rather than easel paintings, the wall be-

came the ground and the panels became the marks on the wall. The first work that has this literal space is *Window, Museum of Modern Art, Paris* [pl. 36]. It is a replica of a window that does not exist as either window or painting but as painting/object. The actual window is an integral part of the building and was built into the wall; what I did was to build a relief that loses its identity. The flattening of the forms in paintings condenses vision and presents a three-dimensional world reduced to two dimensions. I think that my panel paintings are very different from the paintings of Mondrian and many of the abstract works being done then. The works that led to *Window, Museum of Modern Art, Paris,* are *Plant I* [pl. 17] and *Plant II* [pl. 18], *Face of Stones* [pl. 24], *Kilometer Marker* [pl. 22] and *Window I* [pl. 30]. All strive to be free of the canvas, like the reliefs with string, which become objects. *Window, Museum of Modern Art, Paris* was a great step forward." (EK/NB)

"From then on, painting as I had known it was finished for me. The new works were to be painting/objects, unsigned, anonymous. Everywhere I looked, everything I saw became something to be made, and it had to be made exactly as it was, with nothing added. It was a new freedom: there was no longer the need to compose. The subject was there already made, and I could take from everything; it all belonged to me: a glass roof of a factory with its broken and patched panes, lines of a roadmap, the shape of a scarf on a woman's head, a fragment of Le Corbusier's Swiss Pavilion, a corner of a Braque painting, paper fragments in the street. It was all the same, anything goes. At that time I wrote: Everything is beautiful but that which man tries intentionally to make beautiful. The work of an ordinary bricklayer is more valid than the artwork of all but a very few artists." (Kelly, in Coplans 1971, 28, 30)

The Renaud-Barrault troupe performs *Hamlet* at the Marigny Theater in the André Gide translation, music by Arthus Honegger, and André Masson's spare staging consisting of two black-and-gray curtains with lighting effects. Interested in the space he sees between the curtains, Kelly does a rapid sketch. Always intrigued by the window motif, he does *Relief with Blue* (pl. 47), 1950, after the drawing of 1949.

In December, he leaves for Sanary to rejoin Ralph Coburn who has rented an apartment in the port. They decide to pay a visit to the Picasso Museum at Antibes, where his black and white paintings are on view, works that reinforce the impression of those exhibited in July at the Maison de la Pensée Française.

Ellsworth Kelly, Hôtel de Bourgogne, Paris, 1949
(photo: Ellsworth Kelly)

Studies for *Gate-Board,* 1949
ink on paper, 12⅛ x 17⅛

1950

Kelly returns to Paris to the Hôtel de Bourgogne; from drawings he made at Sanary he does *Window V* (pl. 35), his first shaped painting, and *Gate-Board* (pl. 42): "*Window V* is the projection of light at night from a street lamp shining through an irregular-shaped window onto the wall of my room. The horizontal bands are shadows of telephone wires. A piece of paper was placed onto the image and traced exactly. The projection of light was made palpable by cutting the form out of wood the same size and painting the telephone-wire bands black on a white ground." (Kelly, in Coplans 1971, 33)

Gate-Board took form from the drawings of a gate: "In rural France many houses have metal driveway gates with vertical decorative rods lined up in relief. In *Gate-Board,* this kind of gate was copied. Using a panel for the doors of the gate, I laced string dyed black through holes in the panel." (Kelly, in Coplans 1971, 32)

Kelly meets Michel Seuphor, painter, critic, and historian of the De Stijl movement. Founder of the Circle and Square group with Joaquim Torres-Garcia, Seuphor was one of the first defenders of Mondrian. He has just published the controversial *L'Art Abstrait, ses Origines, ses Premiers Maîtres* with Editions Maeght, in conjunction with the exhibition *Premiers Maîtres de*

l'Art Abstrait at the Galerie Maeght. He visits Kelly's studio and soon after, at the opening of *Hans Richter: Peintures et Rouleaux* at the Galerie des Deux-Iles, he introduces Kelly to Jean Arp.

At the *Premier Salon des Jeunes Peintres,* at the Galerie des Beaux-Arts, from 26 January to 15 February, 1950, Kelly exhibits *Wood Cutout with String III* (pl. 32). Jean Bouret writes in *Arts,* 27 January 1950: "Although the Salon of young painters provides no stunning revelation from anyone in particular exhibiting for the first time, I must mention Jenkins, Kellyellsworth [sic], Rivers, as very talented newcomers." (Bouret 1950)

Picasso's black and white paintings seen the summer before at the Maison de la Pensée Française, and in December at the Château d'Antibes, are inspiration for *Deesis I* and *II* (plates 37, 38), *Romantic Landscape* (pl. 39), and *Medieval Landscape* (pl. 40), made from drawings done in Sanary.

On 17 February Jean Arp invites Kelly, Jack Youngerman, and Ralph Coburn to his studio in Meudon. Arp shows them his work in progress, and the work of Sophie Taeuber-Arp, who died in 1943. "Their collages of 1916–1918 were my first introduction to fragmented forms arranged according to the laws of chance. At the same time,

Brushstrokes Cut into Twenty-Seven Squares and Arranged by Chance, 1951
collage and ink on paper, 4¾ x 14 (photo: Gamma One Conversions, New York)

Ellsworth Kelly and Delphine Seyrig, 1952–1953
(photo: Jack Youngerman)

Delphine Seyrig, 1957
ink on paper, 8½ x 8½

Ellsworth Kelly and *Reliefs*
Paris, 1950
(photo: Sante Forlano)

I began making my own chance collages. Although similar in spirit to those of the Arps, their squared component shapes were regular in size and ordered in predetermined rows. The element of chance was introduced in the random placement of each square and in the resulting patterns of fragmented ink brushstrokes." (Kelly, *Artist's Choice: Ellsworth Kelly, Fragmentation and the Single Form,* exh. cat. The Museum of Modern Art, New York, 15 June–4 September 1990)

Kelly fills his notebooks with sketches and makes reliefs: *Neuilly* (pl. 41), after the flagstones in the garden of the American Hospital at Neuilly; *Saint-Louis I* and *II* (plates 43, 44), after a wall on the Ile-Saint-Louis. During the spring he does a series of collages with discarded drawings, torn up and arranged by chance.

Kelly meets Georges Vantongerloo, a member of the De Stijl group and founder, with Auguste Herbin, of the Abstraction-Création movement (1931). Kelly also meets Alberto Magnelli, and attends one of Francis Picabia's "Sundays." He is impressed by both artists' works, and especially by the last works of Picabia, consisting only of a few small circles of color. In April, at the Galerie René Drouin, Kelly sees a Max Ernst exhibition.

Kelly meets Félix Del Marle, secretary general of the Salon des Réalités Nouvelles, who invites him to exhibit in the fifth Salon. Created in 1946, with the avowed purpose of bringing together non-figurative artists, the salon is international in its calling. The majority of committee members are artists: Fredo Sidès, president and founder; Auguste Herbin, vice-president; Sonia Delaunay, Jean Dewasne, Albert Gleizes, Jean Gorin, Antoine Pevsner, Jean Arp (who quits the committee in 1949 following the stand taken against Michel Seuphor's book on abstract art). *Cahiers Réalités Nouvelles* is published yearly and contains a list of participants, reproductions, and articles. The salon dominates the artistic life of the time; its choices are not always free of dogmatism. The times are characterized by disputes, splits, factions. Kelly and his friends keep themselves informed but separate. The geometric abstraction of Réalités Nouvelles is too indebted to neo-plasticism and constructivism as far as they are concerned.

In May, Kelly makes *White Relief* (pl. 48), then *Relief with Blue* (pl. 47), and *Célestins Relief* (pl. 45), a relief of stonework between two doors, 14, quai des Célestins.

Ellsworth Kelly, Meschers, 1950
(photo: Jack Youngerman)

phine's family: her father, Henri, an archeologist stationed in Beirut, who visits Paris often and who buys *Antibes* (pl. 50), the only painting Kelly sells in France; her mother, Hermine, a writer; and her brother, Francis, a musician (author of the music of the Alain Resnais film *Last Year at Marienbad*).

Kelly pays Jean Arp another visit on 24 June, this time with Ralph Coburn. Several months later he writes to John Cage: ". . . when I visited him again I showed him photographs of my recent work which he liked and said that I was courageous, which I don't quite understand. It was courageous for him in 1916 and for Mondrian and Kandinsky. Benefitting (from) their struggle it is very natural today to continue." (letter to John Cage, 4 September 1950)

Kelly makes his first painting from a collage: *Pink Rectangle* (pl. 54). The four pieces of paper—green, pink, violet, and black with yellow and violet—have been found in the street. It is the first painting in bright colors.

Madame Seyrig invites Kelly to spend the month of August at La Combe, her house in Meschers (Charente-Maritime), where he draws and makes collages and photographs the entire stay. He does numerous sketches of shadows of a railing falling across the steps of a stairway, the source of the *La Combe* series (plates 66, 64, 63, 65).

Kelly writes to John Cage and sends him photos of his recent works: "Last month I visited friends who have a house near Royan and there I was able to do many collages in bright colored

Rue des Deux-Ponts, Paris, 1967
(photo: Ellsworth Kelly)

In June, Kelly, Coburn, and Youngerman show work at the Salon des Réalités Nouvelles. Kelly exhibits *Wood Cutout with String I, II, III* (plates 33, 34, 32), *Relief with Blue* (pl. 47), and *Antibes* (pl. 50). *White Relief* (pl. 48) is refused on the pretext of its not being a work of art.

Jack Youngerman marries a young actress, Delphine Seyrig. At this time Kelly meets Del-

papers. . . . The collages are very pretty, but however are not very practical . . . I shall probably do paintings from them. The problem is the new ideas which are marching so quickly—I have hardly time to finish up old things. . . . My collages are only ideas for things much larger—things to cover walls. In fact all the things I've done I would like to see much larger. I am not interested in painting as it has been accepted for so long—to hang on the walls of houses as pictures. To hell with pictures—they should *be* the

Boulevard de Courcelles, Paris, 1967 (photo: Ellsworth Kelly)

Ile Saint-Louis, Paris, 1967 (photo: Ellsworth Kelly)

Alain Naudé, 1951
pencil on paper, 20¼ x 16¼

To get to the American School, Kelly takes a bus from Ormesson that goes along the quai de Bercy. It is November, the trees have lost almost all their leaves, which serves for the idea for *November Painting* (pl. 61): "The painting was made by tearing up a discarded black-and-white drawing and throwing the pieces onto a white board, which also by chance was lying nearby, ready to be painted on. Kelly then contrived to "find" the pieces of fragmented paper on the surface, and with as little rearrangement as possible, to make a painting." (Coplans 1971, 33–34)

On 27 December Denise René invites Youngerman and Kelly to present their work to the gallery's artists for consideration to exhibit in the gallery. In spite of Denise René's favorable opinion, the paintings are not accepted.

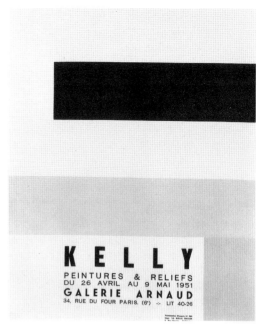

1951

Kelly completes the *La Combe* series (plates 66, 64, 63, 65) in February with his three-dimensional work, *La Combe II* (pl. 64), a folding screen containing nine panels, and is the inspiration for a "directed" work that Kelly gives to a class of twelve-year-olds: "I kept the watercolor of a girl by the name of Elizabeth Huffer and used it as the model for the painting which I called *La Combe IV: Collaboration with a Twelve-Year-Old Girl* [pl. 65]." (EK/NB)

Eduardo Paolozzi, the English sculptor, who has a studio on the Ile-Saint-Louis, introduces Kelly to Louis Clayeux, director of the Galerie Maeght.

Jean-Robert Arnaud and John Franklin Koenig own a bookshop on the rue du Four, near Saint-

wall—even better—on the outside wall—of large buildings. Or stood up outside as billboards or a kind of modern icon. We must make our art like the Egyptians, the Chinese and the African and Island primitives—with their relation to life. It should meet the eye—direct." (letter to John Cage, 4 September 1950)

With his funding from the G.I. Bill about to end, Kelly accepts a position at the American School, where he teaches art to children.

In September he goes to stay at Ormesson in the summer house of Nicole Ladmiral. Ladmiral, who will star in Robert Bresson's *Diary of a Country Priest*, is the wife of Francis Seyrig. It is through Seyrig that Kelly makes the acquaintance of Alain Naudé, a South African pianist who has come to study with Nadia Boulanger, and who shares a studio at the Cité Universitaire with a Tunisian painter, George Koskas, whose research coincides with that of Kelly and his friends.

In October, Jack Youngerman participates in the exhibition *Les Mains Eblouies* at the Galerie Maeght, along with Pierre Alechinsky, Eduardo Chillida, and Corneille.

From drawings of chimneys on the walls of buildings he does *Ormesson* (pl. 58). Each of its three contiguous panels represents a wall from a different neighborhood of Paris (see page 187).

Galerie Arnaud, Paris, May 1951 (photo: Sante Forlano)

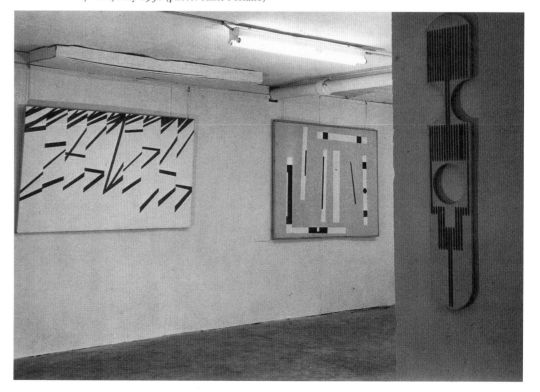

Germain-des-Près. John Koenig is well acquainted with the American colony in Paris, in particular a friend of Delphine Seyrig, Dick Seaver. Seaver introduces Kelly, Youngerman, and Koskas to Arnaud. These three convince Arnaud and Koenig to turn the cellar of the shop into a gallery and open it to artists of their generation, at the same time asking older and more established artists like Henri Nouveau and César Domela to provide backing. They will be the first artists to exhibit and they assume an active role in renovating the space. Only a few galleries are exhibiting the work of young artists: Denise René (though she deals only in geometric abstraction) and the Colette Allendy Gallery (considered out of the mainstream). The market is practically nonexistent. The idea is to break the monopoly of Réalités Nouvelles. Involved in the launching of the gallery, Kelly makes an appeal to Michel Seuphor and together with Koskas and Youngerman solicits support from Henri-Pierre Roché "to get the art world to come to the Galerie Arnaud." It is at Roché's that Kelly sees his first Duchamp: *Rotative Demi-Sphère (optique de precision), 1925.*

Youngerman opens the gallery; Kelly follows him from 26 April to 9 May, exhibiting thirty works made between June 1949 and April 1951. None is sold. The exhibition does, however, encounter some critical response. In the *Observateur* of 10 May, Charles Estienne scans the exhibitions (there is in Paris at the time an exhibition of mosaics from Ravenna at the Musée de la Fresque): "It is this interior fabric of individual pictorial thought and of the collective thought of an age that sheathes with so great a certainty and not only decoration, the cupolas of the cathedral of Ravenna and the Arians' baptistery. That common adherence from within that, it seems to me, is the only valid basis of order. And is it called classical or human? Today, it is no mystery, we are still rather wide of the mark; and in art, romanticism and individual lyricism still have something to say. A certain abstract classicism based on geometry, it seems to me, is sooner or later inevitable: the rectangular panels and reliefs of the American Kelly, for example (Galerie Jean-Robert Arnaud)." (Estienne 1951a)

The "Flâneur des Deux Rives" in the *Nouvelles Littéraires* of 3 May: "The paintings and reliefs of Kelly at the Galerie Arnaud have the wherewithal to seduce the admirers of Mondrian and Vantongerloo."

The *Arts* critic, 4 May: "American, Kelly gives us the fruit of an extended rational investigation into abstraction and pictorial composi-

Original sketch for *Cité,* 1951
ink on paper, 1⅞ x 2⅛

tion. He intentionally cultivates broken rhythms, fragmented areas of color, and studied fragmentation. He returns to the old Russian suprematist strategy of white on white. Kelly works lovingly and with sincerity. In him, the spirit of investigation that formerly reigned with such ruthlessness at the Bauhaus is reborn at Saint-Germain-des-Près." (G.B. 1951)

Combat, 8 May: "We would have grouped together these two painters whose exhibitions follow one after the other (Youngerman and Kelly), so similar are these works in appearance.

They have a common quality: the spirit of investigation that informs them is practically identical. But unlike the paintings of Youngerman, those of Kelly are the work of a pure technician whose concern in fact seems to be painting/objects. His abstraction is much colder and his relentless stripping away attains a pure white inflected only by his lines. This austerity is in no way deficient and Kelly's work has the merit of demonstrating that extreme economy guided by responsive reasoning can be something positive." (Combat 1951)

At the sixth Salon des Réalités Nouvelles, Kelly exhibits *Ormesson* (pl. 58); *Rouleau Bleu* (pl. 57); *La Combe IV: Collaboration with a Twelve-Year-Old Girl* (pl. 65).

A special issue of *Art d'Aujourd'hui* (June) is devoted to painting in the United States, with an article by Julien Alvard, "Quelques Jeunes Peintres Americains de Paris": "I try to put myself in the place of one of these young American painters who, one day, decides to come to Europe. What does he expect from this land where the most backward prejudice still reigns; where material life takes its cue so unwillingly from modern discoveries; what does he expect from this Paris that is infatuated with itself, tired of its traditions, and proud of its past, this Paris where greatness no longer seems imperative since political greatness has abandoned it.

Ellsworth Kelly in front of *Cité,* 1951 (*Cité* is upside-down) (photo: Sante Forlano)

Isn't it now the capital grown old and adorned of a West that has long since passed its maturity and is slowly rotting in its shallow Byzantinism. What is there to say of this supposed superiority in the arts, this imperialism that is no longer anything but the shadow of a shadow? Newly sprouted strengths on one hand and the other are part of this exhausted world. There are many important-sounding persons that go repeating again and again like an echo that France is the new Athens, and that revel in fashioning phrases that are more hollow than vain. But who believes them? Their words provoke open laughter. Light will come from another quarter henceforth . . . and yet! And yet young American painters still come to Paris. For them it is not a question of being in the avant-garde at any cost. Being brand new, reinventing everything is not the purpose of a determined will. Innocence is a virtue only once every thousand times. And who wouldn't consent to go astray, run the terrible risk of falling into narcissistic error. Follow in the wake of Mondrian, Kandinsky, Max Ernst? It is easy to do in America, but Europe has nothing more to learn from them. Technicians and romantics confront one another in New York and in San Francisco as they do in Paris or in Rome. But the styles, the ideas, the tastes are at the same time more trivial and more profound in Paris. More trivial because, constantly open to question, they remain pliable; more profound because the artist searches in them for himself above all as man. In this disorder, which is the surest guarantee of independence and the most precious thing Paris has to offer, in these little combats where temperaments confront one another without apparent ceremony, the painter tests himself, opts for himself, finds himself in a simpler and more natural way.

The seven painters that occur and confront one another on these pages are all independents. Some are not even known to one another. They are going where their instinct takes them. Some of them—puristical and blithe—with that extreme clarity of their youth, give themselves up to speculative plasticity with vigor like Kelly, or with great poetic verve like Youngerman. . . ." (Alvard 1951)

Cité (pl. 68) is a work glimpsed in a dream. Kelly is absorbed in his studies with chance and his work with children. "I dreamt that I was working on a scaffold with a lot of children, creating an immense mural composed of square panels on which we painted black bands with huge brushes." (EK/NB)

That morning Kelly hastens to jot down the work on his cafe receipt. Later he makes a draw-

Vertical Band (from *Line, Form and Color*), 1951
collage on paper, 7¼ x 8

Horizontal Band (from *Line, Form and Color*), 1951
collage on paper, 7¼ x 8

ing and cuts it into twenty squares that he arranges randomly (Study for *Cité*). "A week later I left for Meschers. I had a cabinet-maker cut out twenty square wood panels. When the painting was finished I stood out on the balcony and had my friend (Alain Naudé) vary the order of the squares. I thought it could be modified indefinitely. I decided, however, that it was the original drawing/collage that produced the best result and so I set the panels permanently." (EK/NB)

Cité is entitled *Le Rêve* when it is exhibited for the first time. *Meschers* (pl. 67) and *Talmont* (pl. 69) are developed in the same way, but each is painted on a single canvas.

Kelly is dismissed from the American School because of his abstract painting (following the ex-

hibition at the Galerie Arnaud). After a thorough FBI investigation, Kelly obtains a night watchman's job within the framework of the Marshall Plan.

Robert Bresson shows Youngerman and Kelly a preview of his film *Diary of a Country Priest*.

Times are difficult, as much for Jack Youngerman as for Kelly. They apply for a foundation grant by writing Baroness Hilla Rebay, director of the Guggenheim Museum in New York, an old friend of Jean Arp, and herself an artist.

Kelly then applies for a Guggenheim fellowship. A topic is required and Kelly proposes the book *Line, Form, Color*: "This book will be an alphabet of pictorial elements, without text, whose purpose it will be to aid in establishing a larger scale for painting, a closer contact between the

Invitation for *Tendance* exhibition, Galerie Maeght, Paris, 1951

Invitation for *Exposition des Peintures de Ellsworth Kelly,* Galerie Maeght, Paris, 1958

Georges Braque, *L'Atelier IX,* 1952–1953
oil on canvas, 57½ x 57½, Paris, Centre Georges
Pompidou, Musée National d'Art Moderne
(photo: © AGAGP, 1992)

artist and the wall, and a new spirit in contemporary architecture" (excerpt from Kelly's proposal).

Since the proposal must be furnished with references, Kelly petitions Arp, who agrees to sponsor him. *Line, Form, Color* is approximately forty pages long. It begins with a horizontal line, then a vertical, a diagonal, a grid, a square, a triangle, a circle, etc., and finally different color combinations. It is never published.

The Boston Museum School celebrates its seventy-fifth anniversary in September with an exhibition of works by former students. Kelly sends *La Combe III* (pl. 63). After the exhibit it will be sent directly from Boston to John Cage in New York, where it will stay until Kelly's return in 1954.

With Alain Naudé and Jack Youngerman, Kelly visits Brancusi in his studio, impasse Ronsin: "Constantin Brancusi's volumetric sculptures are simple forms. For me, his masterpieces are *Fish* (1930) and *Bird in Space* (1928), which rise

above their bases as unique shapes. While visiting Brancusi in his Paris studio in 1950, I was impressed by the purified nature of his abstraction and by his creation of simple, often solitary forms. For me, his art was an affirmation; it strengthened my intention to make art that is spiritual in content." (from Kelly, *Artist's Choice: Fragmentation and the Single Form,* exh. cat. The Museum of Modern Art, New York, 15 June–4 September, 1990)

In October, Louis Clayeux organizes the exhibition *Tendance* at the Galerie Maeght, bringing together five artists: Jacques Germain, Pablo Palazuelo, Pierre Pallut, Serge Poliakoff, and Ellsworth Kelly; he exhibits four of Kelly's works done during the year: *Cité* (pl. 68), *Gironde* (pl. 70), *Talmont* (pl. 69), and *Meschers* (pl. 67) (entitled at that time: *Le Rêve I, Le Rêve II: Entrée dans Bangor, Le Rêve III: Eté,* and *Le Rêve IV: Meschers*).

Charles Estienne, who has just published *L'Art Abstrait est-il un Académisme?,* writes "L'Art est une Réalité" for *Derrière le Miroir:* ". . . And in truth, there are no tendencies here, by that I mean those bizarre plastic verities that unify groups. There is rather a general tendency. . . . As far as I'm concerned, it seems much more interesting to take account of how different human temperaments—therefore responding differently to plastic reality—have more or less bundled their ways of approaching the profound reality of things, that reality which today cannot be rediscovered, first of all, except within each one of us. And that is why they are all obviously—and very naturally—nonfigurative. And

Design for Fabric, 1951
ink on paper, 20 x 29¾

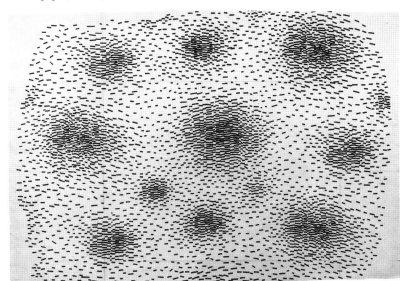

Fabric Design II, 1951
silk, 8½ x 12

certainly Palazuelo, and especially Kelly, seem to protect and almost hide their rigor beneath the choice, the manner, the rigor of plastic means. . . . So then, where is the common tendency? Not only in nonfiguration; not only in the recognition or acceptance of the abstract fact; I sense it rather in the progress, in the obscure thrust of that art—expression of still young but already mature painters—toward an autonomy which is neither refusal nor separation, but a taking in hand again, through the proper means of art, of a reality—and that is the real problem—which has simply but imposingly changed its place. . . . The art whose evidence we see here is not realist and it does not have to be, because it is already, of itself, a reality." (Paris 1951c)

Georges Braque visits the exhibition and pauses for a long time in front of *Meschers* (pl. 67). Marguerite Maeght later confides to Kelly that this painting suggested to Braque a pictorial solution to him for *L'Atelier IX, 1952–1953,* which he was completing at that time. Braque is not the only one interested in *Meschers;* Gustav Zumsteg, an important Swiss textile manufacturer, art collector, and close friend of the Maeghts, asks Kelly to draw fabric designs for him. Kelly accepts the offer and resigns from the Marshall Plan job.

Seine (pl. 71) is the outcome of several studies of his observations of water and reflected light and a means of testing strategies of chance. The final study is realized in the following way: Kelly draws a grid forty-one rectangles high and eighty-two rectangles long. From a box containing forty-one numbered pieces of paper he takes the first number. In the first column he marks the rectangle corresponding to the number, puts the piece of paper back into the box, and takes out two more for the next column, and continues in that way until he gets to the center of the grid, then carries out the operation in reverse to the opposite side of the grid.

The collages, *Spectrum Colors Arranged by Chance I* through *VIII,* are realized in a similar manner but with a square format. Kelly practices the art of collage intensively. *Study for White Plaque: Bridge Arch and Reflection* captures the form of the arch of the Tournelle Bridge and its reflection in the water. It is only in 1955, after his return to New York, that the arcs will be cut out of wood to make a shaped painting (pl. 95).

In November, Kelly returns to Sanary where he settles with Ralph Coburn, Anne Weber, a friend from the Boston Museum School, and

Anne Weber in dress designed by Ellsworth Kelly, Sanary, 1952

Alain Naudé, who gradually forsakes the piano for painting. Kelly paints *Colors for a Large Wall* (pl. 74): "A painting in sixty-four panels, the first painting of multiple panels, in which each panel is only one color. There is neither form nor ground in the painting. The painting is the form and the wall is the ground. . . . a work midway between painting and sculpture." (EK/NB)

Kelly spends Christmas in Saint-Paul-de-Vence at the Colombe d'Or with the Maeghts, Louis Clayeux, and Gustav Zumsteg. Dominican priest, Jacques Laval, art enthusiast and friend of Naudé, suggests Kelly and Naudé visit the Dominican convent at Saint-Maximin, where they have lunch in the refectory surrounded by the abstract paintings of Manessier, Lanskoy. . . .

1952

From 18 January to 1 February, the Galerie Bourlaouën in Nantes presents *Abstractions,* including the work of Arnal, Dmitrienko, Mavignier, Morellet, Youngerman, and Kelly. The promoter is Almir Mavignier, a Brazilian artist strongly influenced by concrete art and Max Bill. François Morellet is a young artist from the provincial town of Cholet where he has taken over his father's factory. When war breaks out in Korea he decides to leave for Brazil. In Rio de Janeiro, Almir Mavignier introduces Morellet to Brazilian artistic circles, and later, in

Paris, presents him to Jack Youngerman, Naudé, and Kelly. Living very much on the periphery of the art world, the four of them form, as Morellet calls it, "a clique without knowing it. . . ." There was a Puritan ethic; there was an enormous reaction against the School of Paris. They have in common the desire to follow a course apart from the geometric abstractionists, the Salon des Réalités Nouvelles, and the great debates of the time: "Our great mania of the 1950s, the absence of composition, the 'all over' . . . for me it was a moral question, composition, it is symmetrical, it is asymmetrical—good taste." (conversation, François Morellet/NB)

Kelly remains in Sanary until May. In the South of France, Kelly has the opportunity to use stronger color: *Two Yellows* (pl. 76), *Sanary* (pl. 73), *Painting for a White Wall* (pl. 81), *Red Yellow Blue White* (pl. 77), the latter made with fabric bought in Sanary. His use of dyed cotton emphasizes the anonymous aspect of the surface. With the same material he designs a dress for Anne Weber.

Kelly goes to Marseilles to see Le Corbusier's apartment house, L'Habitation: "The wide slabs in primary colors on the balconies surprised me, but, I thought that Le Corbusier was using color in a decorative way. I wanted to use color in this way, over an entire wall, but I didn't want it to be decorative." (EK/NB)

Later, in 1953, Alain Naudé meets Le Corbusier and shows him slides of Kelly's work *Kite I* (pl. 83), *Colors for a Large Wall* (pl. 74), and *Méditerranée* (pl. 75) and tells how "he asked for details about their dimensions, and added that young artists like ourselves could do whatever we wanted, but that our art called for a new architecture and that the problem was that there wasn't any!" (EK/NB)

Art d'Aujourd'hui publishes a special issue: *Le Graphisme et L'Art,* series 3, nos. 3 and 4, February–March 1952. The poster made by Kelly for the exhibition of his paintings at the Galerie Arnaud is reproduced in an article by Roger Gindertael, "L'Art au Service de la Publicité." The first Pollock exhibition takes place at Studio Facchetti (March), but because he is in Sanary, Kelly does not see it.

In May, Kelly leaves Sanary for Torcy, a village on the Marne, where he joins Naudé at the villa "Les Charmettes," owned by a friend, Joanna Wieder. In an interview with Paul Taylor, he discussed the effect of Monet's late work on his own art: "In 1952, I began to wonder what—

happened to Monet in his last years. So I wrote to his stepson in Giverny and was invited to visit. He took us out to the big studio where all the paintings of water lilies were kept. There must have been at least a dozen huge paintings, each on two easels. There were birds flying around. The paintings had been abandoned, really. And one of the things I remember most was one painting, a huge one, that was all white, very heavily painted. There was some orange and some pink maybe, and some pale green. And in the middle of it was a big, jagged cut. The stepson said that Monet had slashed it himself. And then we went into a second studio, and there must have been a hundred paintings there of medium size that were just jammed together. When we went back to Paris and talked to dealers about the paintings, everyone said that Monet was color-blind toward the end of his life and that these paintings were worthless. But we kept talking about them, and eventually the Museum of Modern Art purchased one of them.

PT: *Were they an inspiration for your own paintings?*

EK: I liked the quality of the painting. Monet was losing his sight and was fascinated by the movement of the leaves underwater. And the scale was also impressive. Of course, there are all the huge Davids and Géricaults in the Louvre, and when I saw them, I realized I wanted to do paintings their size, the size of walls. But if you don't have any money and have only a small hotel room, you can't do things like that. The day after I visited Giverny I painted a green picture, a monochrome [*Tableau Vert,* pl. 89]. I had already done paintings with six different color panels, but now I wondered if I

could do a painting with only one color. So that is my Monet influence." (from Paul Taylor, *Interview* 21, no. 6, June 1991, 102)

Pierre Reverdy, Aimé Maeght, and Louis Clayeux come to Torcy. Kelly hangs his paintings on a wall in the grounds. Reverdy remarks that since Braque and Picasso he has not seen two artists who work together as well as Alain Naudé and Kelly. Kelly paints *Fête à Torcy* (pl. 79), *Tableau Vert* (pl. 89), *Kite I* and *II* (plates 83, 82) at Torcy.

In August, *Primera Muestra Internacional de Arte Abstracto* opens at the Galerie Quatro Muros in Caracas, organized by the Venezuelan journalist José Bricenio. Youngerman, Coburn, and Kelly send pictures. Several works mysteriously disappear and are never returned. Kelly sends *Red Yellow and Blue* (pl. 59), *Royan* (pl. 60), and *Fond Rouge* (pl. 53). The latter work is recovered with the help of Alexander Calder in 1956.

In September, Kelly moves to a studio at Cité des Fleurs.

Kelly appears again in *Tendance* at Galerie Maeght, this time with Olivier Debré, Jean Degottex, Alain Naudé, and Pablo Palazuelo.

He exhibits *Méditerranée* (pl. 75), *Colors for a Large Wall* (pl. 74), *Sanary* (pl. 73), and *Fête à Torcy* (pl. 79). Michel Seuphor writes in *Derrière le Miroir*: ". . . And here we are before the American Kelly. He is a rhythm-maker of surfaces, whose style is quietly assuring and

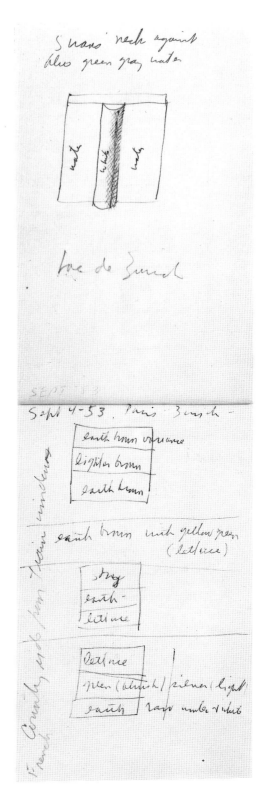

Pages from a Sketchbook, 1953
ink and pencil on paper, 6½ x 4½

Geert-Jan Visser, 1953
pencil on paper, 19⅛ x 25⅛

truly distinctive. His virtuosity is made dazzling by the very sobriety of his means. Here again, as with Palazuelo, we see that the patient lesson of Mondrian bears fruit—and fruit having its own particular savor to be sure. The art of Kelly is transparent and gentle like the morning air at high elevation. I would like to see him design work for large airports, all suffused in light. His simple, carefully harmonized designs would be like a precise, sweet piece of music helping the spirit to lift off to the high tableland of a conceivable perfection where everything would be repose." (Paris 1952)

1953

In January, Kelly sees Samuel Beckett's *Waiting for Godot,* with staging by Roger Blin, produced at the Babylone Theater.

Exposicion International de Arte Abstracto in Santander at the Museo de Arte Contemporaneo: France is represented by Bellegarde, Damian, Deyrolle, Dmitrienko, Natalia Dumitresco, Gilioli, Istrati, and Poliakoff. Kelly exhibits *Dominican* (pl. 78).

In the spring, working for Zumsteg in Zurich, Kelly meets Geert-Jan Visser, a Dutch student, who later collects Kelly's work. "On a train from Paris to Zurich in September 1953 he studied landscapes, reading them in terms of color areas. The paintings he imagined would be squarish (the same proportions as the train window) and composed of horizontal bands of color. The most literal was "Sky/Earth/Lettuce"— blue over red-brown over green. A painting of this type was made that year, its bands of green over dark green over yellow derived from fields of lettuce, spinach, and mustard (*Train Landscape* [pl. 80])." (from Trevor J. Fairbrother,

Ellsworth Kelly: Seven Paintings [1952–55/1987], exh. cat. Museum of Fine Arts, Boston, 1987)

At the Cité des Fleurs, Kelly does *Tiger* (pl. 85), *Train Landscape* (pl. 80), *Spectrum I* (pl. 88), *Red Yellow Blue White and Black* (plates 84, 87), *Red Yellow Blue White and Black with White Border* (pl. 86), *Spectrum Colors Arranged by Chance* (pl. 72), *Black, Two Whites* (pl. 92), *White, Two Blacks* (pl. 93). "*Black Square* (pl. 90) and *White Square* (pl. 91) are the last paintings completed in Paris. The inspiration for these works were the panes of a glass enclosure used in winter around a café terrace. After measuring the squares of glass and their metal frames, I had an ébeniste construct them in wood, and then painted them. Thus, my first important work in Paris begins with the *Window, Museum of Modern Art, Paris* (pl. 36) and ends with *Black Square* and *White Square* an idea of space seen through glass as a monochrome." (EK/NB)

Kelly meets Marcel Breuer, who is in charge of the UNESCO headquarters project in Paris, hoping to get a mural commission. He meets Alexander Calder, whose friendship he will cherish once he is back in New York. In the autumn of 1953, Kelly is evicted from his studio at Cité des Fleurs, because another artist, a friend of the landlord, wants the studio for himself. This is the beginning of the end of his stay in Paris.

François Morellet's parents, who live in the rue de Rivoli, offer him temporary use of the maid's quarters.

On 21 October, Kelly receives a letter from Michel Seuphor whom he had informed of his difficulties and of the fact that, without a studio, he was obliged to put his works in storage. Seuphor writes: "Of all the serious successors to

Mondrian I think that you will be the best. It is a shame that we may not have access to your magnificent works for several months."

At the invitation of Geert-Jan Visser's parents, Kelly spends Christmas in their home at Papendrecht, near Rotterdam. Visser takes him to see the Mondrian collection of Solomon Slijper, who shows them a few of the early works but none of the abstract paintings. At that time there are no Mondrians in Paris museums or galleries, so Kelly is to see for the first time a group of late Mondrian paintings at the Boymans Museum in Rotterdam.

1954

Kelly works primarily on collages. His eviction from the studio at Cité des Fleurs, the scant recognition accorded his painting, and the small space in which he is now compelled to work— disappointments are piling up. William Sandberg has proposed to do an exhibition in Amsterdam of the young Americans in Paris and has invited Kelly to participate, but the project is canceled.

From 2 February to 9 March Kelly is treated at the American Hospital for jaundice and emerges severely weakened. The family of Geert-Jan Visser suggests he convalesce at Papendrecht. Kelly stays there for a time and makes collages. He goes back to Paris and collects his things to return to America. At Brentano's he reads an article in the December 1953 issue of *ArtNews* on the Ad Reinhardt exhibition at the Betty Parsons Gallery. The paintings reproduced in the article make him think that his paintings would be well-received there. His involvement with questions of scale and architecture seem to him to be better suited to the New York artistic climate. In July 1954, Kelly leaves France on the Queen Mary.

Appendix: Paintings

Oradell, New Jersey, and Boston, 1940–1948

Grain Elevator, 1940, oil on canvas board, 17⅞ x 24 in, EK X.1

Ailanthus, 1948, oil on canvas, 13 x 18 in, EK B.20

Marion, 1946, oil on wood, 23¾ x 17⅝ in, EK B.1

Portrait of a Woman, 1947, oil on wood
36 x 24 in, EK B.26

Nude, 1947–1948, oil on wood, 30 x 23⅞ in, EK B.34

Nude, 1947–1948, oil on wood
48 x 24 in, EK B.39

Nude, 1947–1948, oil on canvas
48¼ x 24¼ in, EK B.28

Sherman, 1947, oil on wood, 34 x 24 in, EK B.25

Nude, 1947–1948, oil on canvas
40 x 20 in, EK B.33

Nude, 1947–1948, oil on canvas
48 x 24 in, EK B.29

Head of a Woman, 1947, oil on wood
23¾ x 14½ in, EK B.10

Woman in a Red Dress II, 1947, oil on wood
30 x 23⅞ in, EK B.12

Self-Portrait, 1947, encaustic on wood, 20 x 16 in, EK B.4

Self-Portrait with Bugle, 1947
oil on paper mounted on masonite
65¼ x 24⅞ in, EK B.6

Head of a Young Man, 1947, oil on wood, 17½ x 13⅜ in
EK B.8

Self-Portrait with Thorn, 1947, oil on wood
35¾ x 23⅞ in, EK B.5

Portrait of a Man, 1947, oil on wood, 22⅛ x 20 in, EK B.13

Gladys, 1948, oil on canvas, 30 x 22¼ in, EK B.19

Landscape with Doris, 1948, oil on canvas, 31¾ x 36⅛ in, EK B.24

Henry Devlin, 1947, oil on wood, 29⅞ x 23⅞ in, EK B.16

Doorway, 1947, oil on canvas
36 x 22 in, EK B.14

Laura, 1948, oil on canvas, 19 x 13½ in, EK B.21

Still Life with Doll, 1947, oil on wood
48 x 23½ in, EK B.2

Untitled, 1947, oil on wood, 18 x 24 in, EK B.18

Grain Elevator, 1940
oil on canvas board
17⅞ x 24 (45.4 x 61)
Inscriptions, verso: lower left, GRAIN ELEVATOR / ORADELL, NEW JERSEY
1940; lower right, KELLY
EK X.1

Marion, 1946
oil on wood
23¾ x 17⅝ (60.3 x 44.8)
Inscriptions, verso: upper left, B1; upper right, EK 1946;
center, MARION; bottom (upside down) KELLY
EK B.1

Still Life with Doll, 1947
oil on wood
48 x 23½ (121.9 x 59.7)
Inscriptions, recto: lower left, KELLY
Inscriptions, verso: upper right, K3;
upper stretcher bar, 1946–47 DOLL-CLOTHES-FORM
EK B.2

Boy in a Tub, 1947
oil on canvas
24 x 48 (61 x 121.9)
Inscriptions, recto: lower right, KELLY
Inscriptions, verso: KELLY
EK B.3

Self-Portrait, 1947
encaustic on wood
20 x 16 (50.8 x 40.6)
Inscriptions, recto: lower right, EK
Inscriptions, verso: upper left, B4 20 x 16; upper right, 1947
EK B.4

Self-Portrait with Thorn, 1947
oil on wood
35¼ x 23⅞ (90.8 x 60.6)
Inscriptions, recto: upper left, KELLY
Inscriptions, verso: upper left, EK5; upper right, KELLY
EK B.5

Self-Portrait with Bugle, 1947
oil on paper mounted on masonite
65¼ x 24⅞ (165.7 x 63.2)
Inscriptions, recto: upper left, KELLY
Inscriptions, verso: top, ELLSWORTH KELLY / EK#B6 BOSTON;
upper left, OIL ON PAPER/MASONITE; upper right, 1947
EK B.6

Norfolk House, 1947
oil on canvas
48⅛ x 29¾ (122.2 x 75.6)
Inscriptions, recto: lower right, KELLY
Inscriptions, verso: upper stretcher bar, right, ELLSWORTH KELLY;
lower stretcher bar, PLAYGROUND
EK B.7

Head of a Young Man, 1947
oil on wood
17½ x 18⅛ (44.5 x 34)
Inscriptions, verso: upper right, 1947; lower left, B10 [crossed out]
B8 / BOSTON; lower right, KELLY
EK B.8

Onni, 1947
oil on canvas mounted on wood
17 x 12½ (43.2 x 31.8)
Inscriptions, verso: upper left, ONNI B–9; upper right, 1947 EK
EK B.9

Head of a Woman, 1947
oil on wood
23¾ x 14½ (60.3 x 36.8)
Inscriptions, verso: upper left, B10; upper right, 1947
EK B.10

Woman in a Red Dress I, 1947
oil on wood
30 x 20 (76.2 x 51)
Inscriptions, verso: upper left, B11; upper center (upside down), KELLY
EK B.11

Woman in a Red Dress II, 1947
oil on wood
30 x 23⅞ (76.2 x 60.6)
Inscriptions, recto: upper right (partly painted out), KELLY
Inscriptions, verso: upper left, B12 / (upside down) KELLY
EK B.12

Portrait of a Man, 1947
oil on wood
22⅛ x 20 (57.5 x 50.8)
Inscriptions, verso: upper left, B13 / 22⅛ x 20; upper right, 1947
EK B.13

Doorway, 1947
oil on canvas
36 x 22 (91.4 x 55.9)
Inscriptions, verso: upper stretcher bar, left, B14
EK B.14

Henry Devlin, 1947
oil on wood
29⅞ x 23⅞ (75.9 x 60.6)
Inscriptions, verso: upper right, EK47 (crossed out) SWAN; center, B16
EK B.16

Boy with Sailboat, 1947
oil on wood
20 x 16 (50.8 x 40.6)
Collection of Mrs. Linda Kelly Rogazewski, Haddonfield, New Jersey
EK B.17

Untitled, 1947
oil on wood
18 x 24 (45.7 x 61)
Inscriptions, verso: top, BOSTON B–18 18 x 24; center, PENCIL SKETCHES;
lower left, KELLY
EK B.18

Sherman, 1947
oil on wood
34 x 24 (86.4 x 61)
Inscriptions, verso: upper left, B25 34 x 24; upper right, 1947 EK 47;
bottom (upside down), KELLY
EK B.25

Portrait of a Woman, 1947
oil on wood
36 x 24 (91.4 x 61)
Inscriptions, verso: upper left, B–26; upper right, EK '47
EK B.26

Nude, 1947–1948
oil on wood
48 x 24 (121.9 x 61)
Inscriptions, verso: lower left (sideways) B27/ (upside down) KELLY
EK B.27

Nude, 1947–1948
oil on canvas
48¼ x 24¼ (122.6 x 61.6)
Inscriptions, recto: lower right, KELLY
Inscriptions, verso: upper left, B28; upper stretcher bar, B28 KELLY
EK B.28

Nude, 1947–1948
oil on canvas
48 x 24 (121.9 x 61)
Inscriptions, verso: upper left, B29; upper stretcher bar, B29 KELLY
EK B.29

Nude, 1947–1948
oil on canvas
40⅛ x 25 (101.9 x 63.5)
Inscriptions, verso: upper left, B30;
upper stretcher bar (upside down) B30 KELLY
EK B.30

Nude, 1947–1948
oil on wood
48 x 24 (121.9 x 61)
EK B.31

Nude, 1947–1948
oil on wood
36 x 24 (91.4 x 61)
Inscriptions, verso: upper left, B32; upper right, KELLY; diagonally, KELLY
EK B.32

Nude, 1947–1948
oil on canvas
40 x 20 (101.6 x 50.8)
Inscriptions, verso: upper left, B33; upper stretcher bar, right, KELLY
EK B.33

Nude, 1947–1948
oil on wood
30 x 23⅞ (76.2 x 60.6)
Inscriptions, verso: upper left, B34; upper right, KELLY
EK B.34

Nude, 1947–1948
oil on canvas
36¼ x 23⅞ (92.1 x 60.6)
Inscriptions, verso: upper right, B35
EK B.35

Nude, 1947–1948
oil on canvas
27 x 18 (68.6 x 45.7)
Inscriptions, verso: upper left, B36
EK B.36

Nude, 1947–1948
oil on wood
30 x 24 (76.2 x 61)
Inscriptions, verso: upper left, B37; center (upside down), KELLY
EK B.37

Nude, 1947–1948
oil on wood
36 x 23⅞ (91.4 x 60.6)
Inscriptions, verso: upper left, B38
EK B.38

Nude, 1947–1948
oil on wood
48 x 24 (121.9 x 61)
Inscriptions, verso: upper right, B39 KELLY
EK B.39

Nude, 1947–1948
oil on canvas
36 x 24 (91.4 x 61)
Inscriptions, verso: upper left, B40; diagonally, KELLY
EK B.40

Gladys, 1948
oil on canvas
30 x 22¼ (76.2 x 57.8)
Inscriptions, verso: upper right, EK '48
EK B.19

Ailanthus, 1948
oil on canvas
13 x 18 (33 x 45.7)
Inscriptions, recto: lower left, EK
EK B.20

Laura, 1948
oil on canvas
19 x 13½ (48.3 x 34.3)
EK B.21

Shoes, 1948
oil on canvas
30 x 40⅛ (76.2 x 101.9)
Inscriptions, recto: upper left, KELLY
Inscriptions, verso: upper stretcher bar, B23 BOSTON EK 1948;
vertical stretcher bar, SHOES
EK B.23

Landscape with Doris, 1948
oil on canvas
31¾ x 36⅛ (80.7 x 91.8)
Inscriptions, recto: center bottom, KELLY
Inscriptions, verso: left vertical stretcher bar, LANDSCAPE WITH DORIS;
upper stretcher bar, B–24 ELLSWORTH KELLY
EK B.24

Select Bibliography and Exhibition History

Alvard 1951
Alvard, Julien. "Quelques jeunes américains de Paris." *Art d'Aujourd'hui* 6 (June 1951), 24–25

Amsterdam 1979
Ellsworth Kelly: Schilderijen en beelden 1963–1979. Essay by Barbara Rose. Exh. cat. Stedelijk Museum. Centre national d'art et de culture Georges Pompidou, Musée national d'art moderne, Paris, and Staatliche Kunsthalle, Baden-Baden

Anderson 1980
Anderson, Susan Heller. "Paris Hails Ellsworth Kelly, Foster Son, and his Art." *The New York Times*, 26 July 1980

Annandale-on-Hudson 1985
The Maximal Implications of the Minimal Line. Exh. cat. The Edith C. Blum Art Institute, Bard College

Armstrong 1987
Armstrong, Elizabeth, et al. *Tyler Graphics: The Extended Image.* Minneapolis, 1987

Art in America 1957
"New Talent in the U.S." *Art in America* 45 (March 1957), 13–33

Ashton 1968
Ashton, Dore. "New York Commentary: 'The Art of the Real' at the Museum of Modern Art." *Studio International* 176 (September 1968), 92–93

Axsom 1987
Axsom, Richard H. *The Prints of Ellsworth Kelly: A Catalogue Raisonné 1949–1985.* New York, 1987

Baden-Baden 1980
Ellsworth Kelly: Gemälde und Skulpturen 1966–1979. Exh. cat. Staatliche Kunsthalle

Baker 1973
Baker, Elizabeth C. "The Subtleties of Ellsworth Kelly." *ArtNews* 72 (November 1973), 30–33

Battcock 1968
Battcock, Gregory. "The Art of the Real: The Development of a Style 1948–1968." *Arts Magazine* 42 (June/Summer 1968), 44–47

Blistène 1980
Blistène, Bernard. "Ellsworth Kelly: La Peinture en Représentation." *Artistes* (February–March 1980), 20–23

Boston 1951
The 75th Anniversary Celebration Exhibition of the Boston Museum School. Checklist. Museum of Fine Arts

Boston 1987
Fairbrother, Trevor J. *Ellsworth Kelly: Seven Paintings (1952–55/87).* Exh. cat. Museum of Fine Arts

Bouret 1950
Bouret, Jean. "La premier Salon des Jeunes Peintres." *Arts: beaux-arts, littérature, spectacles* (Paris), 27 January 1950, 1, 4

Brenson 1982
Brenson, Michael. "In Sculpture, Too, He Is an Artist of Surprises." *The New York Times*, 12 December 1982

Buffalo 1989
Auping, Michael. *Abstraction-Geometry-Painting: Selected Geometric Abstract Painting in America Since 1945.* Exh. cat. Albright-Knox Art Gallery

Butler 1956
Butler, Barbara. "Ellsworth Kelly." *Arts Magazine* 32 (October 1957), 56–57

Caracas 1952
Primera Muestra Internacional De Arte Abstracto. Galeria Cuatro Muros

Colpitt 1979
Colpitt, Frances. "Americans in Paris." *Artweek* 10 (10 November 1979), 5

Cologne 1981
Glover, Laszlo. *Westkunst: Zeitgenossische Kunst seit 1939.* Exh. cat. Der Museen de Stadt Köln

Combat 1951
"Tour d'expositions: Kelly." *Combat* (Paris), 8 May 1951, 4

Coplans 1969
Coplans, John. "The Earlier Work of Ellsworth Kelly." *Artforum* 7 (Summer 1969), cover, 48–55

Coplans 1971
Coplans, John. *Ellsworth Kelly.* New York, 1971

Dantzic 1990
Dantzic, Cynthia Maris. *Design Dimensions: An Introduction to the Visual Surface.* Englewood Cliffs, New Jersey, 1990

Debs 1972
Debs, Barbara Knowles. "Ellsworth Kelly's Drawings." *The Print Collector's Newsletter* 3 (September/October 1972), 73–77

Debs 1983
Debs, Barbara Knowles. "Precise Implications." *Art in America* 71 (Summer 1983), 119–125

Donohue 1989
Donohue, Marlena. "Interview: Ellsworth Kelly." *The Christian Science Monitor* (Boston), 10 July 1989, 16–17

Dorsey 1988
Dorsey, John. "The World as Color and Shape." *The Sun* (Baltimore), 29 May 1988, P 1, 3

Drweski 1969
Drweski, Alicia. "Artificial Paradise." *Art and Artists* 4 (April 1969), 50–53

Duffy 1983a
Duffy, Robert W. "The Refining Light of Ellsworth Kelly's Sculptural Vision." *St. Louis Post-Dispatch*, 27 March 1983, H 5

Duffy 1983b
Duffy, Robert W. "'It Was the Shape of Things That Came to Matter to Me.'" *St. Louis Post-Dispatch*, 27 March 1983, H 5.

Eindhoven 1968
Three Blind Mice: De Collecties Visser, Peeters, Becht. Exh. cat. Stedelijk van Abbesmuseum; Sint Pietersabdij, Ghent

Elderfield 1971
Elderfield, John. "Color and Area: New Paintings by Ellsworth Kelly." *Artforum* 10 (November 1971), 45–49

Estienne 1951a
Estienne, Charles. "Romantiques ou classiques?" *L'Observateur* no. 57 (10 May 1951), 20–21

Estienne 1951b
Estienne, Charles. "Architecture et peinture." *L'observateur* no. 80 (22 November 1951), 18–19

Fort Worth 1987
Upright, Diane. *Ellsworth Kelly: Works on Paper.* Exh. cat. The Fort Worth Art Museum; Museum of Fine Arts, Boston; Art Gallery of Ontario; The Baltimore Museum of Art; San Francisco Museum of Modern Art; The Nelson-Atkins Museum of Art, Kansas City

G.B. 1951
G.B. "Kelly." *Arts: beaux-arts, littérature, spectacles* (Paris), 4 May 1951

Goossen 1973
Goossen, E. C. "The Paris Years." *Arts Magazine* 48 (November 1973), cover, 32–37

Graevenitz 1980a
Graevenitz, Antje von. "Vexierspiele der Hard edge-Malerei." *Suddeutsche Zeitung* (Munich), 16 January 1980, 12

Graevenitz 1980b
Graevenitz, Antje von. "Ellsworth Kelly, Bilder und Skulpturen, 1963–1979: Stedelijk Museum, Amsterdam—Ausstellung." *Pantheon* 38 (April/May/June 1980), 126–127

Halasz 1973
Halasz, Piri. "He Brightens Up the Spectrum of Contemporary Art." *Smithsonian* 4 (November 1973), 42–49

Halder 1980
Halder, Johannes. "Ellsworth Kelly." *Das Kunstwerk* 33, no. 5 (1980), 89–90

Hall 1991
Hall, Lee. *Betty Parsons: Artist, Dealer, Creator.* New York, 1991

Harper's Bazaar 1956
"Ripe for Fashion: Tomato Tweed—Black Cashmere." *Harper's Bazaar* (September 1956), 202–205

Hartford 1962
Continuity and Change: 45 American Abstract Painters and Sculptors. Exh. cat. Wadsworth Atheneum

Hartford 1964
Black, White, and Grey. Checklist. Wadsworth Atheneum

Helman 1990
Helman, Ursula. "The Folding Screen." *Bomb* no. 32 (Summer 1990), 88–93

Hernon 1983
Hernon, Peter. "Artist Lets Viewers Finish His Works." *St. Louis Globe-Democrat,* 23 March 1983, E 1, 3

Hess 1973
Hess, Thomas. "Sincerely Yours, Ellsworth Kelly." *New York Magazine* (15 October 1973), 98–99

Hindry 1990
Hindry, Ann. "Ellsworth Kelly: une investigation phénoménologique sur pans de couleur." *Artstudio* no. 16 (Spring 1990), 90–97

Hughes 1973
Hughes, Robert. "Classic Sleeper." *Time* (17 September 1973), 72–73

Hunter 1973
Hunter, Sam. *American Art of the Twentieth Century.* New York, 1973

Komanecky 1984
Komanecky, Michael. "Screen Plays." *ArtNews* 83 (September 1984), 88–90

Kramer 1968
Kramer, Hilton. "The Abstract and the Real: From Metaphysics to Visual Facts." *The New York Times,* 21 July 1968

Kutner 1987
Kutner, Janet. "Inside the Kelly Mystique." *The Dallas Morning News,* 12 September 1987, C 1–2

Larkin 1988
Larkin, Eugene. *Design: The Search for Unity.* Dubuque, Iowa, 1988

Los Angeles 1970
Color. Exh. cat. The UCLA Art Galleries

Los Angeles 1986
The Spiritual in Art: Abstract Painting 1890–1985. Exh. cat. The Los Angeles County Museum of Art; The Museum of Contemporary Art, Chicago; and Haags Gemeentemuseum, The Hague

Lyon 1988
La Couleur Seule, l'Expérience du Monochrome. Exh. cat. Musée Saint Pierre art contemporain

Masheck 1973
Masheck, Joseph. "Ellsworth Kelly at the Modern." *Artforum* 12 (November 1973), 54–57

McConathy 1964
McConathy, Dale. "Ellsworth Kelly." *Derrière le miroir,* no. 149 (November 1964), 3–12

Michel 1980
Michel, Jacques. "Peintures d'Ellsworth Kelly." *Le Monde* (Paris), 15 May 1980, 20

Millet 1973
Millet, Catherine. "Kelly, Noland, Olitski, Poons, Stella: après l'expressionisme abstrait." *Art Press* (November/December 1973), 10–15

MOMA 1972
Three Generations of Twentieth-Century Art: The Sidney and Harriet Janis Collection of the Museum of Modern Art. New York, 1972

MOMA 1977
Painting and Sculpture in the Museum of Modern Art, with Selected Works on Paper. New York, 1977

Munich 1981
Amerikanische Malerei 1930–1980. Exh. cat. Haus der Kunst. November 1981–January 1982

New Haven 1957
Presented by the Georgians. Checklist. Yale University Art Gallery

New York 1956a
Ellsworth Kelly: Paintings. Betty Parsons Gallery

New York 1956b
Group Show. New School for Social Research

New York 1962
Geometric Abstraction in America. Exh. cat. Whitney Museum of American Art

New York 1963a
Heller, Ben. *Black and White.* Exh. cat. The Jewish Museum

New York 1963b
Robert Morris, Larry Poons, Kenneth Noland, Tadaaki Kuwayama, Don Judd, Frank Stella, Darby Bannard, Ellsworth Kelly. The Green Gallery

New York 1966
Alloway, Lawrence. *Systemic Painting.* Exh. cat. The Solomon R. Guggenheim Museum

New York 1967a
New Work by Ellsworth Kelly. Exh. cat. Sidney Janis Gallery

New York 1967b
Art in Series. Finch College Art Gallery

New York 1968
Goossen, E. C. *The Art of the Real: USA 1948–1968.* Exh. cat. The Museum of Modern Art; Grand Palais, Paris; Kunsthaus, Zurich; The Tate Gallery, London

New York 1969
New York Painting and Sculpture: 1940–1970. Exh. cat. The Metropolitan Museum of Art

New York 1970
String and Rope. Exh. cat. Sidney Janis Gallery

New York 1971
Recent Paintings by Ellsworth Kelly. Exh. cat. Sidney Janis Gallery

New York 1973
Goossen, E. C. *Ellsworth Kelly.* Exh. cat. The Museum of Modern Art; Pasadena Art Museum; Walker Art Center, Minneapolis; Detroit Institute of Arts

New York 1978
Grids: Format and Image in Twentieth-Century Art. Essay by Rosalind Krauss. Exh. cat. Pace Gallery; The Akron Art Institute

New York 1982a
American Artists Abroad 1900–1950. Exh. cat. Washburn Gallery

New York 1982b
Sims, Patterson, and Pulitzer, Emily Rauh. *Ellsworth Kelly: Sculpture.* Exh. cat. The Whitney Museum of American Art; Saint Louis Museum of Art

New York 1986a
Reality Remade. Exh. cat. Kent Fine Art Inc.

New York 1986b
Of Presence and Absence. Essay by John Bowlt. Exh. cat. Kent Fine Art Inc.

New York 1986c
The 1950s, Part III: American Artists in Paris. Exh. cat. Denise Cadé Gallery

New York 1988
Ellsworth Kelly. Essay by Robert Storr. Exh. cat. BlumHelman Gallery

New York 1989
Ellsworth Kelly: Curves/Rectangles. Essay by Barbara Rose. Exh. cat. BlumHelman Gallery

Nordness 1962
Nordness, Lee, ed. *Art USA Now.* Volume II. Lucerne, 1962

Northridge 1979
Americans in Paris: The 1950s. Exh. cat. The Fine Arts Gallery, California State University at Northridge

Paris 1950a
Premier salon des jeunes peintres. Exh. cat. Galerie des Beaux-Arts

Paris 1950b
Réalités nouvelles 1950, numéro 4. Exh. cat. and checklist. Salon des réalités nouvelles

Paris 1951a
Kelly: Peintures et Reliefs. Checklist. Galerie Arnaud

Paris 1951b
Réalités nouvelles 1951, numéro 5. Exh. cat. Salon des réalités nouvelles

Paris 1951c
Derrière le miroir/Tendance, no. 41 (October 1951). Exh. cat. Galerie Maeght

Paris 1952
Derrière le miroir/Tendance, no. 50 (October 1952). Exh. cat. Galerie Maeght

Paris 1961
Art abstrait constructif international. Exh. cat. Galerie Denise René

Paris 1977
Paris-New York. Exh. cat. Centre national d'art et de culture Georges Pompidou, Musée national d'art moderne

Paris 1980
Ellsworth Kelly, peintures et sculptures 1968–1979. Exh. cat. Centre national d'art et de culture Georges Pompidou, Musée national d'art moderne

Paris 1981
Paris-Paris/Créations en France: 1937–1957. Exh. cat. Centre national d'art et de culture Georges Pompidou, Musée national d'art moderne

Paris 1988
Les Années 50. Exh. cat. Centre national d'art et de culture Georges Pompidou, Musée national d'art moderne

Perreault 1967
Perreault, John. "Color as Light." *The Village Voice,* 9 March 1967, 12–13

Perreault 1973
Perreault, John. "Two Views: Misty and Clear." *The Village Voice,* 20 September 1973, 29–30

Perrone 1977
Perrone, Jeff. "Castelli Graphics Exhibition." *Artforum* 15 (April 1977), 62

Peters 1979
Peters, Philip. "De Mooie Formalistische Kunst van Kelly." *Kunstbeeld* 4 (December 1979), 29

Philadelphia 1972
Grids. Exh. cat. Institute of Contemporary Art, University of Pennsylvania

Purchase 1986
Delehanty, Suzanne. *The Window in Twentieth-Century Art*. Exh. cat. The Neuberger Museum, State University of New York, Purchase; Contemporary Arts Museum, Houston

Ratcliff 1981
Ratcliff, Carter. "Mostly Monochrome." *Art in America* 69 (April 1981), 111–131

Raynor 1983
Raynor, Vivien. "Ellsworth Kelly Keeps his Edge." *ArtNews* 83 (March 1983), cover, 52–59

Rickey 1967
Rickey, George. *Constructivism: Origins and Evolution*. New York, 1967

Rose 1973
Rose, Barbara. "American Original: Ellsworth Kelly." *Vogue* (November 1973), 208–209, 254

Rosenberg 1973
Rosenberg, Harold. "The Art World: Dogma and Talent." *The New Yorker* (15 October 1973), 113–119

Rubin 1983
Rubin, Michael G. "Ellsworth Kelly Sculpture: Visual Ideas Made Concrete." *St. Louis Globe-Democrat*, 16–17 April 1983, F 5

Rubin 1963
Rubin, William. "Ellsworth Kelly: The Big Form." *ArtNews* 62 (November 1963), 32–35, 64–65

Rudenstine 1988
Rudenstine, Angelica Zander. *Modern Painting, Drawing, and Sculpture Collected by Emily and Joseph Pulitzer, Jr*. Volume IV. Cambridge, 1988

Russell 1982
Russell, John. "Art: Ellsworth Kelly." *The New York Times*, 17 December 1982, C 34

Russell 1987
Russell, John. "Outdoor Abstractions: Ellsworth Kelly's Pure Sculptures in the American Landscape." *House and Garden* (February 1987), 182–184, 200, 202

St. Gallen 1988
Bürgi, Bernhard. *Rot Gelb Blau: Die Primäfarben in der Kunst des 20. Jahrhunderts*. Exh. cat. Kunstvereins St. Gallens

Sandler 1978
Sandler, Irving. *The New York School: The Painters and Sculptors of the Fifties*. New York, 1978

Santander 1953
Exposicion international de arte abstracto. Museo de Arte Contemporaneo

Schmidt 1980
Schmidt, Doris. "Die projizierte Wahrnehmung." *Suddeutsche Zeitung* (Munich), 25 August 1980, 11

Seitz 1972
Seitz, William C. "Mondrian and the Issue of Relationships." *Artforum* 10 (February 1972), 70–75

Seuphor 1953
Seuphor, Michel. "Paris." *The Art Digest* 27 (1 March 1953), 8–9

Seuphor 1960
Seuphor, Michel. "Sens et permanence de la peinture construite." *Quadrum* 8 (1960), 37–58

Seuphor 1962
Seuphor, Michel. *Abstract Painting: Fifty Years of Accomplishment, from Kandinsky to the Present*. Translated from the French by Haakon Chevalier. New York, 1962

Shepherd 1980
Shepherd, Michael. "Ellsworth Kelly." *Arts Review* 32 (29 February 1980), cover, 87

Smecchia 1985
Smecchia, Muni de. "Ellsworth Kelly: Incontro con un protagonista dell'astrattismo." *Vogue Italia* no. 418 (January 1985), 274–279

Spies 1983
Spies, Werner. "Reduktion als Widerstand." *Frankfurter Allgemeine*, 5 February 1983, 25

Storr 1988
Storr, Robert. "Quelques heures et encore moins de mots avec Ellsworth Kelly." *Art Press* no. 128 (September 1988), 18–20

Tillim 1959
Tillim, Sidney. "Ellsworth Kelly." *Arts Yearbook* 3 (1959), 148–151

Trenton 1983
Beyond the Plane: American Constructions 1930–1965. Exh. cat. New Jersey State Museum; The Art Gallery, University of Maryland, College Park

Tuchman 1974
Tuchman, Phyllis. "Ellsworth Kelly's Photographs." *Art in America* 62 (January/February 1974), 55–62

Tyler 1956
Tyler, Parker. "Ellsworth Kelly." *ArtNews* 55 (Summer 1956), 51

Waldman 1971a
Waldman, Diane. *Ellsworth Kelly: Drawings, Collages, Prints*. Greenwich, 1971

Waldman 1971b
Waldman, Diane. "Kelly, Collage and Color." *ArtNews* 70 (December 1971), 44–47, 53–55

Washington 1963
Paintings, Sculpture and Drawings by Ellsworth Kelly. Interview with the artist by Henry Geldzahler. Exh. cat. The Washington Gallery of Modern Art; Institute of Contemporary Art, Boston

Washington 1984
Komanecky, Michael, and Virginia Fabbri Butera. *The Folding Image: Screens by Western Artists of the Nineteenth and Twentieth Centuries*. Exh. cat. National Gallery of Art; Yale Art Gallery, New Haven

Washington 1988
Strick, Jeremy. *Twentieth-Century Painting and Sculpture: Selections for the 10th Anniversary of the East Building*. Exh. cat. National Gallery of Art

Wasserman 1985
Wasserman, Isabelle. "Monumental Art Form for the City?" *The San Diego Union*, 12 February 1985, C 1, 8

Wechsler 1973
Wechsler, Jeffrey. "Kelly Validates His Innovations and Attitudes." *The Daily Targum* (Rutgers University, New Brunswick, NJ), 25 September 1973, 6

Wescher 1951
Wescher, Herta. "Abstrakte Malerei in Paris II." *National Zeitung* (Basel), 7 August 1951

Westfall 1986
Westfall, Stephen. "Ellsworth Kelly at BlumHelman, BlumHelman Warehouse and Kent." *Art in America* 74 (November 1986), 161–162